The Mindful Moment

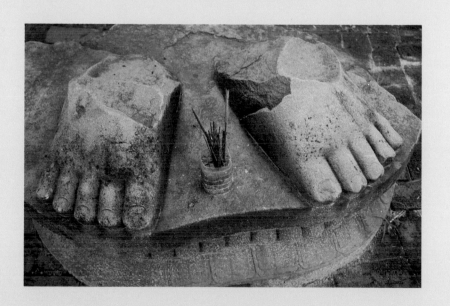

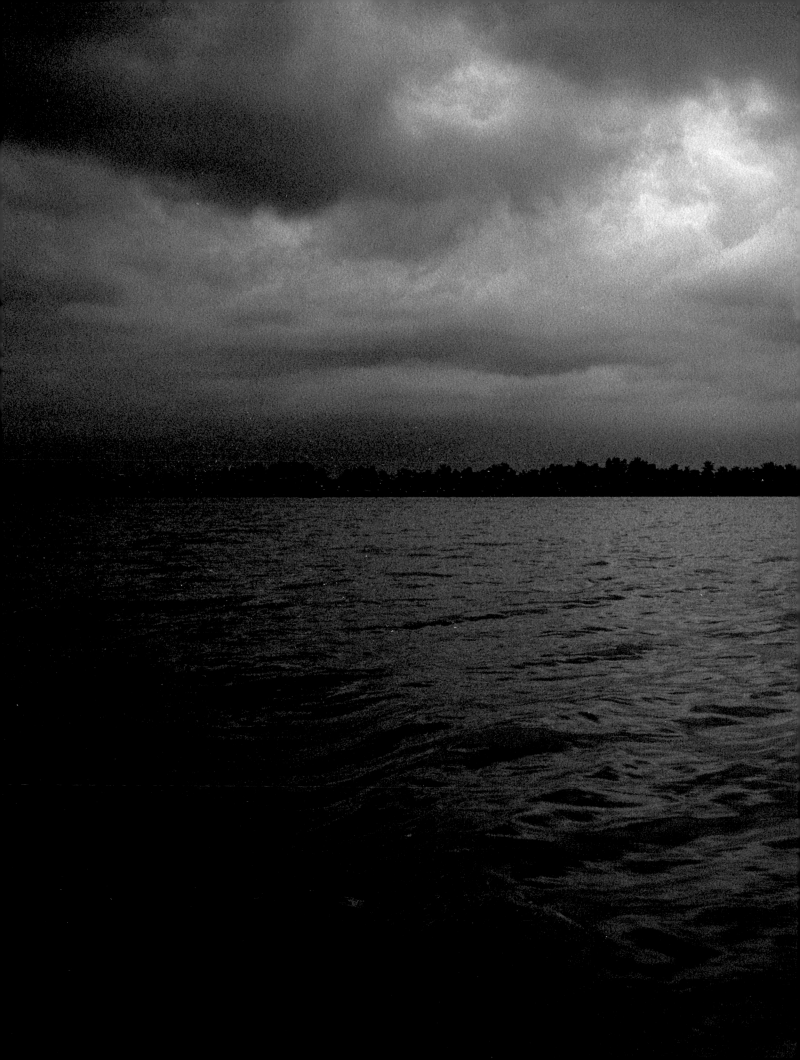

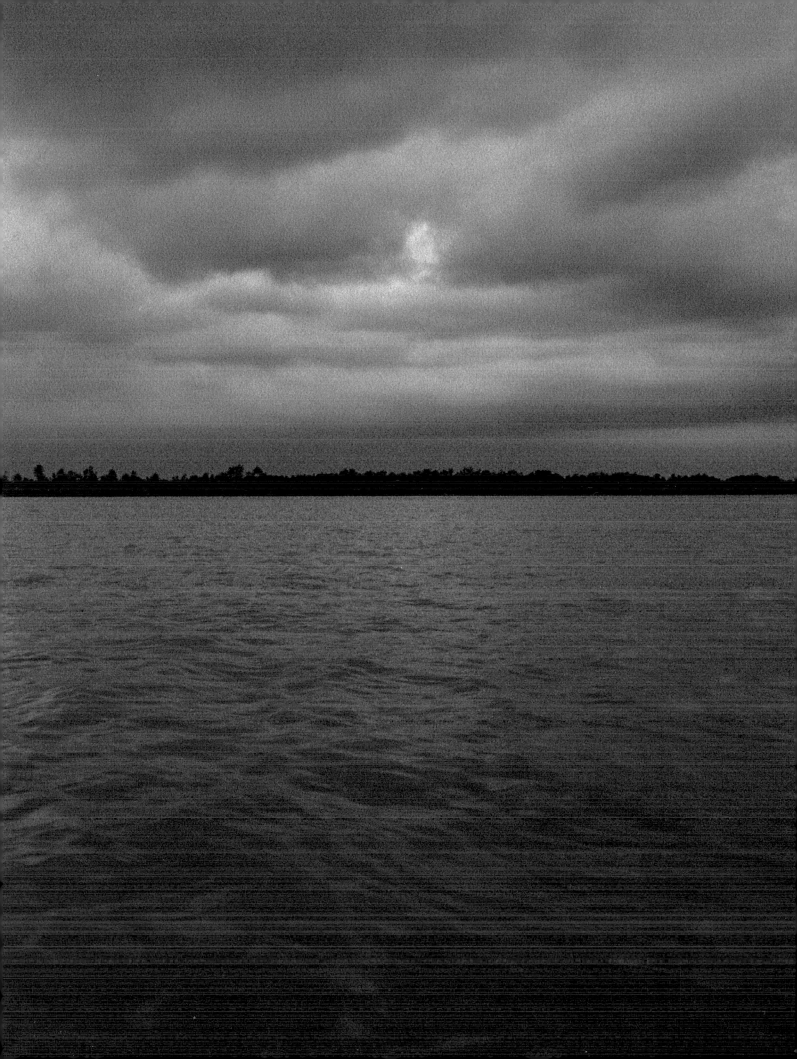

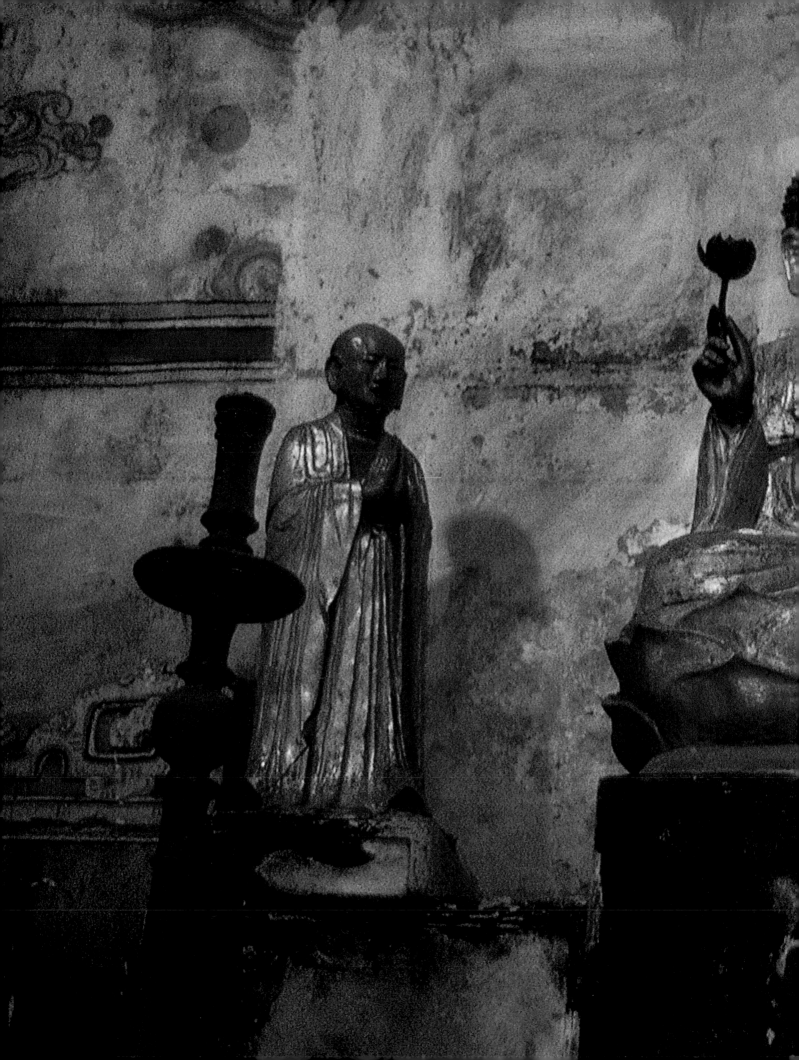

Tim Page

The Mindful Moment

with 136 illustrations, 126 in colour

Thames & Hudson

For my mother; for the patience of all those who have given their *conseils* that helped the living, the creative flow. That our energies and spirit reverb on, so that our children live in an understandable place of sanity and peace.

First published in the United Kingdom in 2001 by Thames & Hudson Ltd, 181A High Holborn, London WC1V 7QX

British Library Cataloguing-in-Publication Data
A catalogue record for this book is available from the British Library

ISBN 0-500-54242-2

Printed and bound in Germany by Steidl Verlag und Druck

On the half-title page: The Cham Museum, Da Nang, Vietnam, 1999

Pages 2–3: Monsoon storm over the Mekong at Ben Tre, Vietnam, 1992

Pages 4–5: Shrine in the ancient Vietnamese capital of Co Lé, Tonkin, 1990

Contents

1 Road

'At first it seemed so far away,
beyond a horizon over which few had travelled.'

There is a privilege in being raised in a time of peace. A luxury that your life is not under immediate threat. War becomes something labelled heroic, often patriotic, nationalistic. There is a cause, it is just and right, and it somehow excuses all the pain and all the loss.

There is always a lull afterwards, a time of shortage for the losers, a time of relative plenty for the victors. Yet no one has really won, for conflict doesn't rage for people's rights or causes but to boost the profits of aerospace and defence corporations. But that is too simple, for it is those at the receiving and perpetrating ends who really suffer, who suffer the worst indignities that a human being can bring upon his fellow human.

We take all this for granted, or at least we think we do, until the brutal reality of war arrives on our own doorstep. Some of us choose to go and find it, to observe and record man's most perverted moments.

Although I was born at a point when World War II was sliding towards victory for the Allies and 'the cause', I have no memories of suffering, no nightmares resulting from bunkered nights. The afterglow of the contest was bolstered by a surfeit of movies and books extolling the epoch. Rationing dominated everyday life, and travel was difficult, fraught and slow. 'Going abroad' was unheard of for most middle-class people like us. Security was the name of the game. Return to normal. Cherish the blessings of what we have. Store for tomorrow. A psychology that World War I and II had imbued prevailed. Horde against the inevitability of another catastrophe.

The Cold War filled the headlines; the inevitable was still a possibility. But we got richer and the apprehensions receded. Foreign news became *de rigueur*. Newer versions of the apocalypse happened with a monotony, though without ever impinging directly on our burgeoning prosperity. We could once again take to the roads, the rails, the waves and the air with freedom. We had come full circle to a peace. A mad balance of power hung between east and west, between ideologies and philosophies. It was to be the biggest poker game that modern man had ever played out. The capitalistic west – 'the best', we were told – would triumph.

Ever since childhood I had only ever dreamt of being a glorious, A-rated fighter pilot or rear gunner. You'd always come safely home from a mission, maybe a little bloodied, but then that was just good for the image. When you're young, pain is perhaps more transitory and easily forgotten, usually avoided altogether. Most of us are secure and well fed – at least not undernourished. Back then we were coddled and protected from the horrors taking place around the world. But the revolution in mass communications, the coming of the digital age, has changed

that for ever. With the click of a remote control we can now beam any one of the planet's couple of dozen conflicts straight into our living rooms. We're told at the top of a report that the images we'll see may be disturbing. Perhaps they should just flash 'Achtung! Reality.'

It all started in the 1960s. Television was about to become all-dominating. Telephones had improved: though not yet mobile, they were good enough to pump images globally. For the first time, colour photographs could be published on the other side of the world on the same day they were taken. The good folk on the ground were changing, too. Veteran reporters with experience of World War II and Korea were thinning out, their expertise, knowledge and wisdom disappearing as quantum leaps in technology ushered in a new age.

The new generation of correspondents came from the privileged, those who had listened to their fathers' and grandfathers' stories of war but had never experienced it themselves. They had bopped the '50s and were now rock-'n'-rolling in the liberated '60s. A new consciousness infiltrated a youth that was demanding an alternative media, a more aware, frank coverage of *their* story and the event dominating it, the Vietnam War. Bolstering the regulars who came to work and play was a new breed, the freelancer, responsible only to himself, looking for a powerful photo to put bread on the table, needing an image in print to lift his reputation and to get the next assignment – living continually at the whims of the story and those who purchase the product.

At first it seemed so far away, beyond a horizon over which few had travelled, too far to be a holiday destination, unless you were very intrepid. The long-haul jet was only just coming on line – propellers still ruled the air. Vietnam was never a patriotic war for America. There were no calls for the people to 'Save the country from the invading yellow hordes!', only weird talk of a domino theory, the red spread of communism.

The real issue was about the spirituality, the righteousness of the cause. For the Viets there was no question – their history dictated survival. Theirs had been a two-thousand-year struggle to maintain a homogeneous national identity, a purpose behind the soil which represents their very being. Dead ancestors return to it, continuing the cycle, energizing the people left behind. The last challenge to their integrity was instigated by a culture just two centuries old, where Mammon had become God, where to consume was to be content, where rich was good and the populace fat. An overweight society accounting for twelve per cent of the global population, yet consuming forty-seven per cent of its energy and resources. New wars are about profit, the stock market and control of a global economy. Some call it neocolonialism, a spin propagated by Coca-Cola,

McDonald's and Microsoft. On the twenty-fifth anniversary of Vietnam's unification, a T-shirt proclaimed 'I got to Vietnam before McDonald's'. Consumerism has done more to despoil the country's social harmony, the family structure, than the decade-long war which cost two and a quarter million lives. 'God' is no longer Buddha but Honda; the pantheon of saints are Sony, Suzuki and Panasonic; the communal wine is provided by PepsiCo.

Not a lot of this was apparent in 1965. For me it was just a break to have gotten out of Laos after eighteen months of total immersion in the most laid-back spot on the planet. There I had had the chance to absorb the experience of overlanding to India in its pre-hippie days. Real spirituality still existed then – it hadn't yet been trampled on by avid consumerism and foreign visitors. A young white face like mine, in the same state of penury as the locals, was a rarity. We had left them after colonization, but now a new generation was returning to savour what was only occasionally assimilated by exploiters. Ours was not a mission of plunder, rather one of passage to another world.

The east has a different face when you're forced to live it on the street, from the perspective of the average local, somewhere between shopkeeper caste and bureaucrat. Survival in a large oriental urban environment is a test of ingenuity. Basics like cooking and washing tax even the most enterprising. Any illness wears you down, the state of medicines (or lack of them) not being conducive to a quick cure. Even today South Asia is guaranteed to slay the visitor with some god-awful bacillus or amoeba. It is dirty, the diet a complete anathema to anyone raised on supermarket food. The way of life compares to nothing we know. We cannot imagine such poverty. Most of us do not suffer from hunger and disease, we have access to education and welfare, and we are not governed by a caste system that makes few concessions to modernity. And then there are deities in the hundreds, thousands by some counts. Coming from the west, you get confused, your Judeo-Christian thing is taken to the cleaners, confounded by scrunched-up mystics, magic men, gurus, and saints that range from plausible to cuckoo's nest.

Eventually, some sort of understanding begins to shape itself out of all these mystic clouds. You start to look at the simple things, the roots of the hodgepodge confronting you. The Hindu thing cruised by overhead unfathomable. In its structured, logical precepts, streamlined for local use, Sikhism worked, or my perception was that it did. It is well known among travellers that you can stay at a Sikh *gudwara* for three nights and be fed simple vegetarian food for free. It is the duty of all believers to welcome visitors. In this way the munificence of the sect is passed on to the poorer members. I overnighted at their main HQ, the Golden Temple in Amritsar. The hospitality there was openly extended with an introduction to the Sikh fundaments, which

pervaded most of my survivalistic dealings during my fifteen months in the subcontinent. The nourishment of the Sikh brotherhood steered me across the whole of India, Nepal and even into Burma a year and a half later.

Burma was about stillness, about contemplation, although admittedly under the gun of a military repressive regime and the insurrectionist ethnic groups that controlled most of the territory outside of the Irrawaddy plains. A chance meeting with the Burmese consul in an ice-cream parlour in Calcutta had gotten me a freak one-month visa, at a time when even tourists were being refused entry. Any foreigner was a novelty, but the Burmese never imposed. They just wanted to be hospitable, especially when you showed interest in their holy sites – then they would guide you deeper towards their calm path. To sit peacefully at dawn atop the platform surrounding the *shwes* of the gold-encrusted Shwedagon Pagoda in Rangoon, bells and gongs occasionally sounding, families and individuals silently passing by performing their devotions, is to be bathed in a serenity and peace that I had never before experienced. Incense and small terracotta oil lamps were lit, leaving a mysterious pungent smell in the air; everywhere flowers were offered to the Buddha. The women all had sandalwood paste spread on their brows and cheeks to preserve their skin; men and women, young and old, wore traditional *longyi* or sarongs. The steps leading up to the pagoda, ascending hundreds of feet in long flights, were lined with stalls selling religious artefacts and materials for offering – a sloping mindful supermarket where every item purchased becomes a social interchange. Burma was a series of passive days travelling at a pace now considered old-fashioned, benignly observing, absorbing and revelling in the pleasure of fulfilling a dream. Coming from somewhere between Buddhism and an inherent belief in the *nats* – the spirits in the trees, rocks and waters – the country weaves a magical, intense, superstition-laden sinew into your soul. You feel its practices should work anywhere, though without the benevolence of the tropics they probably wouldn't – colours just aren't the same elsewhere.

Leaving this tranquillity to arrive in Thailand was like a cork popping out of a champagne bottle. Westernization was already creeping in; regular shops and restaurants were becoming commonplace; neon and air-conditioning were normal. I didn't stay long.

Thankfully, Laos was just a short boat ride across the Mekong. Within two days I had got employment with the USAID mission in the Lao capital, Vientiane. Now it seems farcical, but my first job was in the mission's agronomy section. I was to create a nursery/garden centre to supply the American housing compounds that were paving their way out of the jungle. I was given the keys to a Studebaker pickup truck and six Lao workers, one of whom knew a smattering of French. Our task was to dig up jungle plants and transplant them to our ordained

patch six kilometres north of town. Eventually these rare specimens would grace the barren yards of transposed suburbia, replete with supermarket and bowling alley.

This was at the height of the US military expansionism. All over the world, President Kennedy had sent police-training teams, special forces and plain ground troops into eighty-three countries, either with or without the host nation's consent. In Laos, the land of a million elephants and the white parasol, two and a half million people were in the throes of both overt and covert military intervention. Vast fields of opium poppies and their heroin derivative were not an insignificant consideration. Rival princes of different political persuasions had carved up the country into fiefdoms. There were royalists, with the king residing not in Vientiane but upstream in picturesque Luang Prabang; there were neutralized, though still armed, neutralists based in Vang Vieng; and there were communists, centred on Sam Neua on the Plaines des Jarres in the northeast, close to their fraternal Vietnamese backers and allies. Down south in Champassak there existed a Rouge royal prince, listening only to his own remit. Beside the Americans were the French, the past colonial masters, training the royalist government forces. The Russians favoured the communists but had dabbled with the neutralists, while the Chinese and Vietnamese poured men and materials into the northern and eastern mountains and forests. The capital, a dusty, untidy town of 100,000, served as a setting for spooks, spies and operatives from a dozen different nations' services. The ethnic hill tribes that once lived in primitive bliss were now co-opted in to forming guerrilla armies to fight both brother and lowland Lao, while trying to avoid the wrath of the Viets, who were using much of the country as their own.

Laos is a land of superstitions and of Buddhism. The Lao are not a warrior-minded people – to fight is an anathema; to party and pray is the norm. At that time there were almost a hundred national holidays a year, each full moon guaranteeing a three-day celebration. The work ethic does not dominate Lao life. The working day runs from 7.30-ish to 11.00 in the morning and from 2.00 to 4.00 in the afternoon. At midday nothing functions – even desultory fighting ceases, phones stop ringing and to avoid a siesta verges on the criminal. This was once a land that had a permanent smile, one that is only now beginning to return. The tropical climate guaranteed abundance in any crop; fish proliferated in the Mekong and its tributaries; the hill tracts and mountains were covered in rainforest and jungle. Now it is one of the world's ten poorest countries.

The moment I set foot in this land I assumed its pace of life. Removing my footwear on entering a home or a *wat*, a Buddhist temple, keeping my shoulders covered and my head bare – it all became automatic to me. I adopted the customs of daily life in Laos without barely noticing the transition to a lifestyle so removed from my western upbringing. Even the language, initially

unfathomable, soon came to me. The Lao are so delighted to hear you fumble with their tongue that for every word you learn they lead you to two more. In a couple of months I was street fluent – well, fluent enough to sort out the intricacies of the plant nursery and the opium *fumerie*, fluent enough to find food and shelter.

One day, after landing a job at the AID compound, I met Martin, an elder surrogate brother who was also searching the backwaters of Asia for resolutions that before had only been the subject of academic study. With good fortune we shared our first residence, albeit a house so haunted and spooky that in the end we were forced to move. Black snakes would enter downstairs, a well-screened and sealed area, leaving behind malevolence and bad vibes, taking with them the few homely *pis*, the animistic spirits, that remained. The *pis* in that house were way out of kilter: unripe papayas would fall from the trees in the yard, familiar objects started changing place, and small things went missing. Some things moved at night, footsteps could be heard, and we would all wake up at precisely the same time, totally weirded out. But then the noises, the disturbed spirits, would leave and we would drift back to an uneasy sleep, sundry weapons restashed under our racks. We never did find out what fate or fates had befallen the previous occupants. After our departure I passed the house one day, stopping for a long moment to watch a party of *bonzes*, monks, holding a ceremony to appease the dangerous *pis* from encroaching on the present owner's life. Thirty-four years later I went past again – the place was semi-deserted, the garden overgrown.

Those Laotian years were an idyll, the gentlest method devised to segue a young man from his teens into his twenties. As yet, I'd had no focus, only a reaction to each incident thrown up on the track. I hadn't planned a path since the age of sixteen and an accident on my first bike, a 250cc BSA, had left me 'dead on arrival' at the local hospital, a gushing artery on the forehead, a crushed hand and pelvis. Nothing had been quite the same after that first privileged glimpse of the other side. Upon miraculously finding myself awake, though in pain, there was a bizarre blankness. Someone had hit the delete button, and then forgotten to tell me which buttons to press to boot it all back up again.

Who can say what a near-death experience really is, feels like or means afterwards? It is forever there in the subconscious. There is always a quest, an inquest that the individual will conduct until the eventual finality. Or at least the finality of this passage, this temporary nanosecond in something so infinite that only myth and fable can possibly quench the wildest science fiction. The understanding of that passage is the quest, often conducted unknowingly by many. We are not all allowed the luxury of contemplating this infinite – our mission is to be stewards of the precious for a fleeting moment.

By late '64 I had lost track of time. Barely out of my teens I now inhabited a world so strange that the latest avidly devoured Bond novel read like the norm. Every day planes were shot down, roadblocks fired at buses, mines and bombs exploded. The place swarmed with button-down collars, Rayban-shaded, healthy studs with that distinctive military stance. Everyone had a spurious cover title; assembled civilians would mutedly mumble 'spook' when such a character came into a watering hole. Western newsmen started to target the country, overwhelming the few stringers who were catering to the entire world's requests for stories on Laos. The pulse, the tempo of life, visibly picked up, Lao standards notwithstanding.

My buddy bro Martin was by now the United Press International stringer in the country. Conflicting interests lost him his AID post, but got him a fifth-hand black MGA sports car, a telex card and a tab at the Hotel Constellation, the hub of the western media's activities in Vientiane. Our lifestyle had risen – we now got invites to embassy and mission *soirées*, cocktails with warring factions, and government junkets to upcountry events. Meanwhile, I was teaching English part-time at the French *lycée* under a British Council programme that afforded a freak import – a misguided, British embassy import – a 250cc Cotton moto-cross bike. A new world opened up for the both of us. No one could foretell the future, except the backdrop was going to be an escalating war.

There was a sidebar that year: a magical drive across Thailand and into Cambodia in a diplomatic-plated Ford Cortina. Thailand by now had a network of US-built, laterite-topped roads, linking the proposed new American bases that were then beginning to come on line. Our destination was Angkor in northern Cambodia, a beautiful complex of magnificent stone temples in the middle of dense jungle which had once been the capital of the ancient Khmer Empire, followed by a tour round the nearby Tonle Sap, Cambodia's vast inland sea. By the second night we were in Siem Reap, just six kilometres south of Angkor, having crossed the Thai–Cambodian border at Ban Aranyaphrathet/Poipet. The crossing had been interminably slow due to the guards' surprise that people from Laos wanted to go to downmarket Cambodia – no one took holidays in that kingdom. The monarch apparent, Prince Norodon Sihanouk, was in the process of making a film about the Khmer nation's history – a megaproduction, where the prince was producer, director, chief of photography and played a starring role.

In our three weeks in Cambodia, apart from the time on the film set, we saw only about a dozen other foreign visitors. You could drink your fill in a surfeit of silence, and sink into the atmosphere of a wondrous lost world and civilization pulsating with the energies of its Hindu and Buddhist ancestors. Marcus, my diplomatic buddy, and I rented some bicycles and set off to discover Angkor's architecture, which was surrounded on all sides by prime forest full of

butterflies, birds and, above all, spirits. Angkor soon starts to overwhelm you, ensnares you into meandering deeper into passages shrouded with the thick roots of the sacred banyan trees. The elaborate bas-relief carvings on the temple walls, some encrusted with lichen, surprise in their intricate detail. You can hear the forest breathing, growing, shrinking and decaying around the sandstone. There are times when a strange chill envelopes you, when unfamiliar noises startle, reminding you that man's incursion into the wild is temporary. The jungle rampantly exposes and erodes even the loftiest temple in the complex, the Bayon.

The Bayon looms pyramid-like, skyscraper-like, out of the trees, its surfaces mostly restored, keeping nature at bay. It reaches up in a series of towers, each cornered by four-headed Buddhas that beam serenely over the jungle. This twelfth-century pile has been sufficiently restored that you can scramble almost to the top and just glimpse the other taller sites over the canopy. By night it becomes ethereal, its steps integrated with the awakened spirits of the forest and those emanating from the still warm stones. Trying to sleep on a mat near the top was not easy. The sounds of the wild jungle, miles from humankind, filled the air – only the ancestors and the wisdom that had created the place echoed forth. It was hard to catch the vibrations, hard to still the mind to the disquieting, the unfamiliar, to get in tune with the all-pervading connections that were on offer. Sleep was fitful, and dream bedevilled. It was a hard day's night. A few days later, finally climbing the centre-piece of the complex, the Angkor Wat temple itself, the largest religious building in the world, large enough to be a city in its own right, I looked north and saw the tops of a monument to a once great civilization that had faded to a shadow of its former self. Back in '64, unless you were part of an opposition cell, barely reported in the media, you would have assumed only good things about the gradual development of this fertile Buddhist place. Unlike in Laos, there weren't the large ethnic minorities in the hills or feuding royal aspirants. But peace wouldn't endure for much longer. The veil of war would obliterate the fragile ecosystem and the integrity of the once blessed Khmer people. In that three-week circumnavigation of the Tonle Sap, on roads that closed for twenty years soon after, a certain part of my heart was lost for ever. The itch to return would dog the next three decades.

Back in Vientiane, Martin and I were awoken one morning by the sound of gunfire, a rarity in town. The capital was not on the front lines, although during partial eclipses and certain full moons the Laos would bang away at the heavens with whatever weaponry was to hand. They believed that they could take out the giant rat nibbling the moon, or appease sundry nasty spirits lurking inauspiciously in the neighbouring heavens. But this morning people were shooting back. The phone wasn't working.

My buddy was just back from Tokyo after six weeks of on-the-desk training at UPI to become a regular staff correspondent. He was to be their full-time man in Vientiane. For those weeks I had been the UPI stringer, taking on the side some work from the *Daily Mail*. The reward for the sparse filings and updates on the upcountry conflict was a hundred bucks and a Pentax 35mm camera – both have formed a life-raft since. Like with Martin, AID asked for my resignation – another conflict of interests. As media, we were automatically put in the same category as spies or subversives. We actually walked and talked, wined and dined with the communists. Our crime: communication with the enemy.

But the automatic-weapons fire that morning was not communist-inspired. The army was being attacked by the paramilitary and police units loyal to another set of colonels and junior generals wanting their slice of the aid and opium pie. The fighting was intense only in neighbourhoods adjacent to bases, around the PTT (post office) and ministries, and much farther north out of town at Wattay, the main airbase. Armed checkpoints with rice bags for barricades adorned major intersections looking for opposing renegades. The rebels wore blue ribbons for easier ID. Both factions boasted the same uniforms and US-supplied weapons. The phones were out because the PTT building had become the centre of a heated firefight; the airport was closed; and any cross-river activity had been halted. Loyal airforce pilots attempted strafing runs of rebel riverside positions in their aged T28 fighter-bombers.

Martin took a forward operating base room at the Hotel Constellation. My remit was to cruise round the town on my pale-blue scrambler. My long blond hair, blue eyes, and decidedly non-spook/military attitude would hopefully keep me alive. It seemed like only a slightly fraught doddle; care had to be taken at major crossroads. The odd plopping mortar round never appeared aimed in my direction; the lads at the roadblocks nonchalantly waved me down and posed for pictures, happy to relieve the tension into which they had been cast. I reported back regularly to Martin, who was furiously topping up his dispatch, though the filing was to be done on a pool basis from the US embassy. The staff there were only too happy to pump the agency news, being themselves clueless to the state of play on the street. The true spooks had been outwitted.

That night, with my processed film and Martin's dispatches, I rode through the opposing lines to the river crossing at Tha Deua, rented a boat and rode on to the nearest US Airforce base at Udorn. For the price of my debriefing, UPI was to get the exclusive on the breaking story, the film freighted to Bangkok for wiring globally.

Just after sunrise I was back in Vientiane. We stayed exclusively on the track for three days, until a relative calm returned and a flood of newshounds flocked in. Five days after filing

my first published wire photos, just after the pock-marked PTT had reopened, a blue telegram arrived in the UPI pigeonhole at the Connie addressed to Page c/o Stuart Fox. It had been opened and resealed. It was the first and only telegram I'd ever received in my twenty years. It could have been a harbinger of the disastrous, it could have been a win on the football pools. Martin's grins dissipated any fears. It was my ticket to ride: I had been hired and had to fly directly to Saigon asap.

That was early February 1965, almost three years after I had hitchhiked to Dover with just a vague plan of sailing to South America on a ship from Rotterdam or Amsterdam. From a conventional career in forestry with middle-class aspirations, I was now heading to war, armed only with the Pentax and marginal street-combat experience. My trusty steed would be lashed to the DC-6 cockpit bulkhead; I would roll right off Royalair Laos and right into the heart of a new era, where tranquillity and peace would rarely be savoured. The rhythms of survival would now dictate an artistic curve I couldn't yet see, let alone the pains and traumas involved. Peace was to be a long time coming.

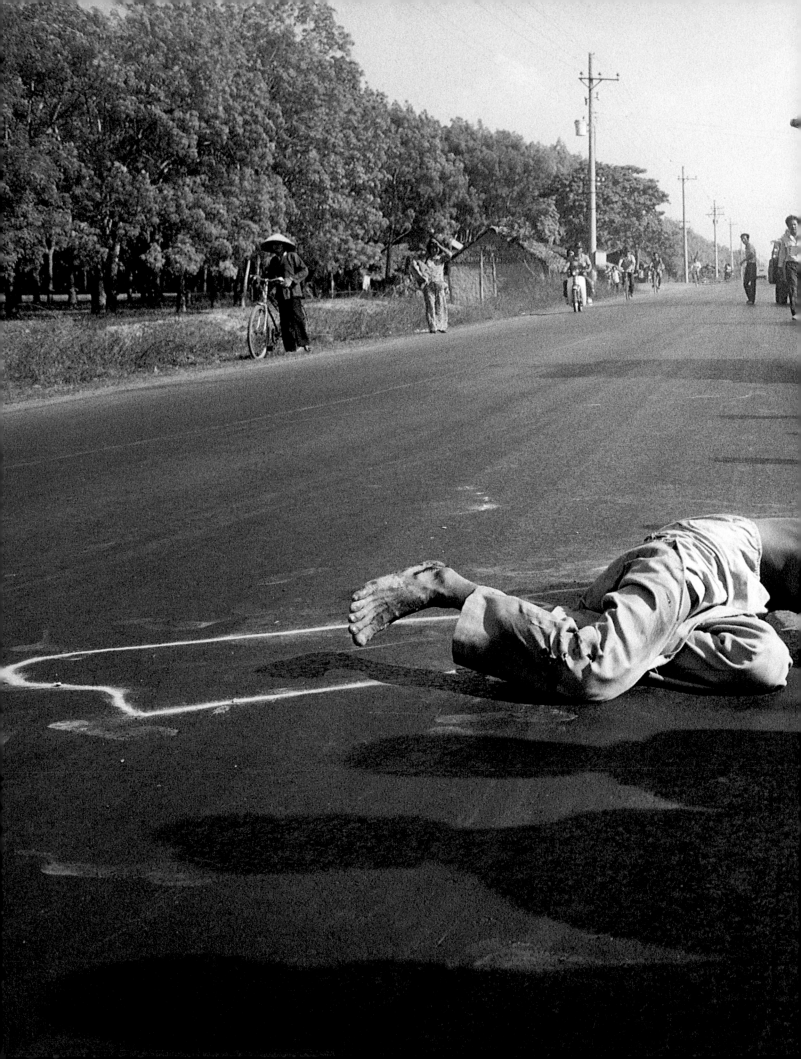

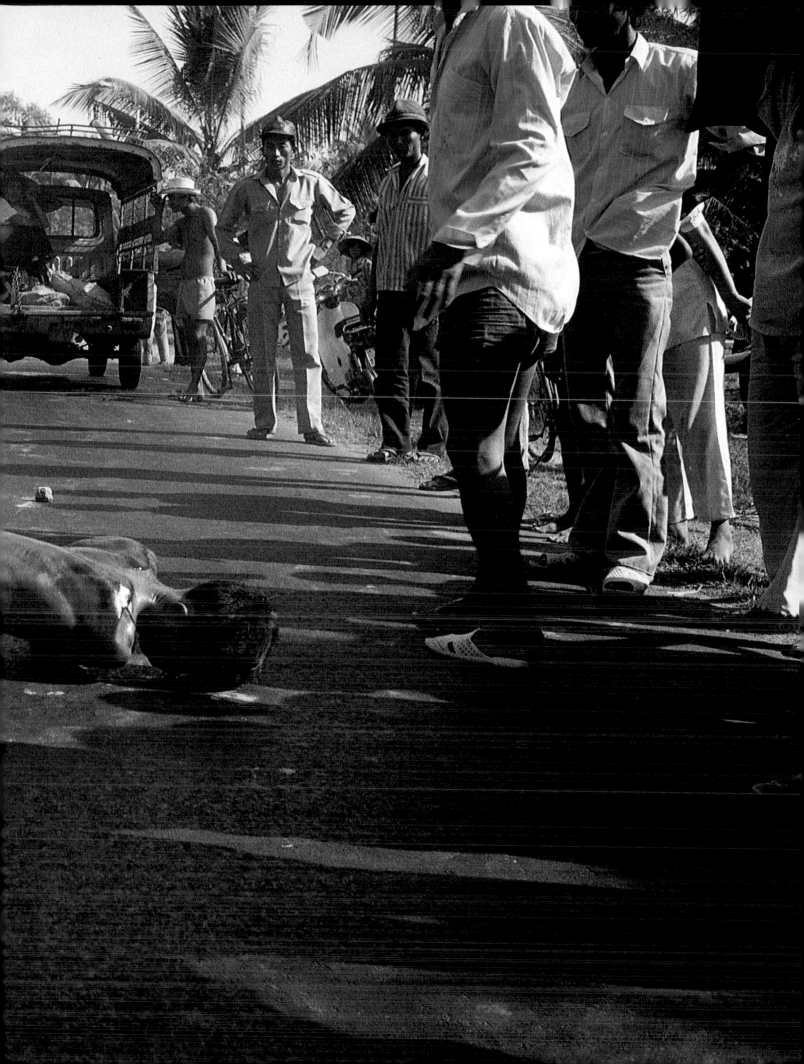

New youth, Hanoi,
Vietnam, 1999

Opposite: The monsoon wind arrives
on the road to Pochentong airport,
Phnom Penh, Cambodia, 1991

Pages 20–1: Accident on road
between Tay Ninh and Ho Chi Minh,
Vietnam, 1990

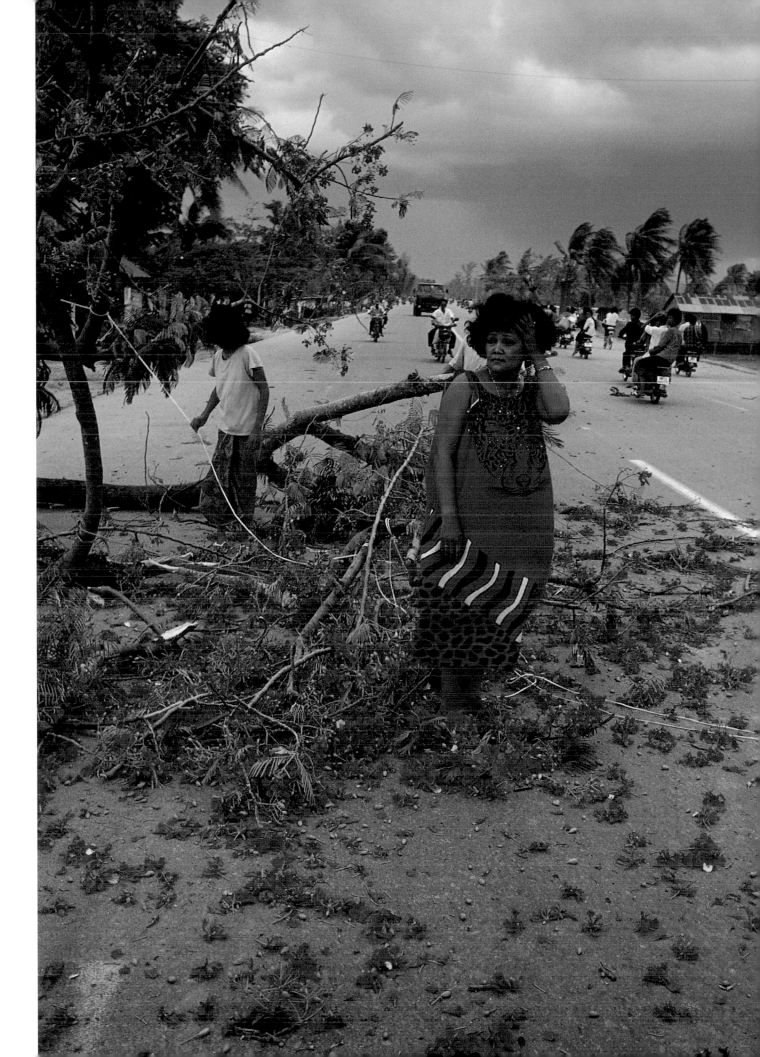

Luggage shop, Saigon,
Vietnam, 1965

Pages 26–7: Firemen at the scene
of the bomb blast heralding the
onset of the Mini-Tet Offensive,
May 1968

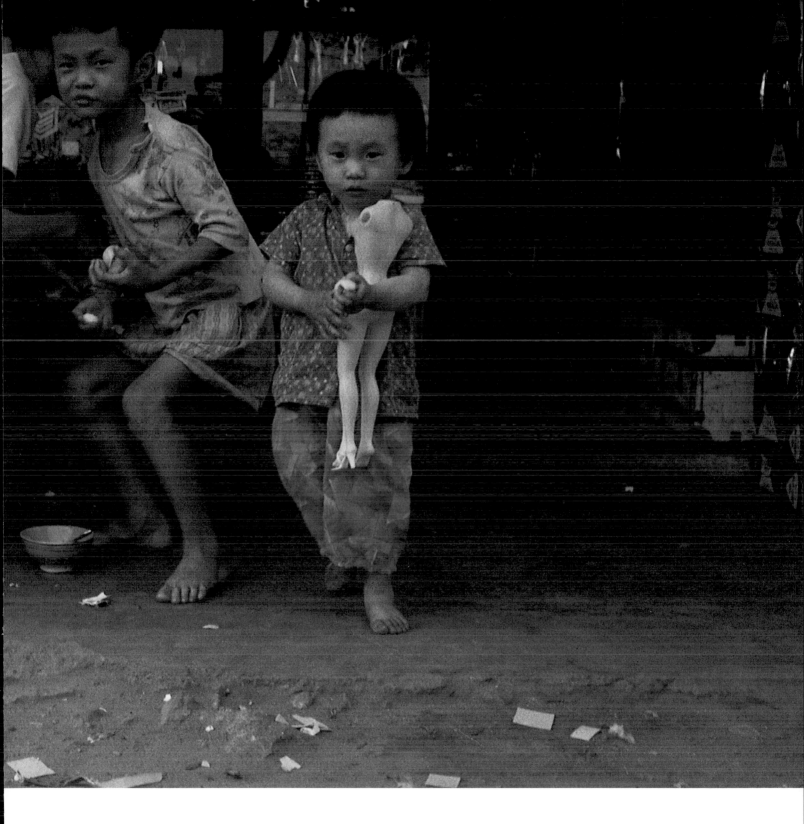

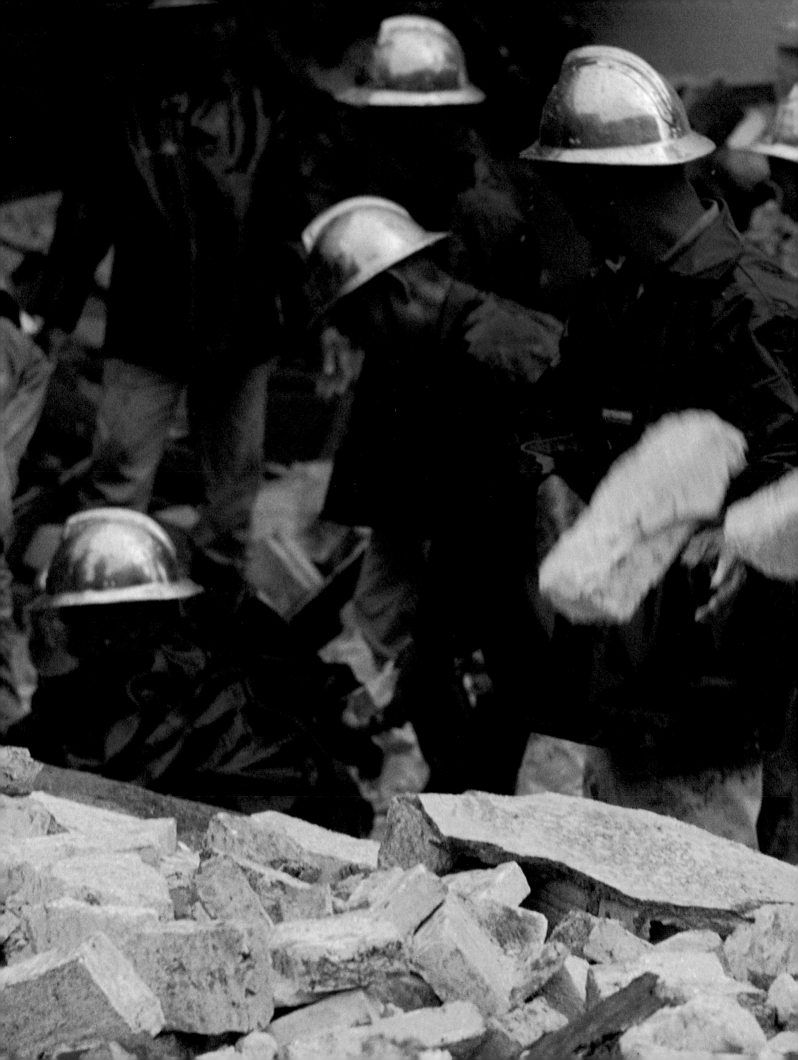

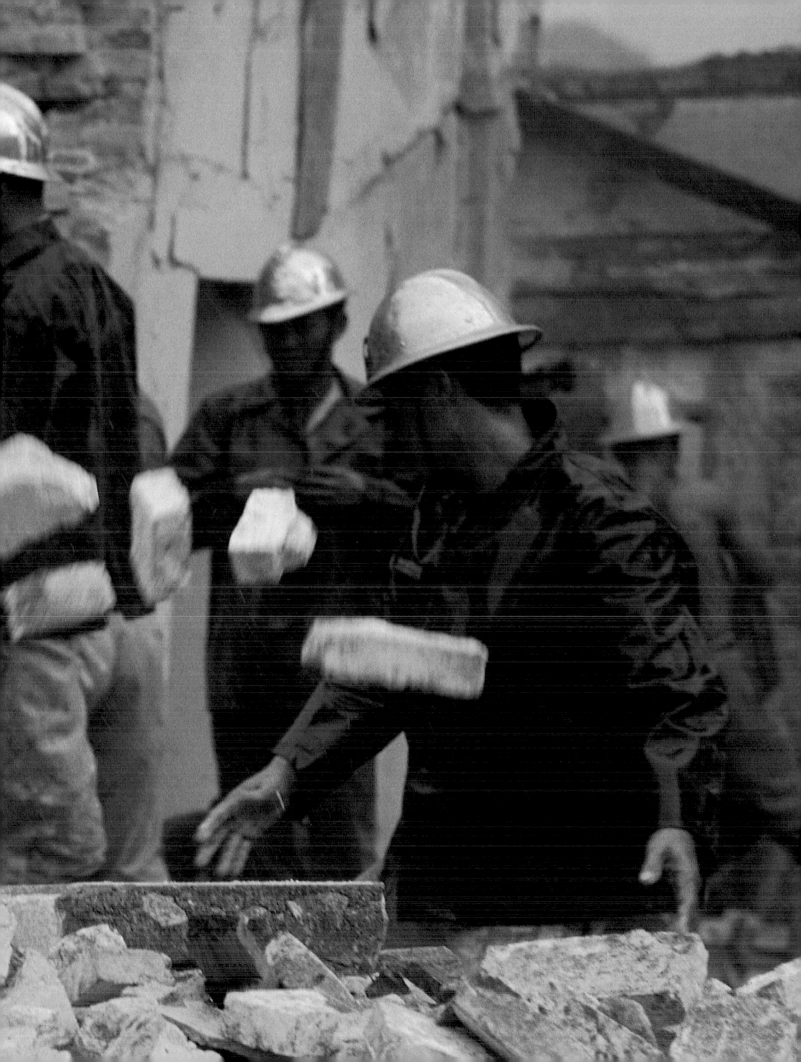

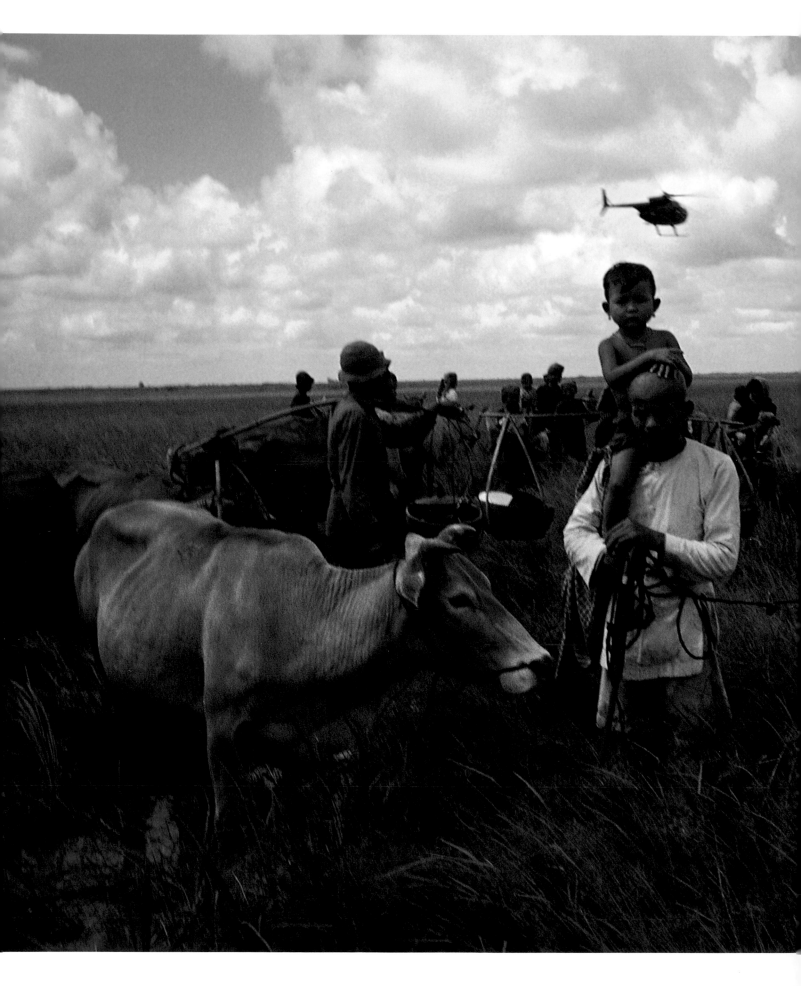

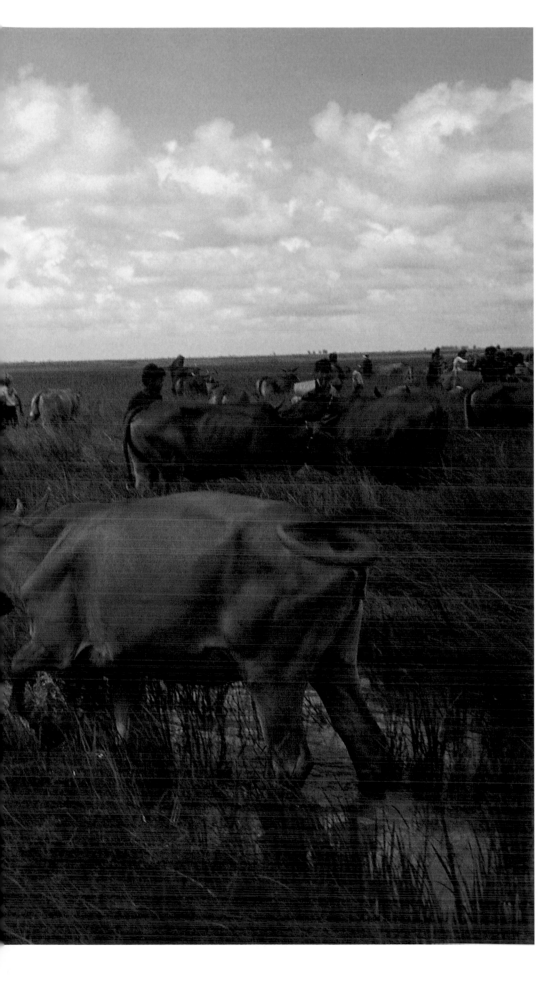

Special forces corral villagers
in an operation near Ba Xoai,
on the Cambodian border, 1968

USS *Constellation*
launches a strike on
Yankee station,
Tonkin Gulf, 1966

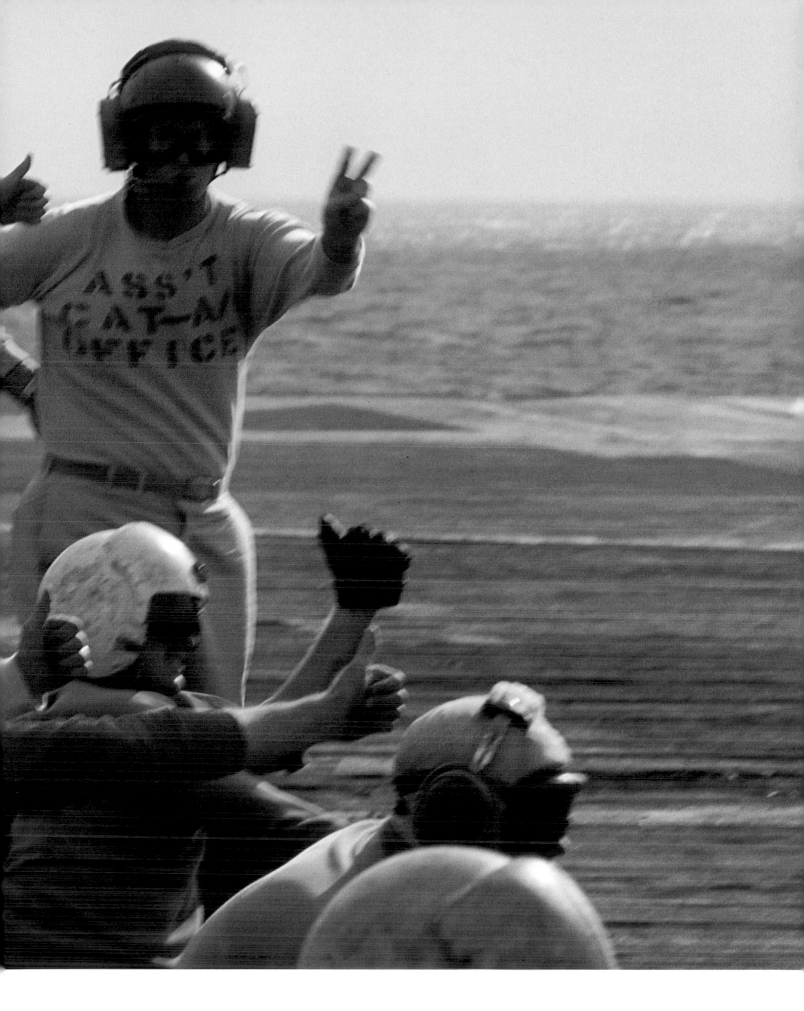

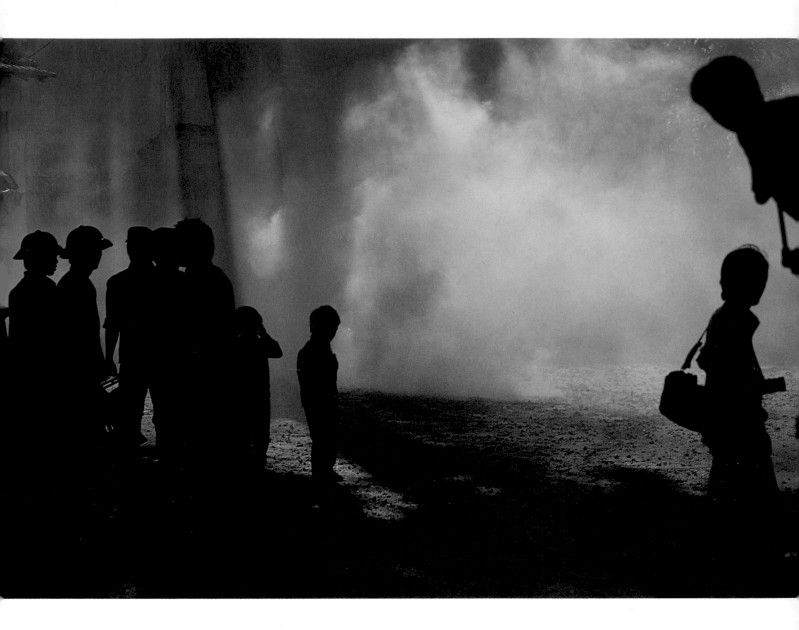

Firecrackers to mark Tet, the
Vietnamese new year, in the
town of Lang Son, on the Chinese
border, 1989

Opposite: Aboard the Reunification
Express near Phuc Le, south
of Hanoi, 1991

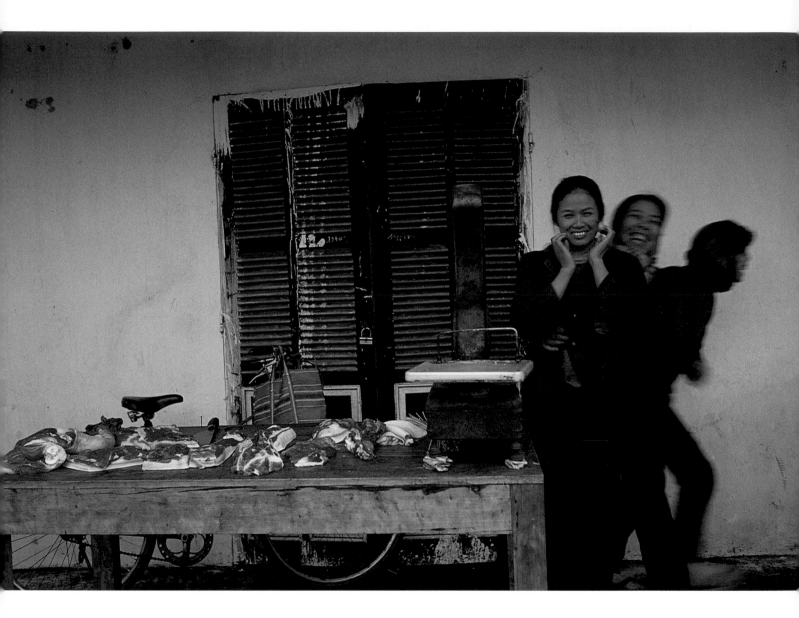

Meat stall in the steel town
of Thai Nguyen, northwest of
Hanoi, 1990

Opposite: Rte 1 in eastern Cambodia,
the town of Chi Phou, 1990

The first British tour group
hits Ho Chi Minh, 1980

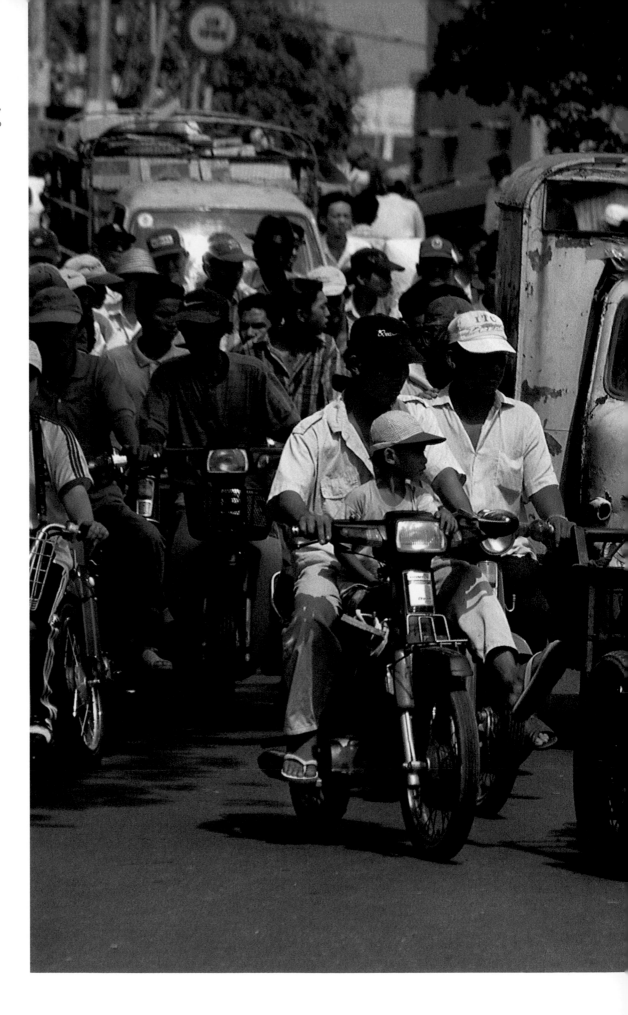

The Y Bridge,
Ho Chi Minh, 1990

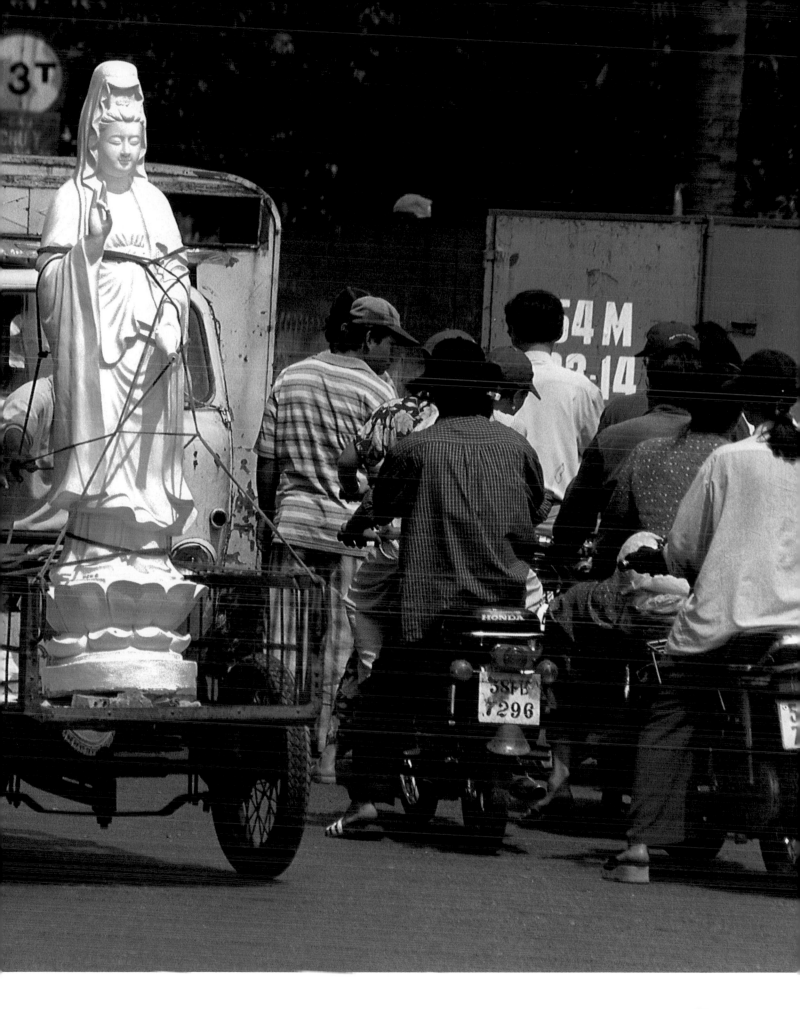

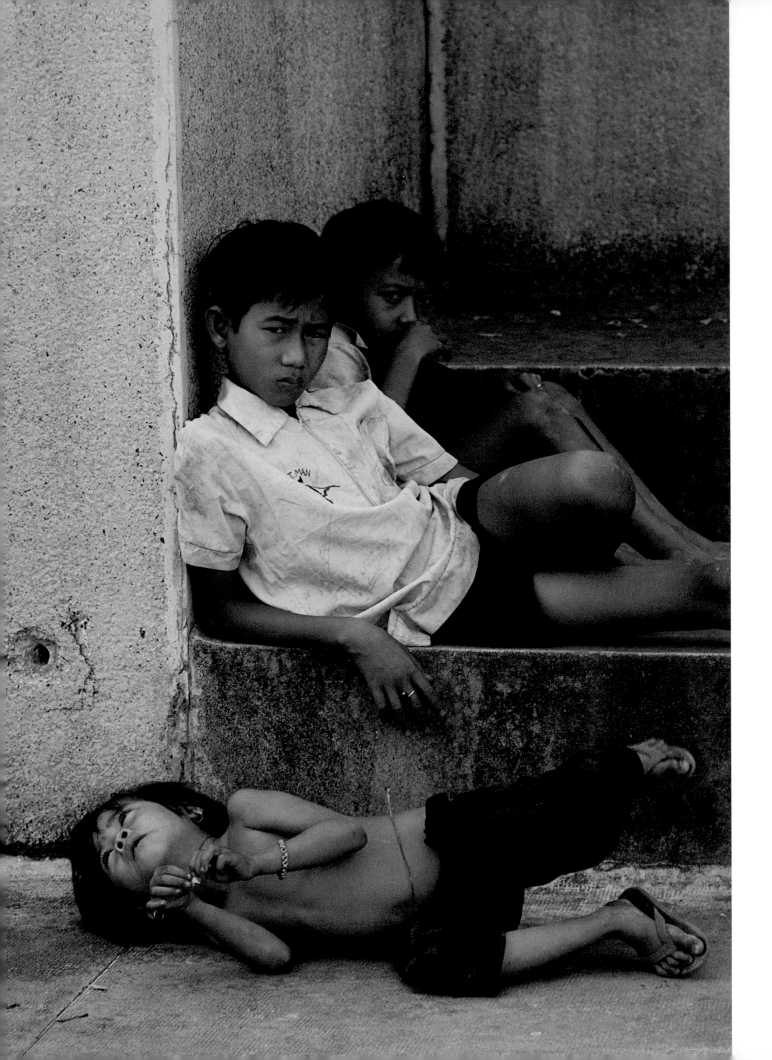

Opposite: At the reopening
of the Phu Tho racetrack after
Mini-Tet, Saigon, 1968

Traditional-medicine seller,
Dalat market, 1990

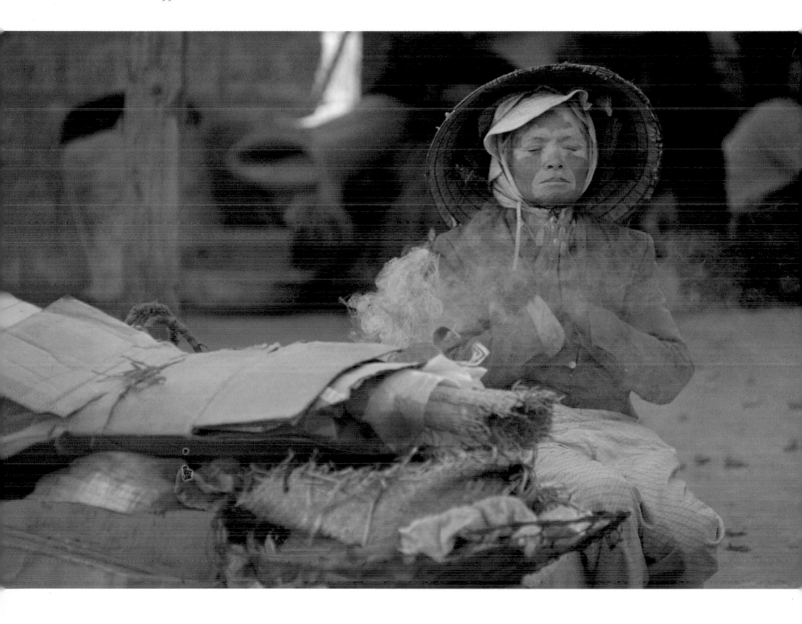

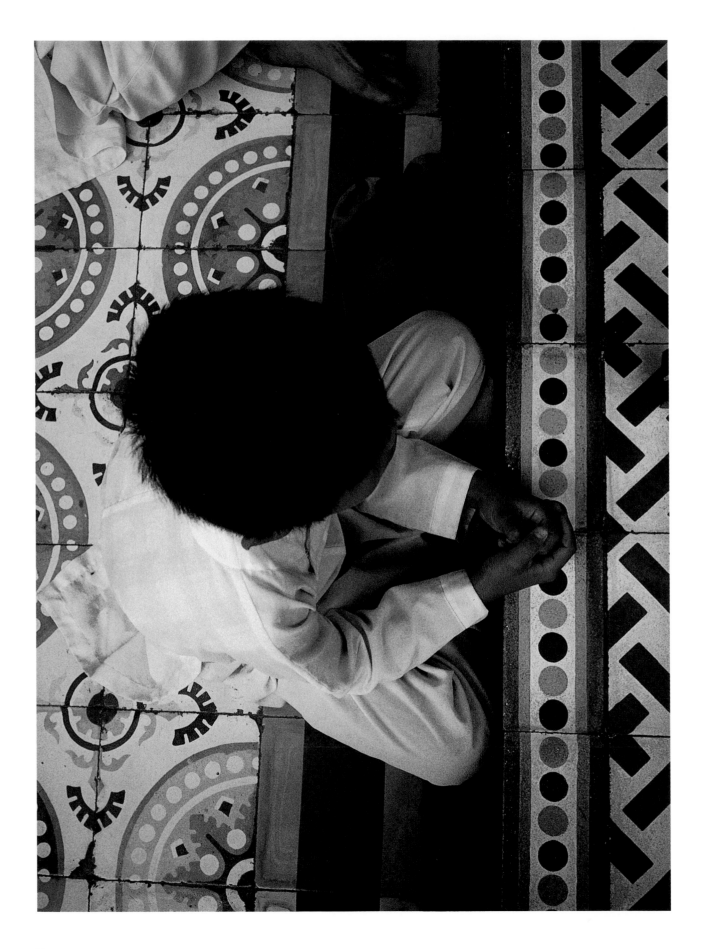

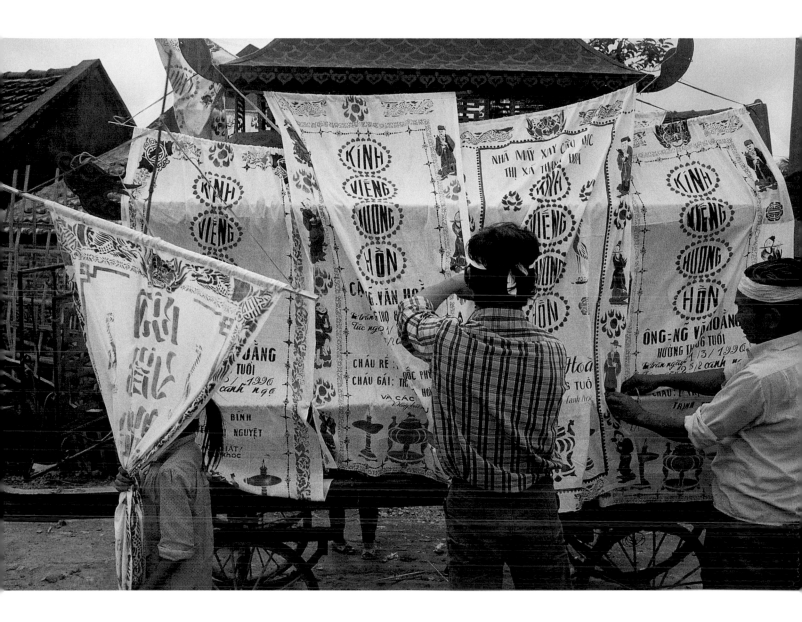

Funeral procession, downtown
Thanh Hoa, Tonkin,
Vietnam, 1990

Opposite: The Holy See of the Cao Dai,
Tay Ninh, Vietnam, 1989

Repassing the site of the 1966
M-79 explosion, Da Nang, 1999

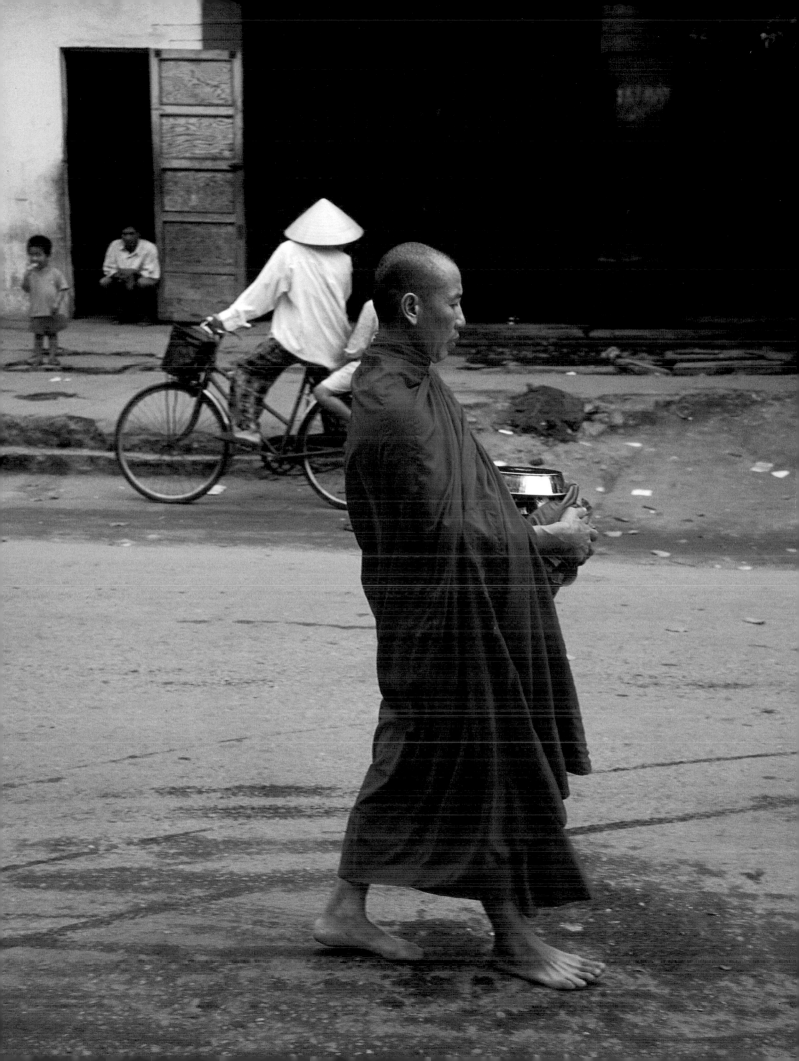

Traditional Vietnamese
Buddhist funeral procession
near Thai Nguyen, 1990

Page 48: Funeral of refugee
Catholic priest killed by
US truck, Saigon, 1969

Page 49: A desecrated grave
in the former Southern
Regime (ARVN) military
cemetery, Long Binh,
Vietnam, 1985

46

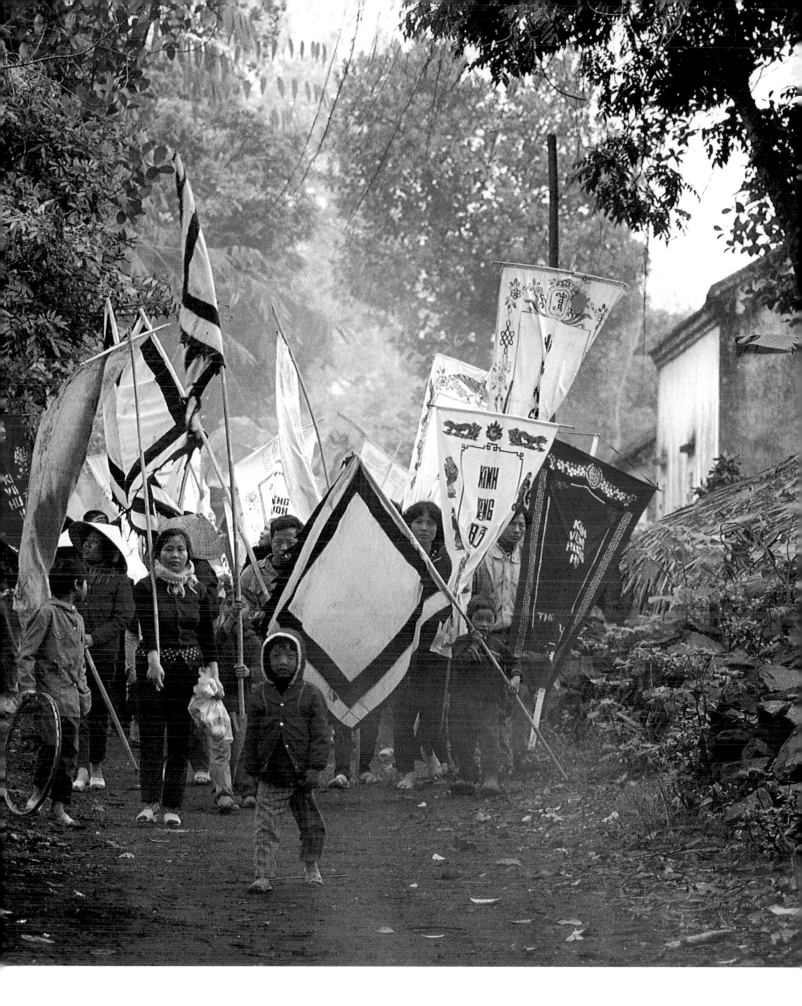

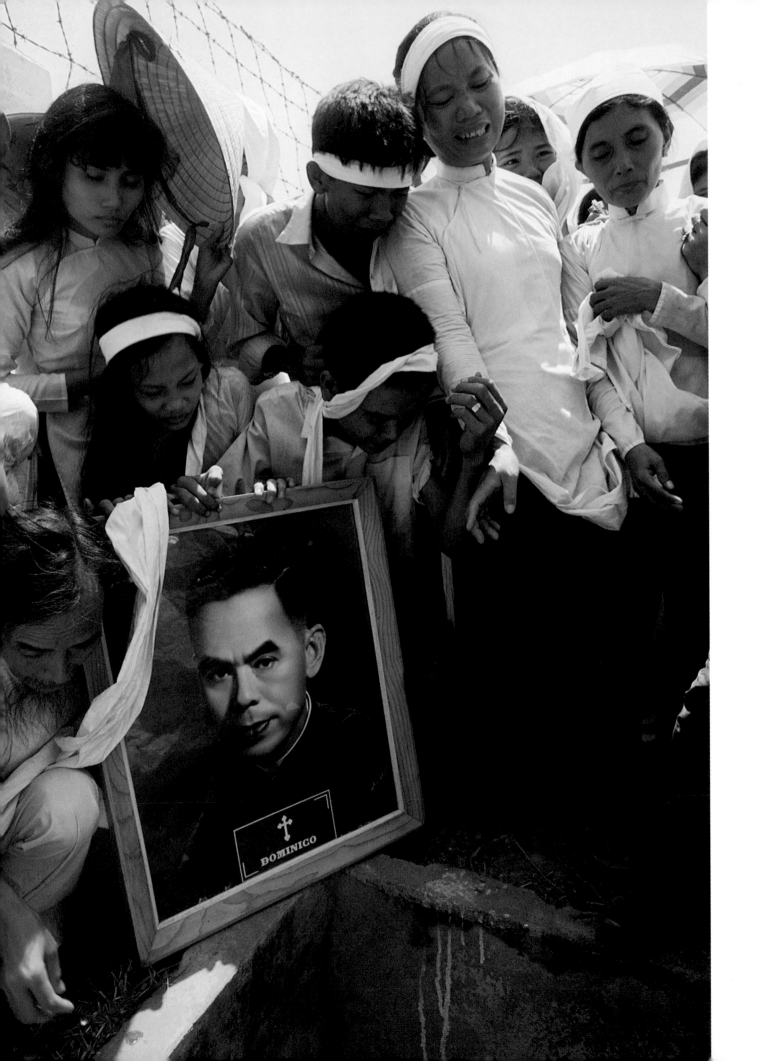

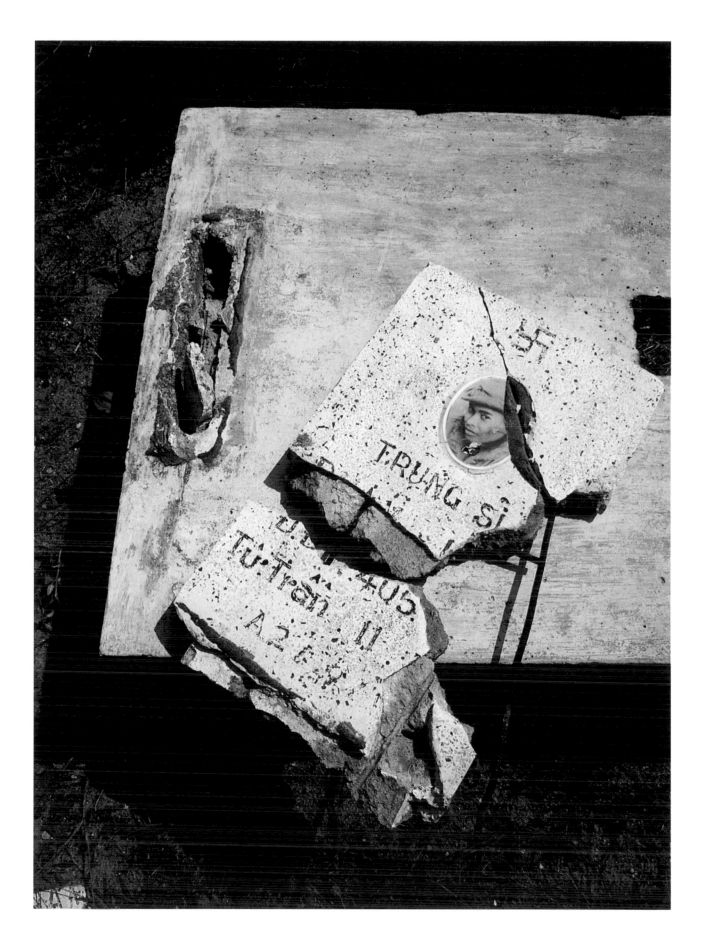

North Vietnamese (NVA)
soldier killed trying to
liberate comrades from a
POW camp at Dong Lach,
near Bin Hoa, Vietnam, 1969

Page 52: Priest's funeral,
Saigon, 1969

Page 53: The Catholic
church at Dong Lach after
the abortive raid to free
NVA POWs, 1969

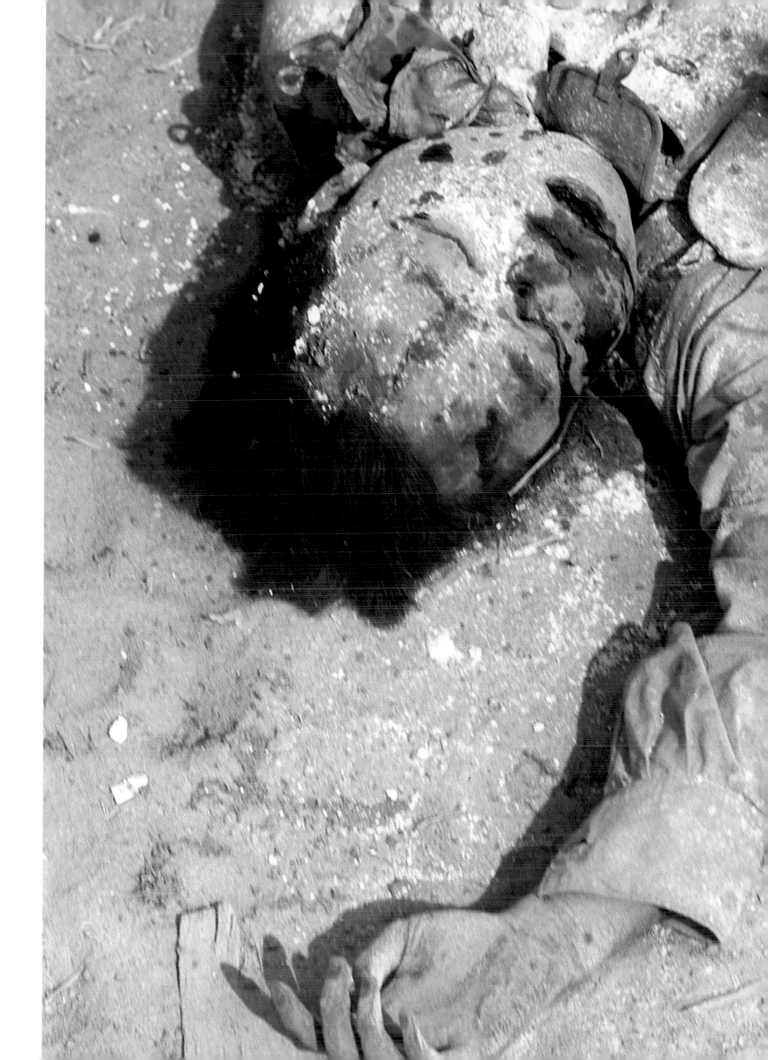

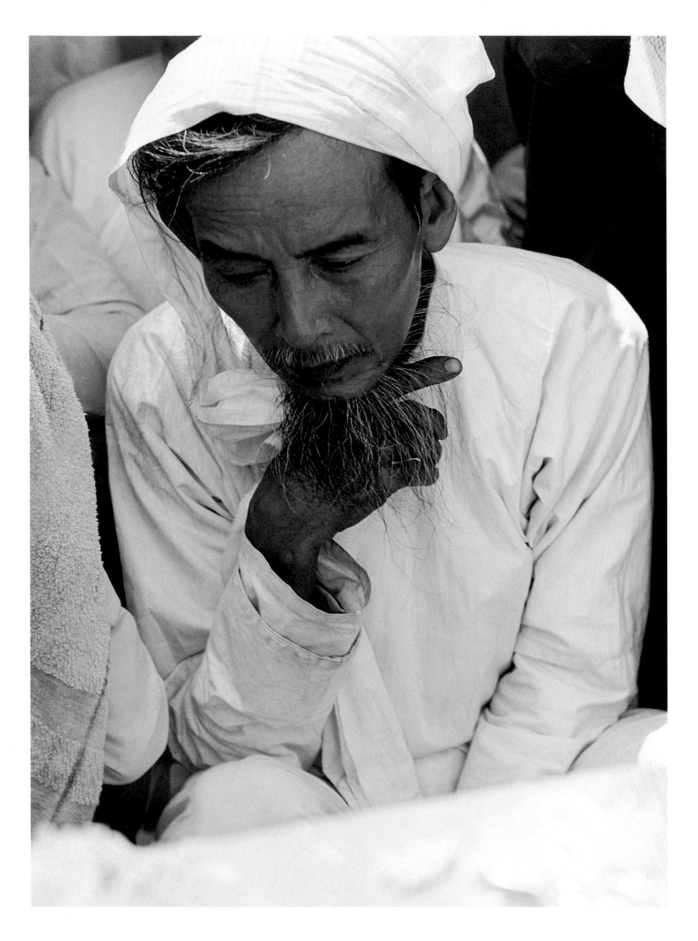

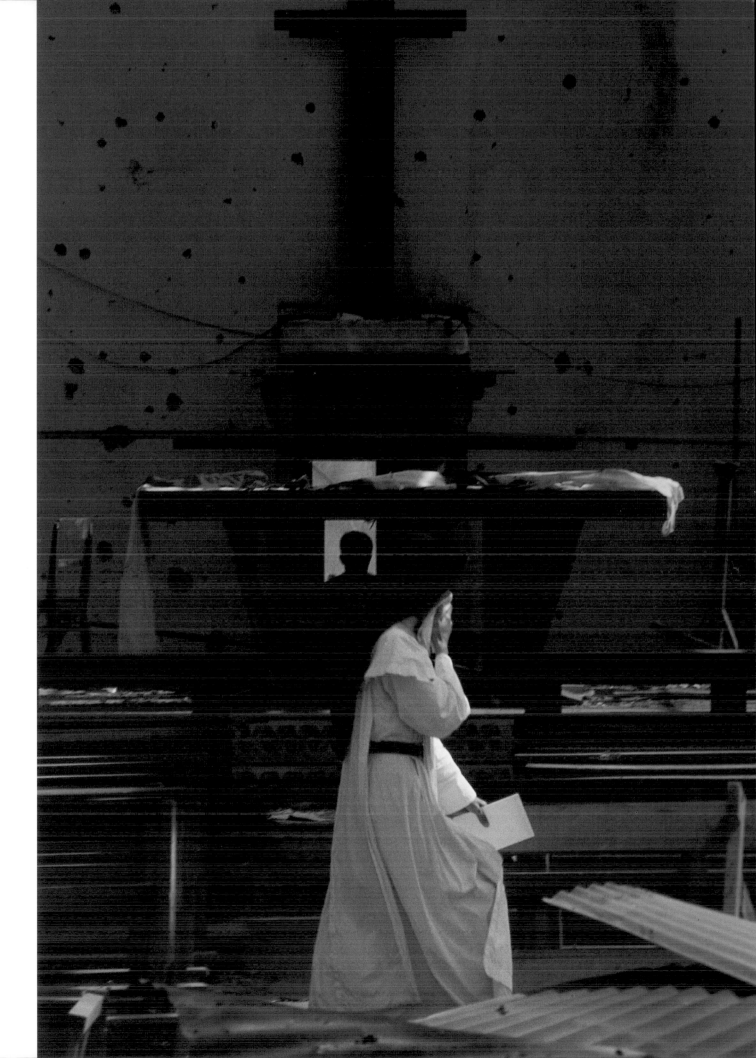

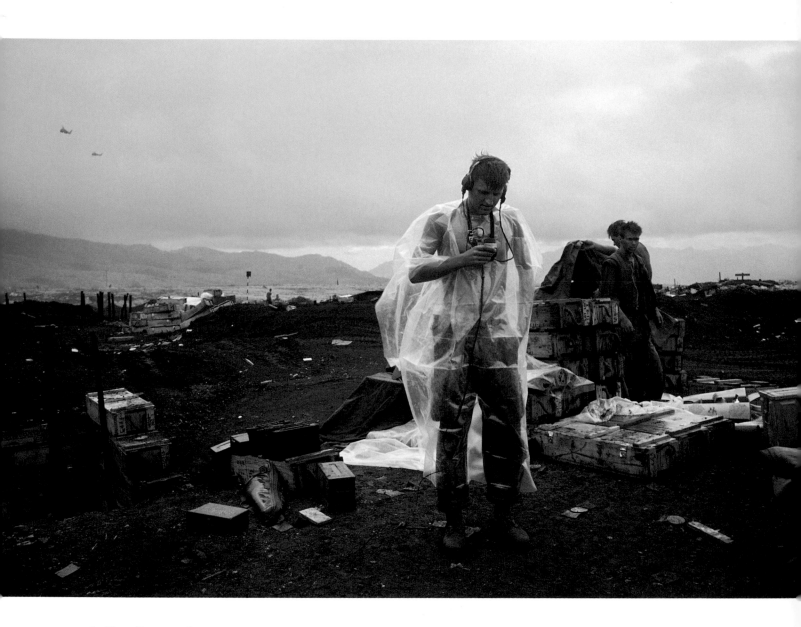

Artillery fire-control,
Khe Sanh Marine combat base,
Vietnam, 1968

Pages 54–5: The parishioners
of Dong Lach, 1969

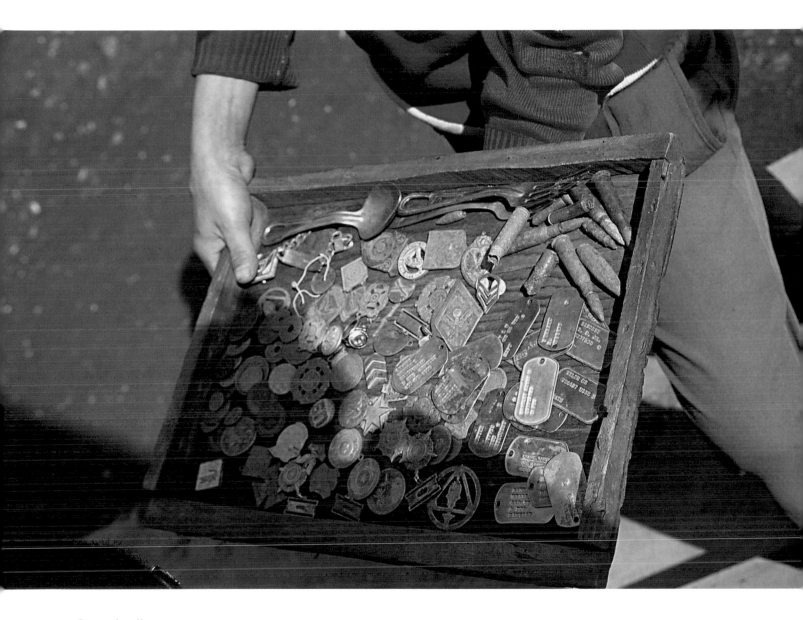

Souvenir seller,
Khe Sanh, 1999

Pages 58–9: Khe Sanh combat
base being demobilized, 1968

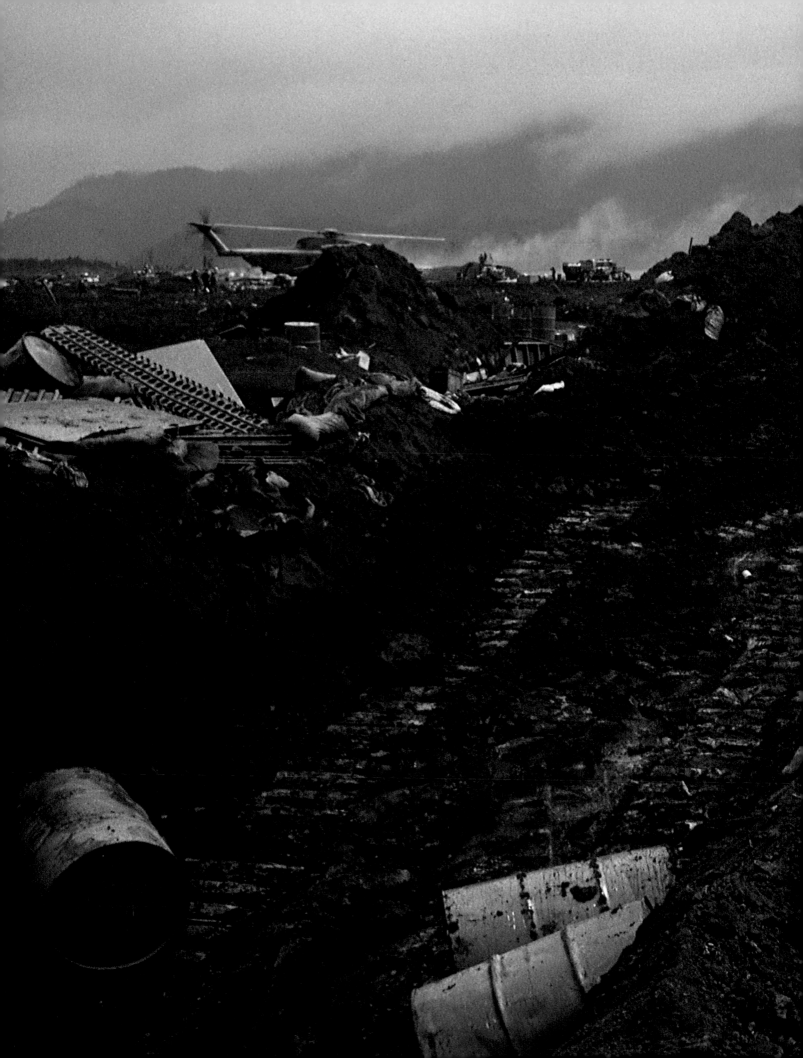

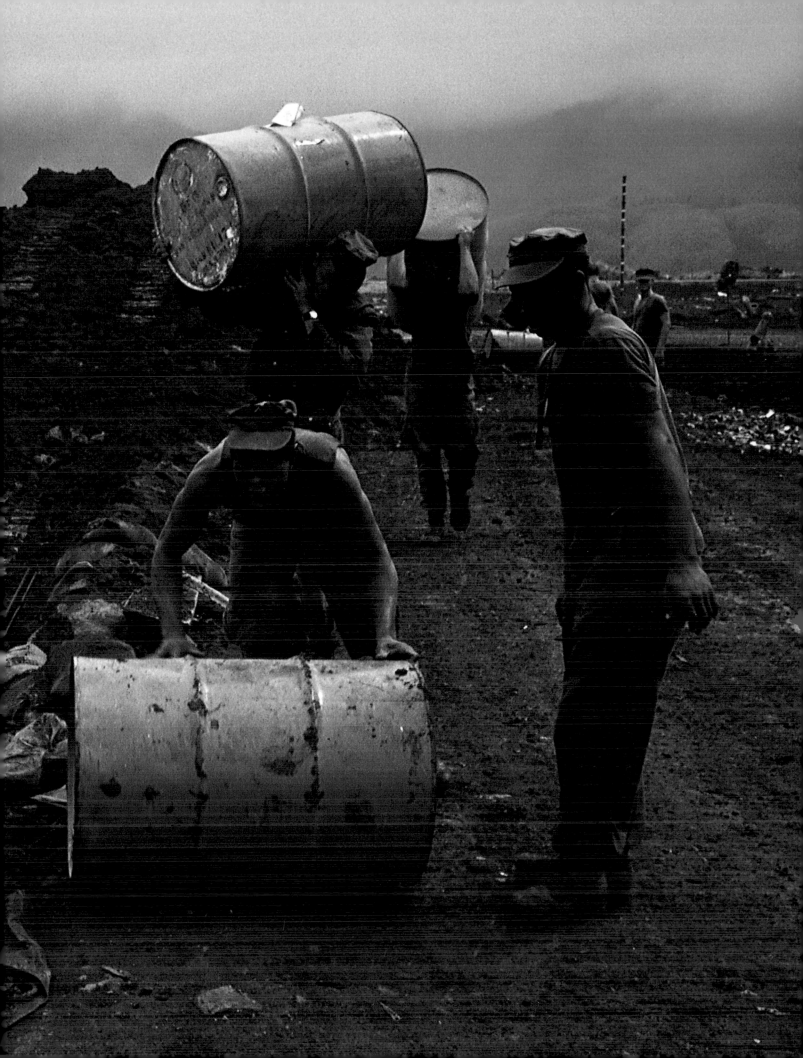

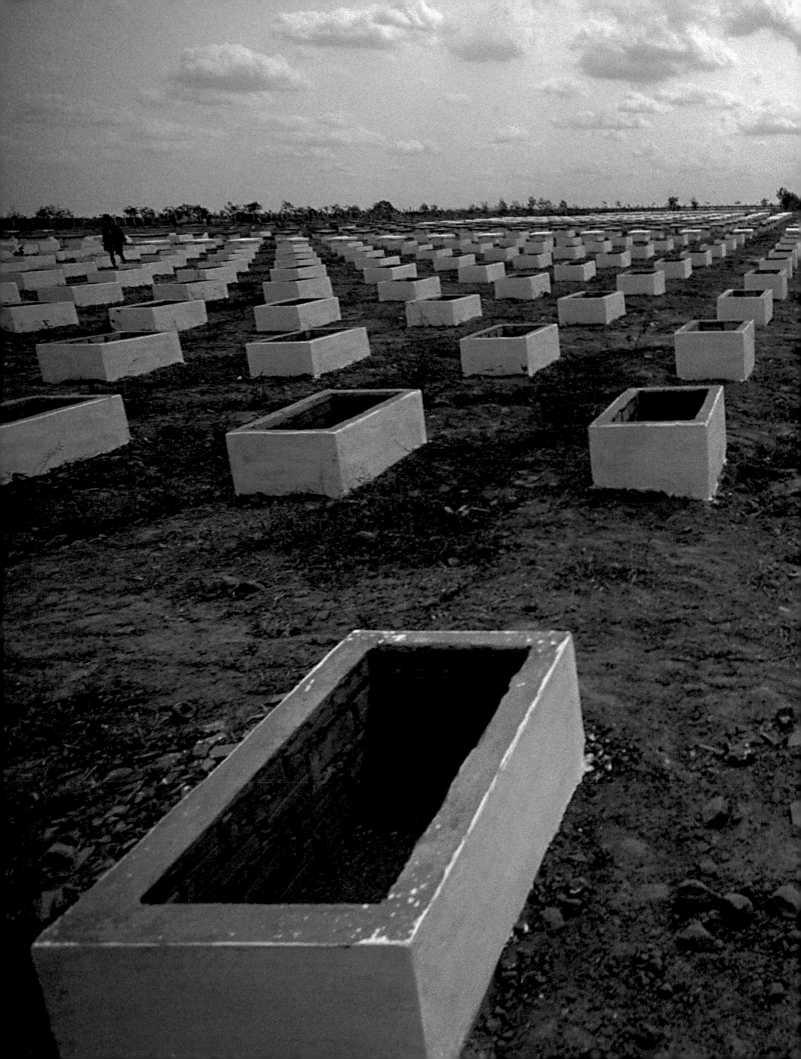

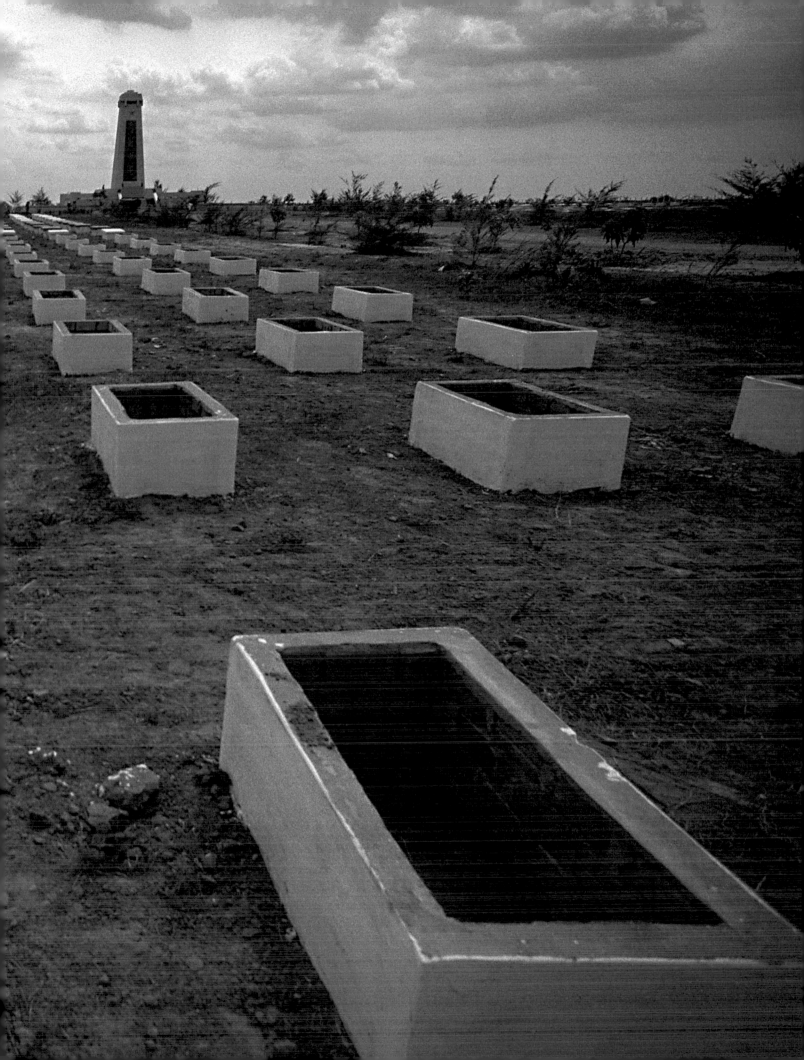

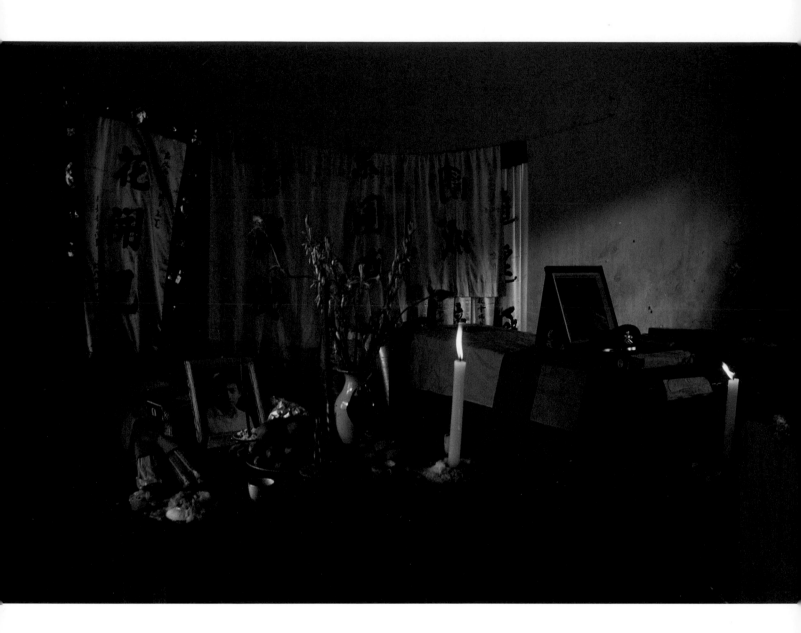

The coffins of rebels killed in
the battle for Da Nang lie in the Thinh
Hoi Buddhist pagoda, Da Nang, 1966

Pages 60–1: New graves await remains
in the Liet Si, the 'Heroes Cemetery',
near the former US base of Cu Chi, west
of Ho Chi Minh, 1980

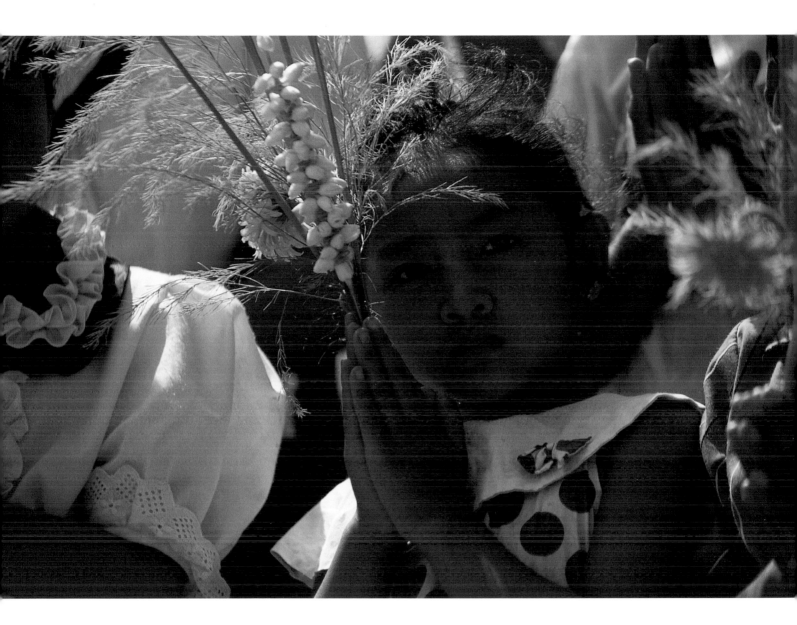

International Buddhist peace march
arrives outside the Royal Palace, Phnom
Penh, during the elections of 1993

Pages 64–5: Dien Bien Phu, near the Lao
border, north-west of Tonkin, 1985

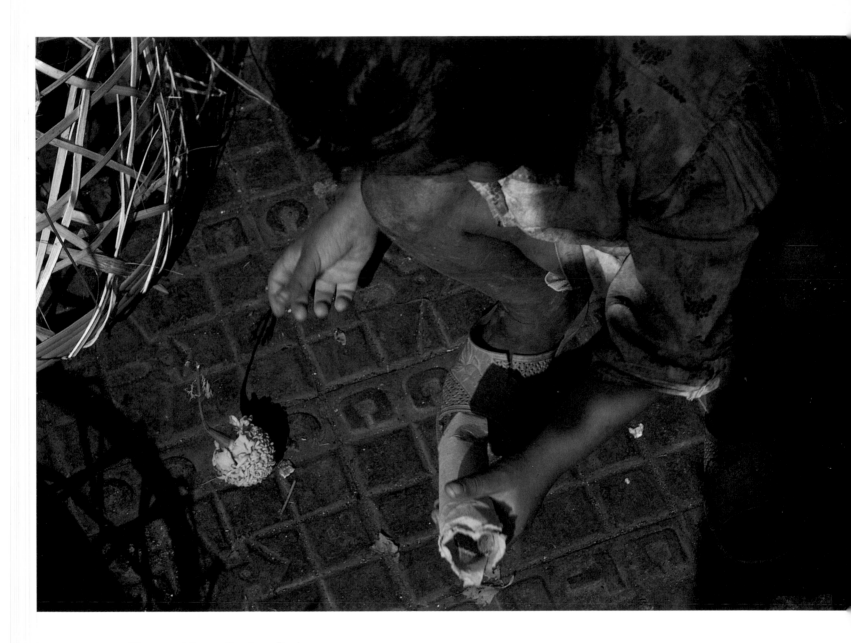

Demented former Southern Regime
soldier at the Ben Thanh market,
Ho Chi Minh, 1984

Opposite: Lay minister brushing sacred
Buddhist texts in the seventeenth-century
Ty My temple between Hanoi and
Hai Phong, 1990

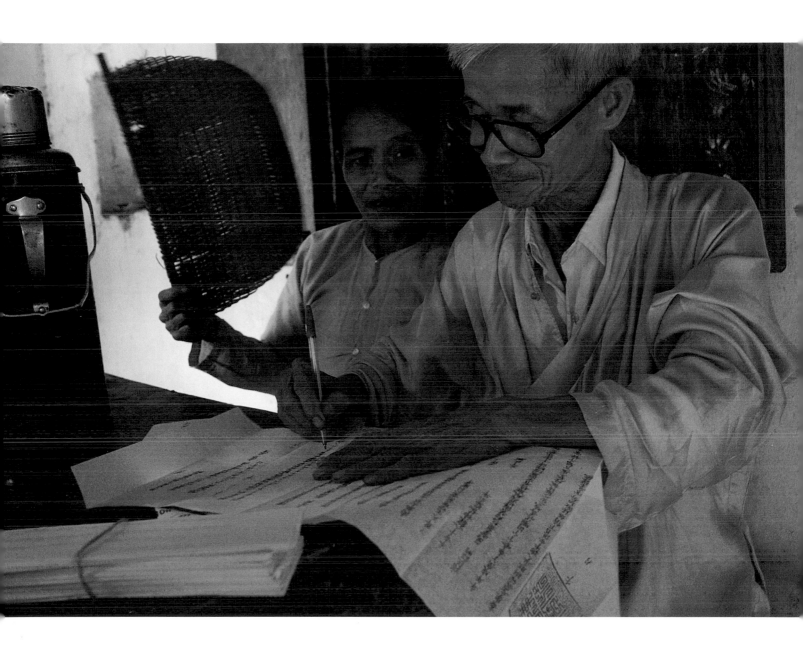

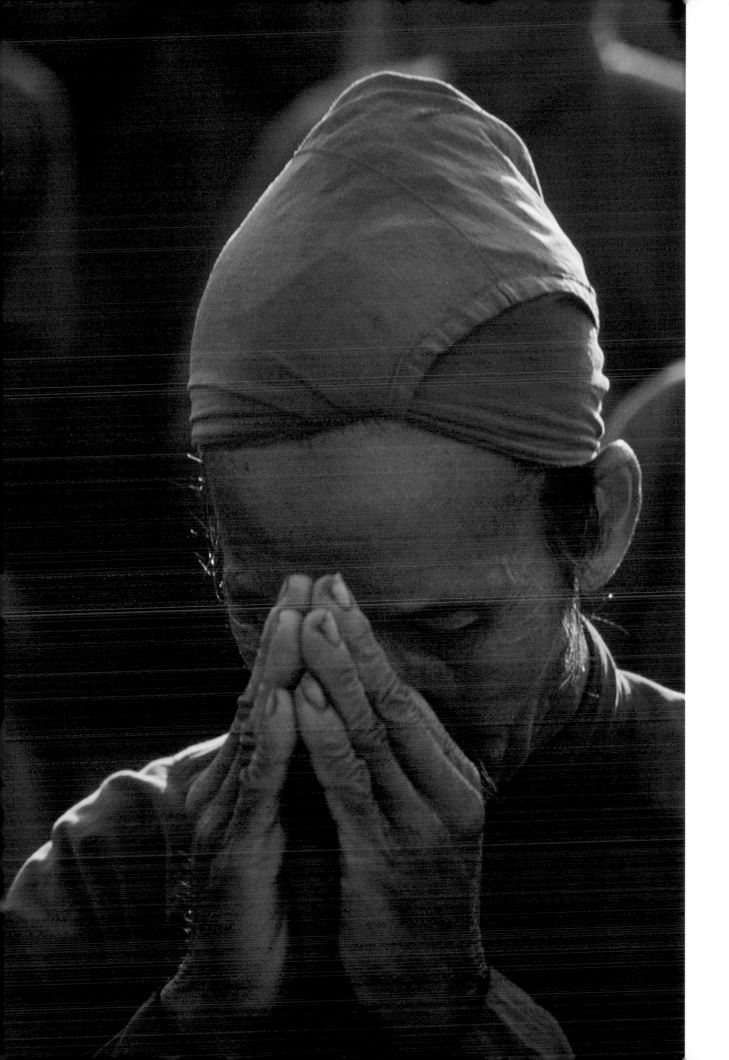

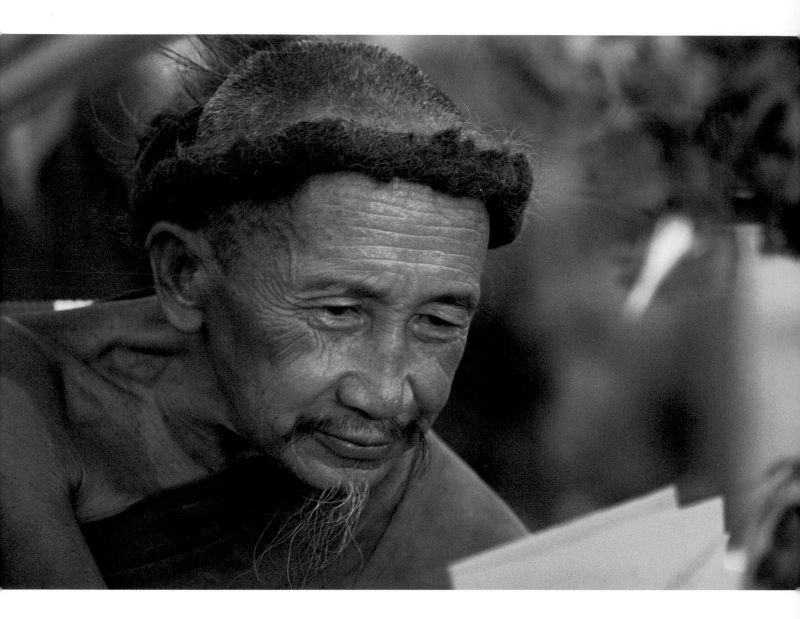

The Dao Dua preaching silently, 1969

Opposite: Finishing the centre-piece
for the Peace Conference table,
Dao island, 1969

Pages 86–7: Flynn *en route* to
the Dao island, 1968

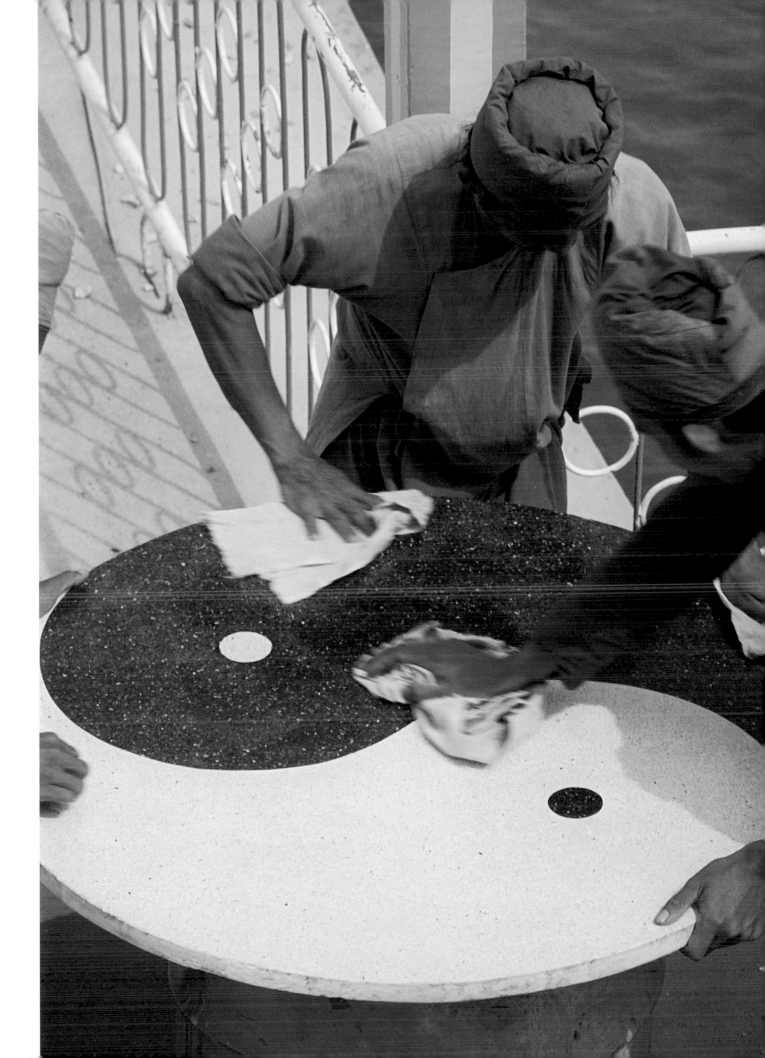

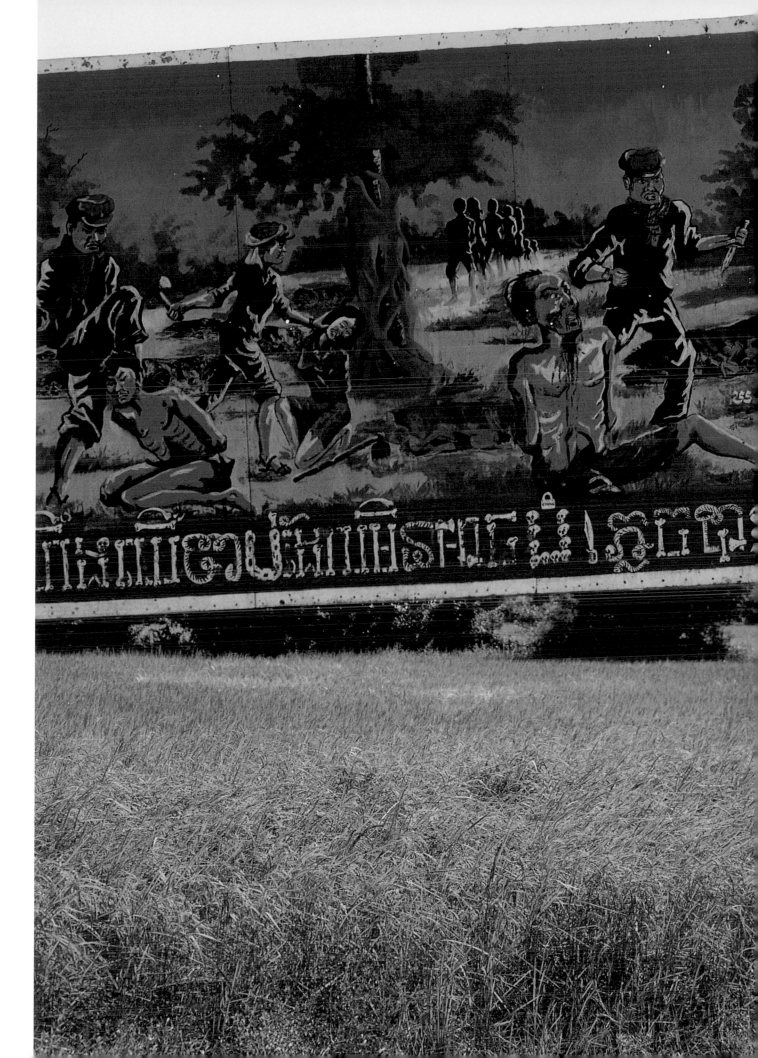

The 11th Armoured Cavalry
moves up to an operation in the Michelin
plantation, northwest of Saigon, 1969

Page 88: Destitute old ARVN trooper,
Cholon, Ho Chi Minh, 1997

Page 89: Entrance to Cheung Ek,
the Khmer Rouge killing fields,
southeast of Phnom Penh, 1991

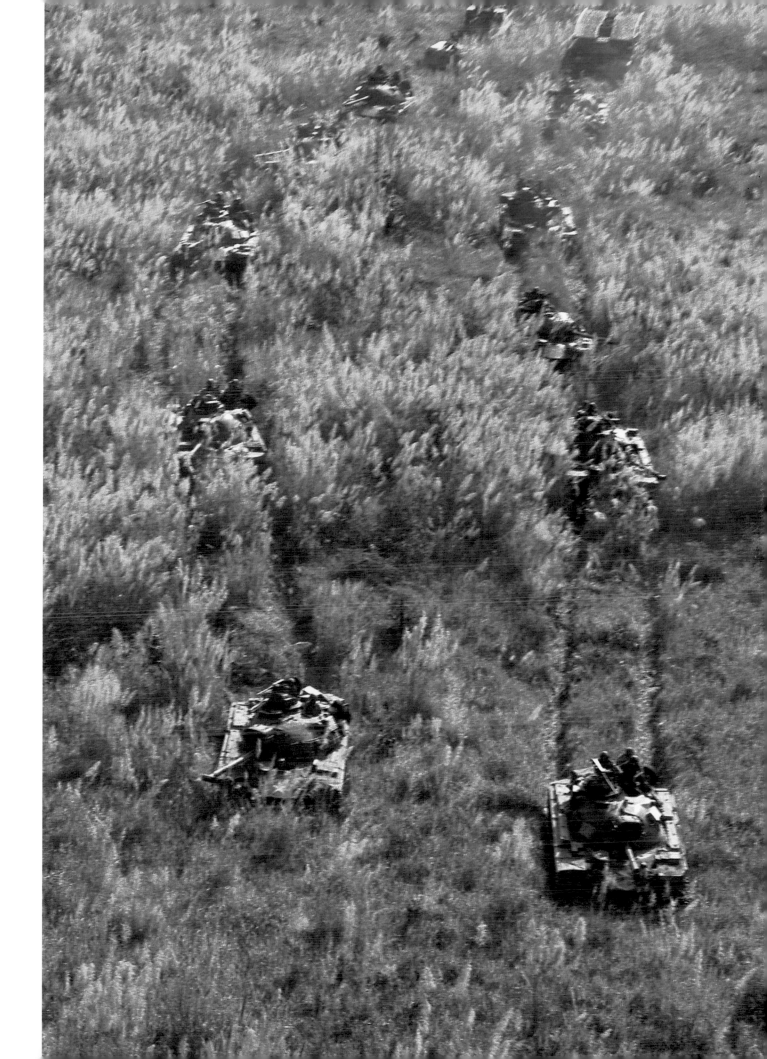

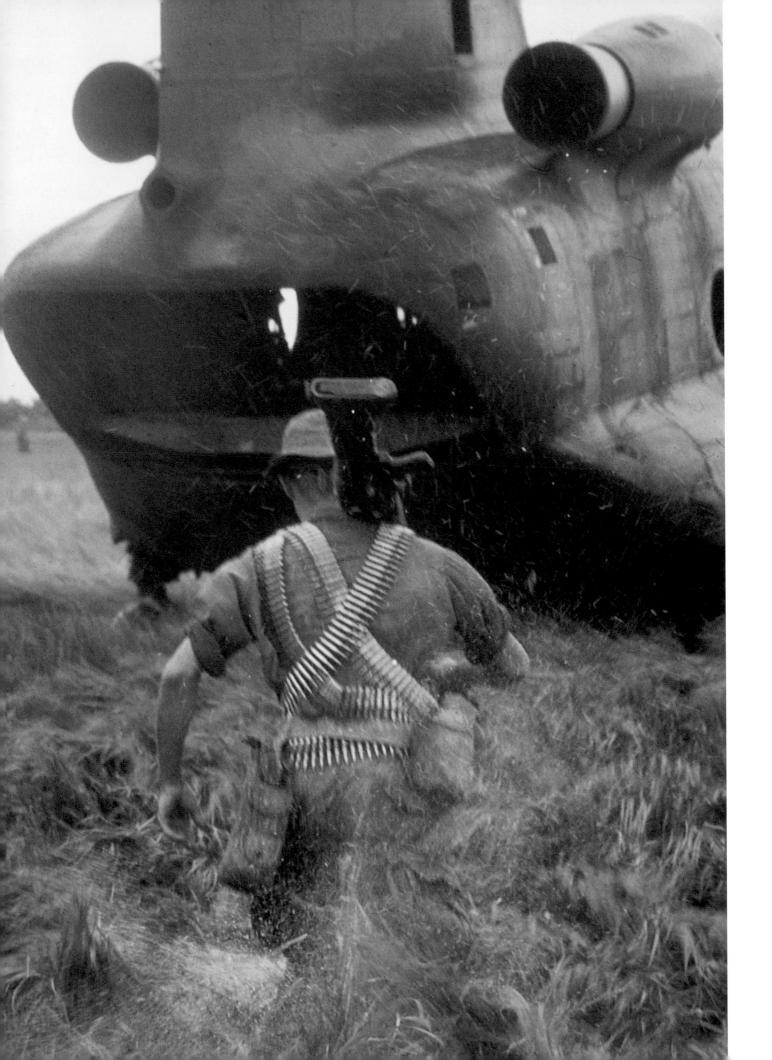

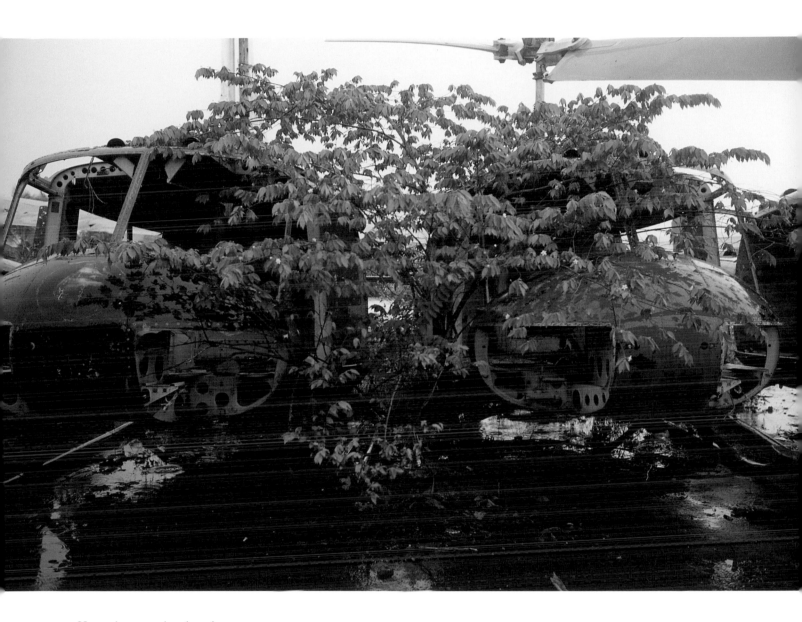

Huey choppers abandoned at
the former USAF Ton San Nhut
airbase, Ho Chi Minh, 1985

Opposite: 9th Division extracting
from a patrol, southeast of Tan An,
near Saigon, 1968

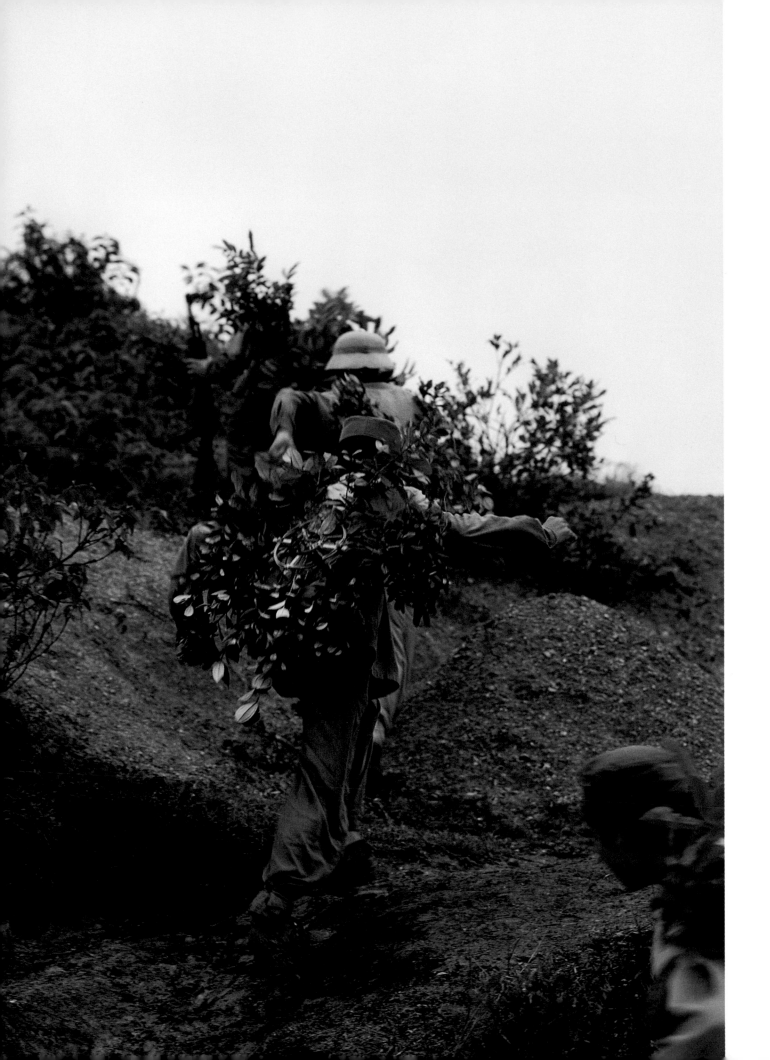

Army barracks, western suburbs of Hue,
Vietnam, 1990

Opposite: Border guards on manoeuvres
near Pac Bo, Uncle Ho's clandestine
World War II base on the Chinese
border, 1990

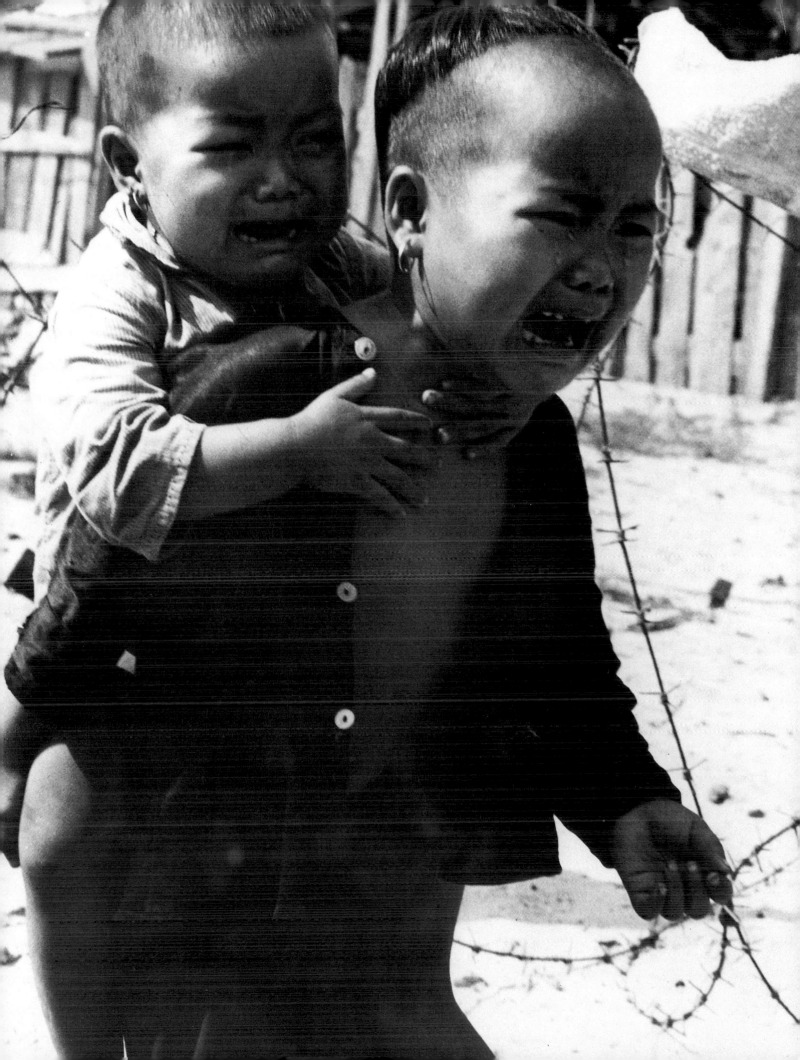

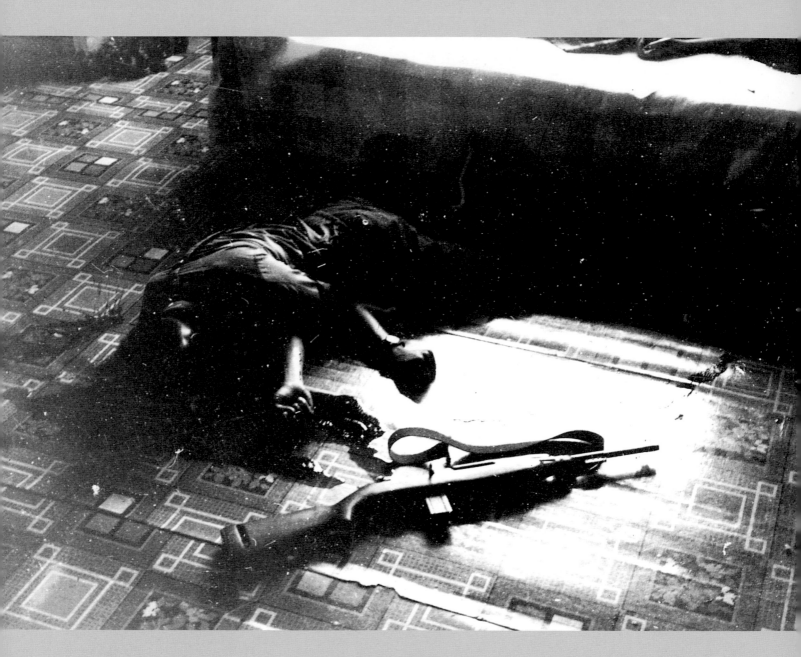

Suicide scene next door,
Don Palang, Vientiane, Laos, 1964

Opposite: Republic of Korea marines
police up a battlefield near Quang Ngai,
I Corps Vietnam, 1966

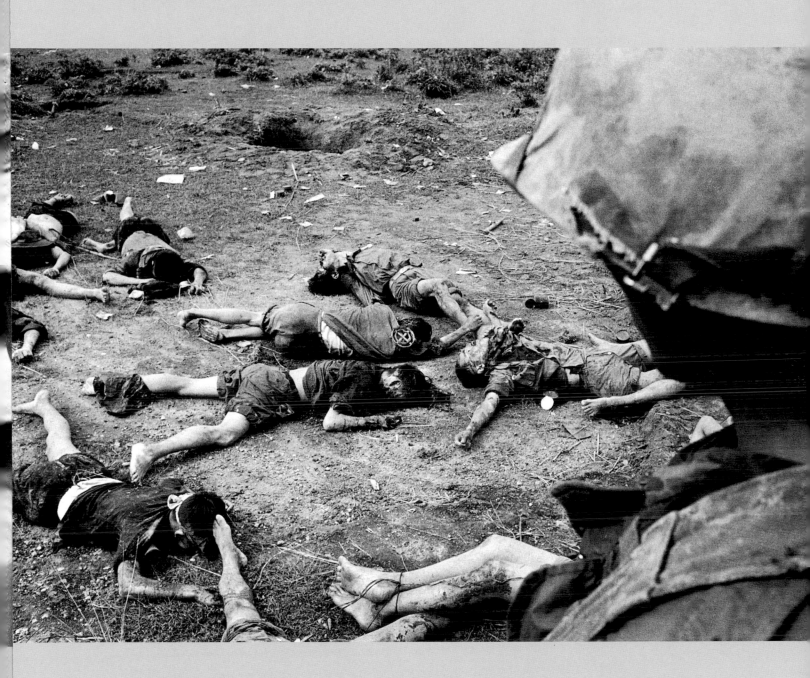

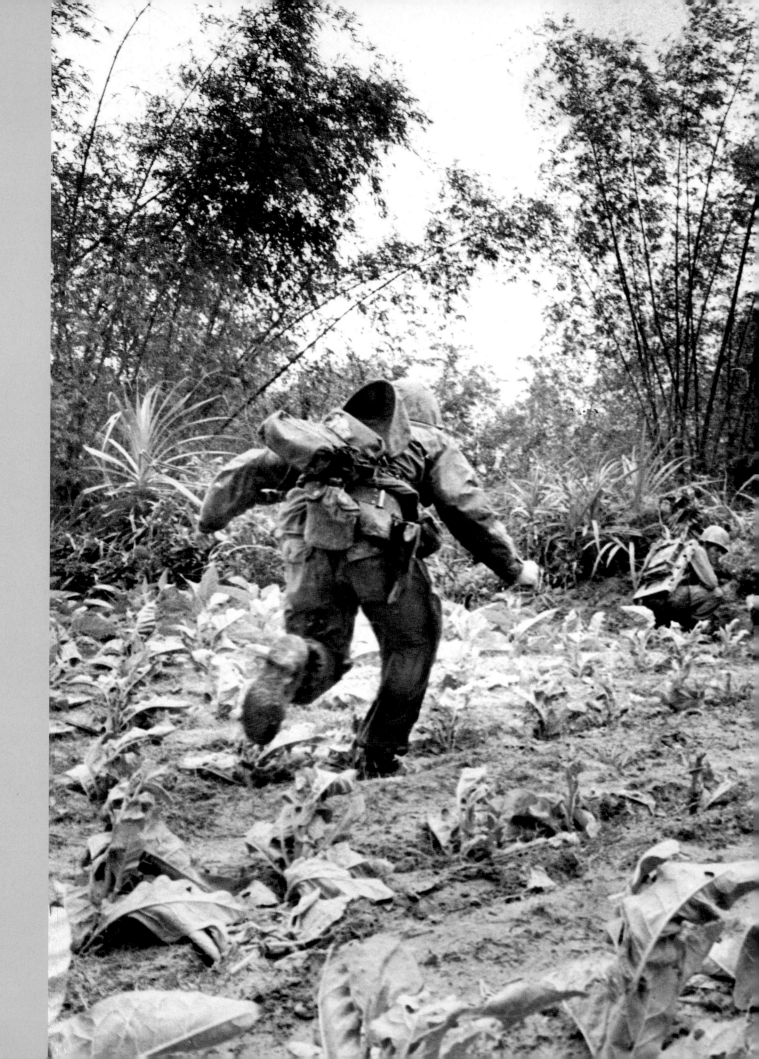

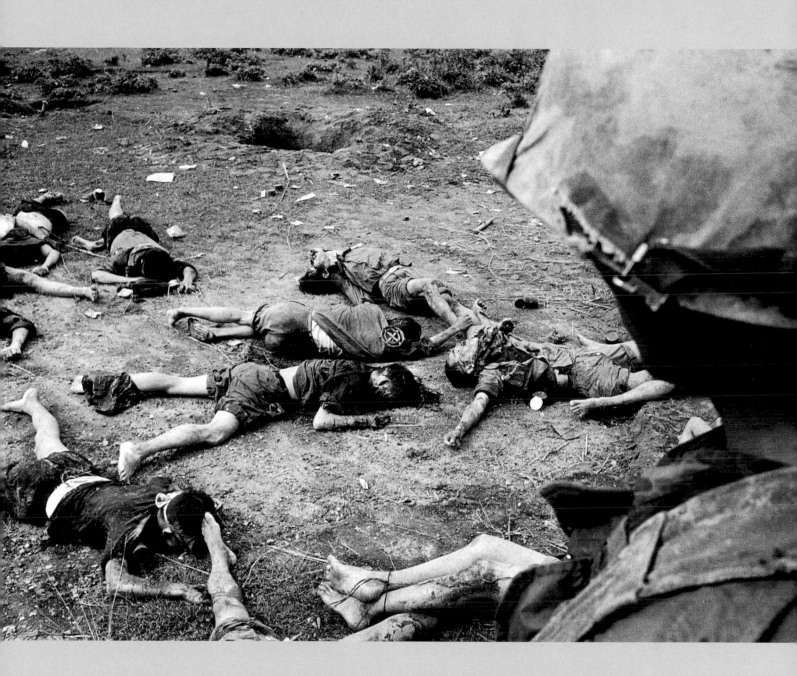

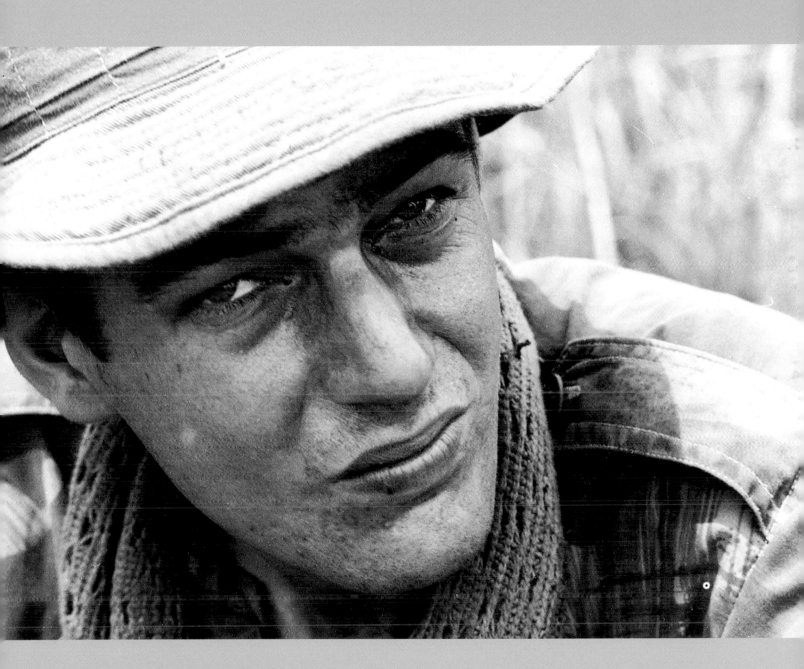

The author during the battle of Chu Phong
Mountain, by Steve Northup, 1965

Pages 102–3: Marines retrieving
booby-trapped buddies on a dust-off,
south of Tam Ky, I Corps, 1965

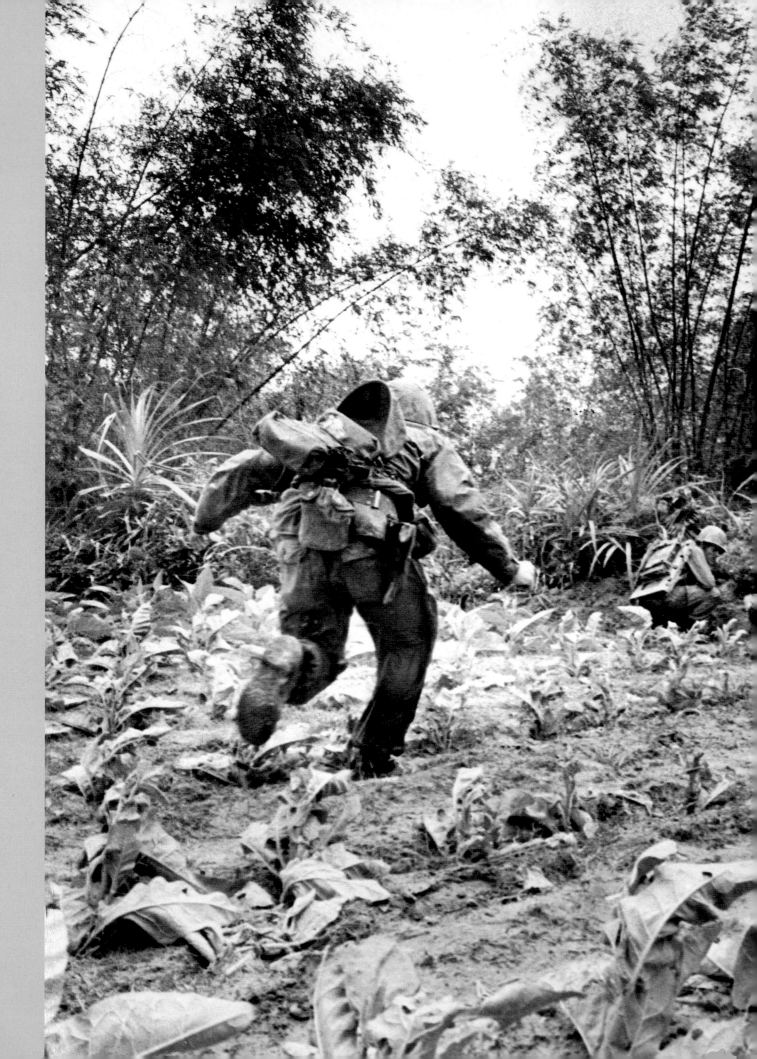

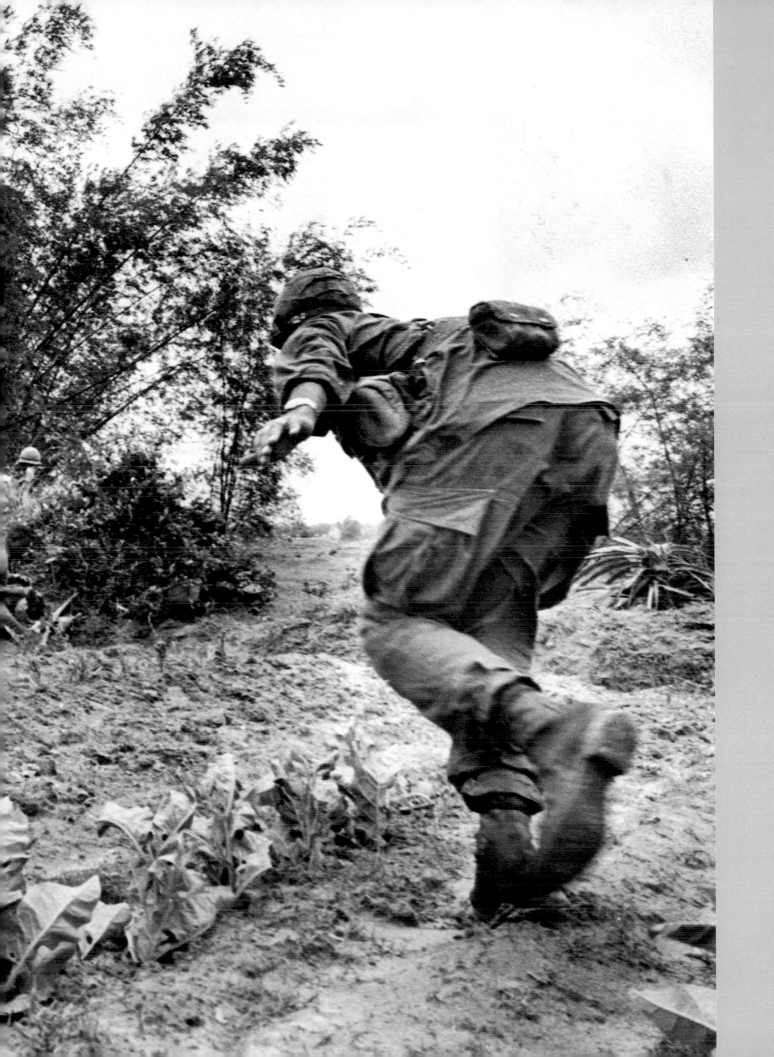

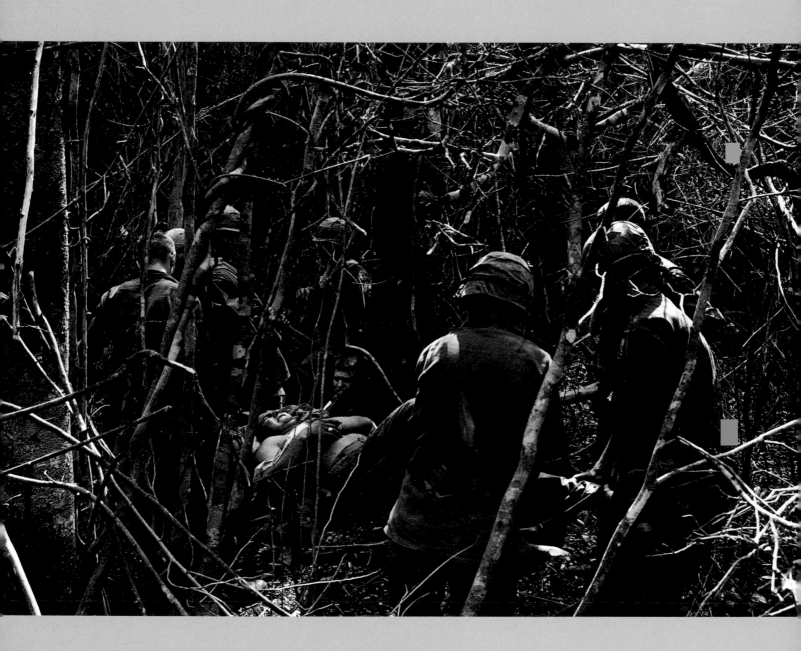

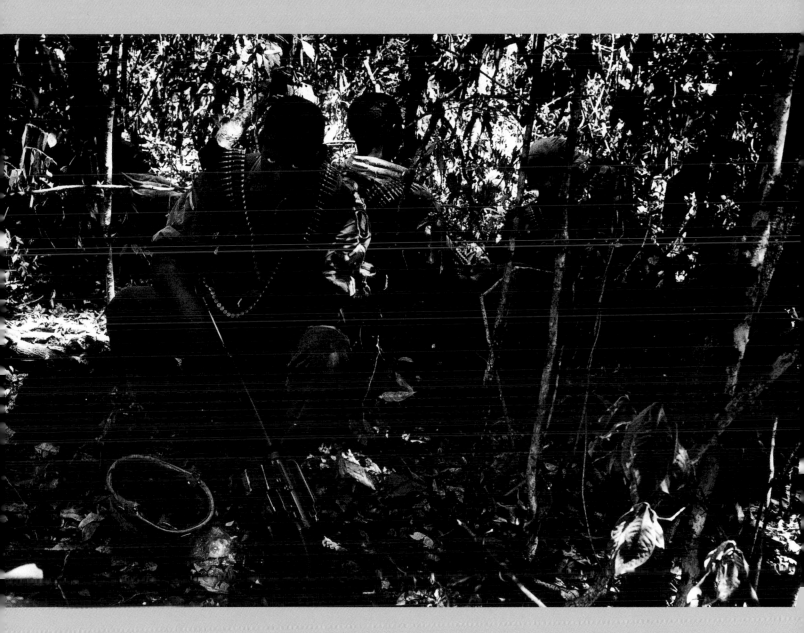

Airborne troopers in the jungle of
Warzone D, northwest of Saigon, 1966

Opposite: American 173rd Airborne
evacuate wounded, Warzone D, 1965

A Cobra gunship on a bomb-
damage-assessment mission along
the Cambodian border, 1968

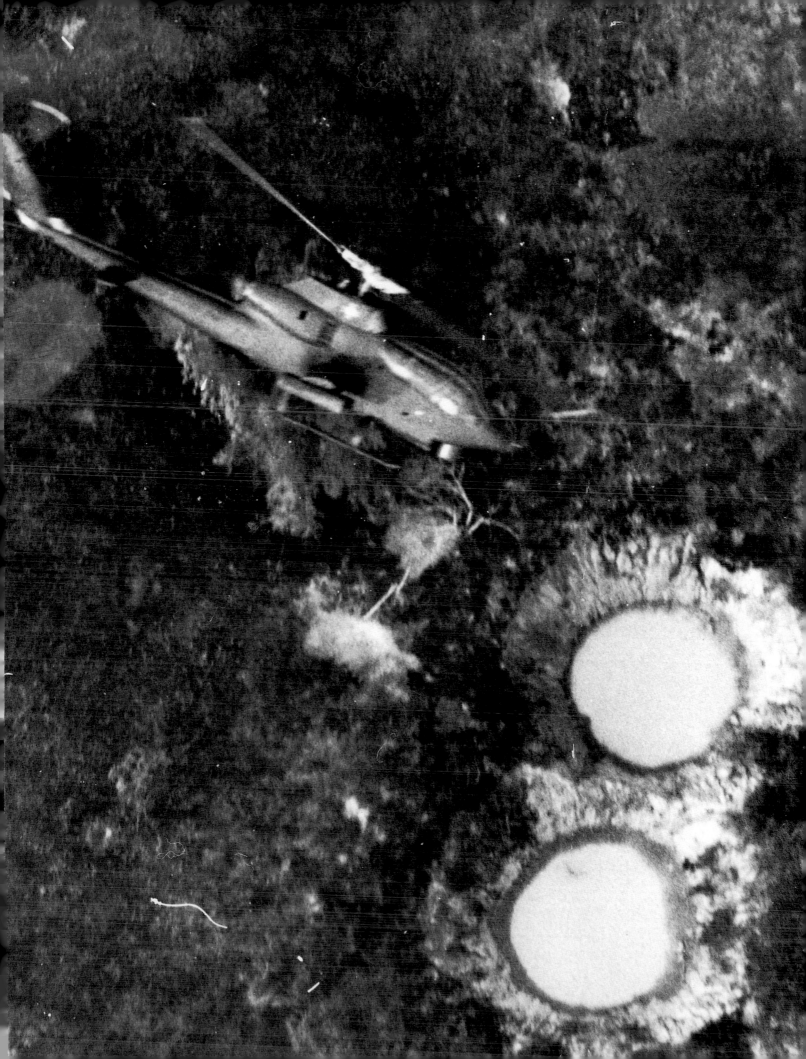

Terrified Viet Cong sympathizers
watch a PACV (patrol air-cushion vehicle)
hovercraft destroy their family home,
Plaines des Joncs, southwest
of Saigon, 1966

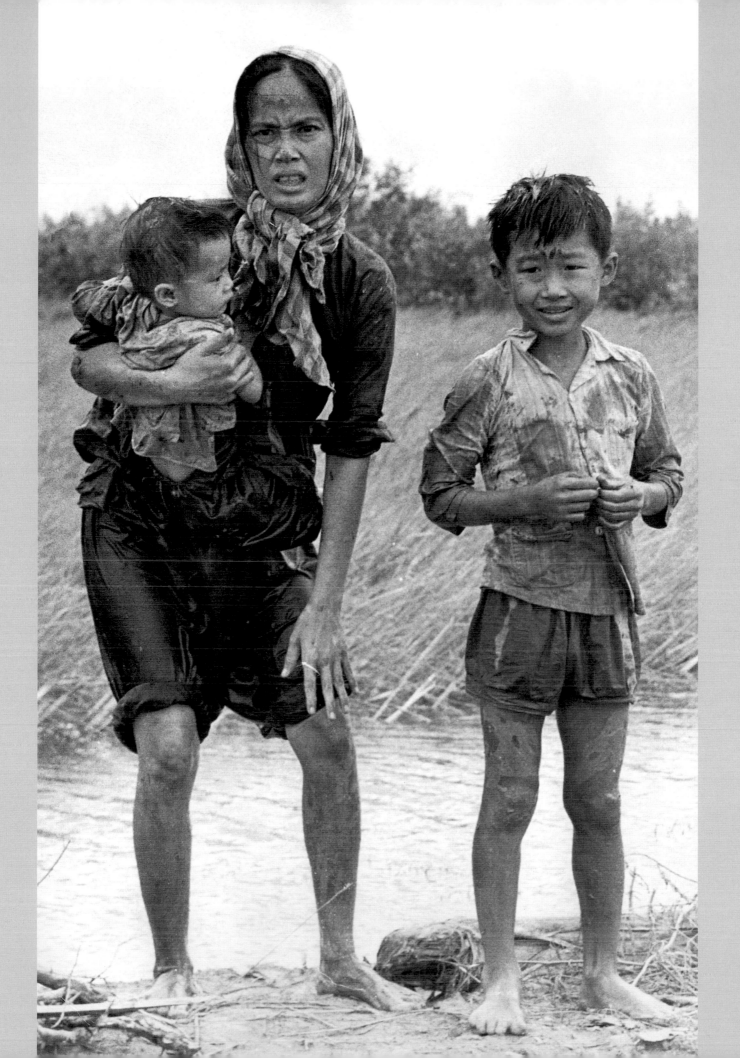

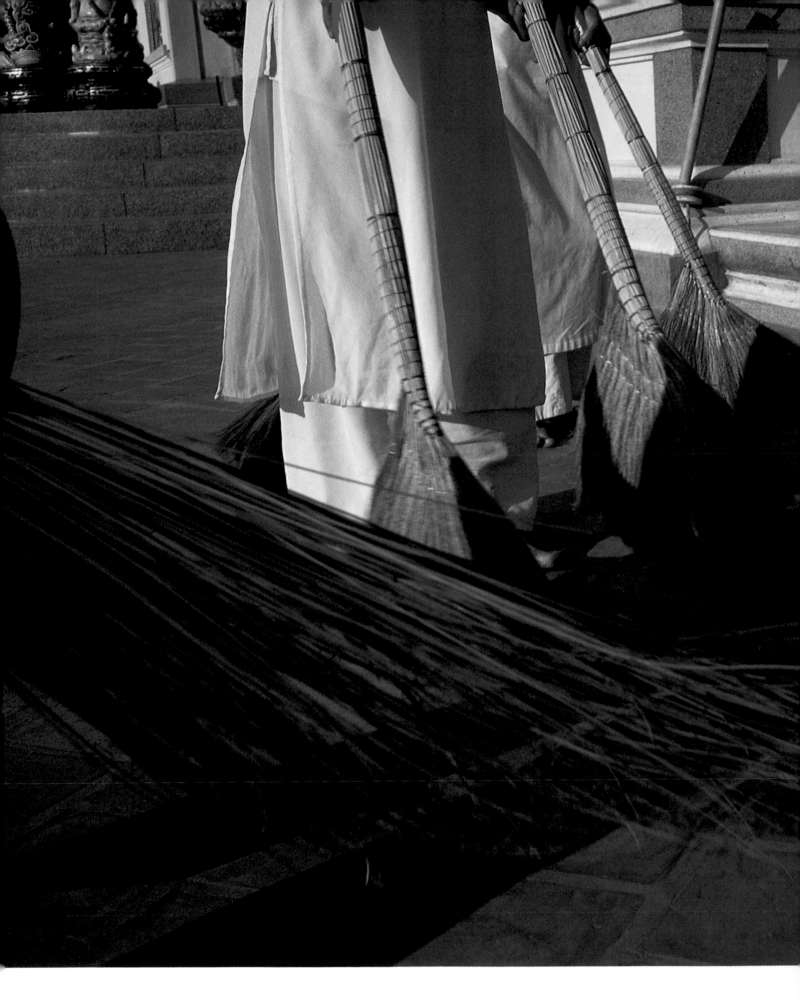

Cao Dai women sweep
the surrounds of the Holy See,
Tay Ninh, Vietnam, 1995

Buddhist funeral,
south of Hue, 1999

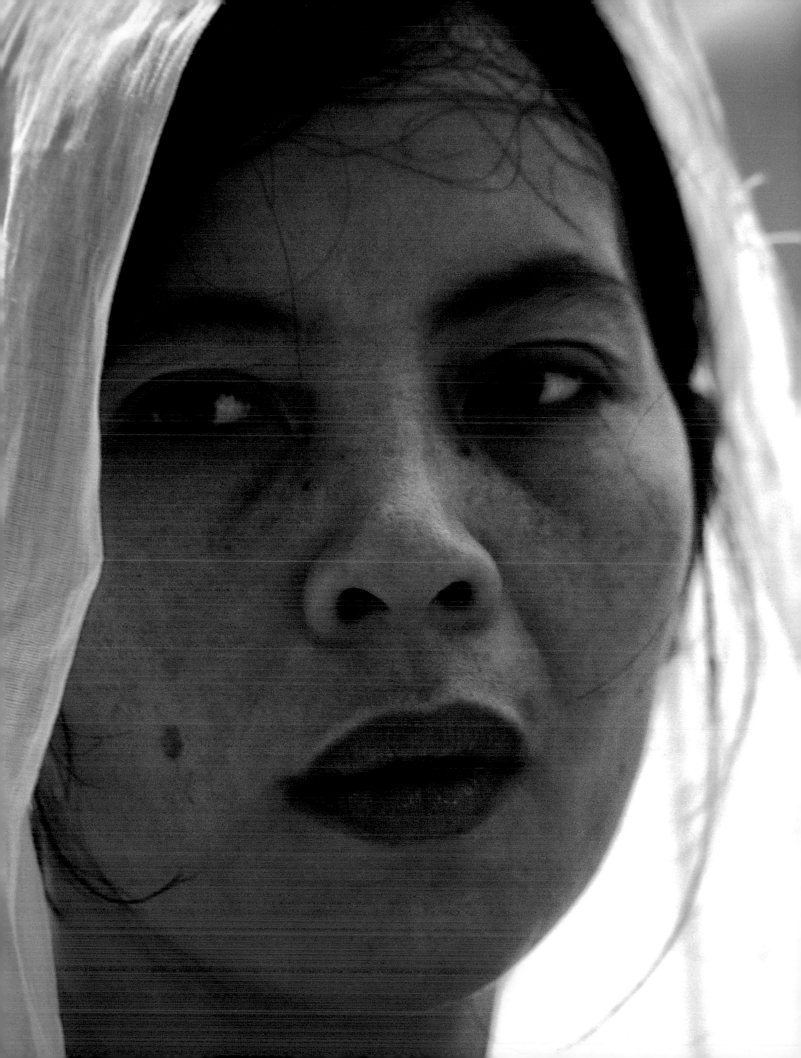

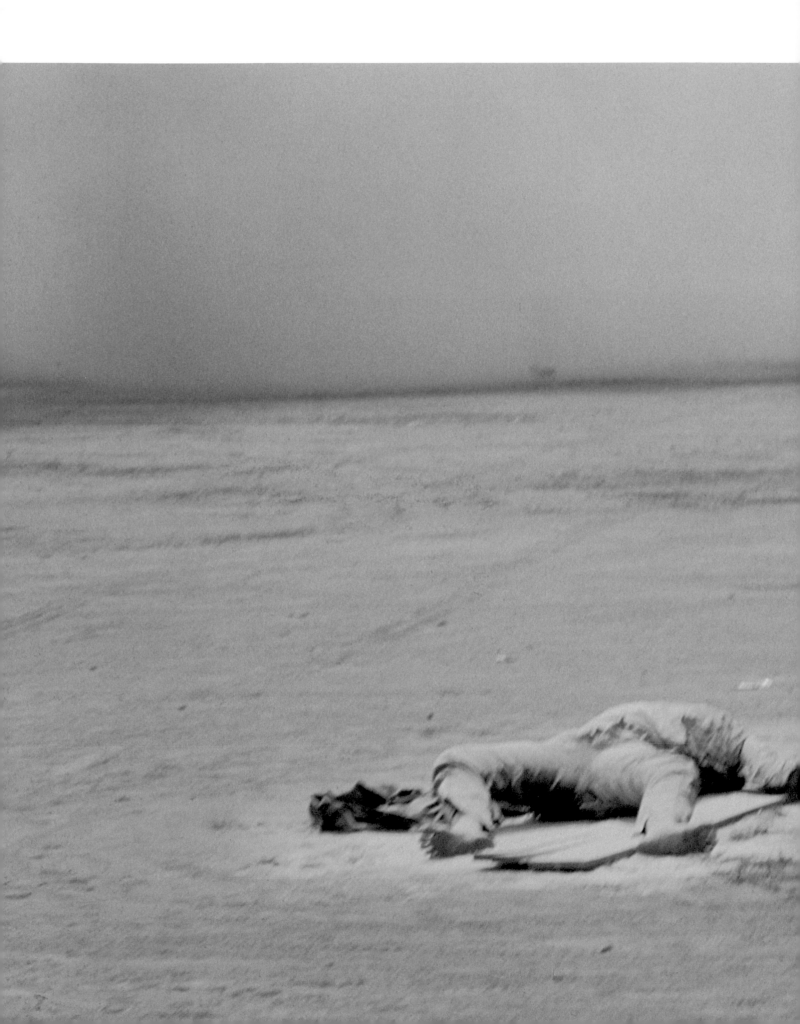

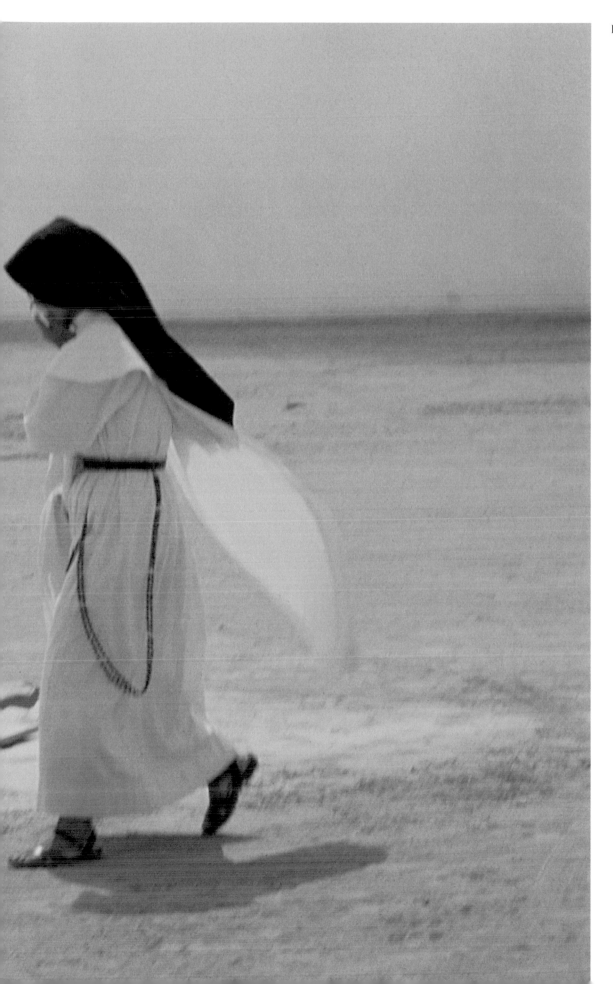

Death at Dong Lach, 1969

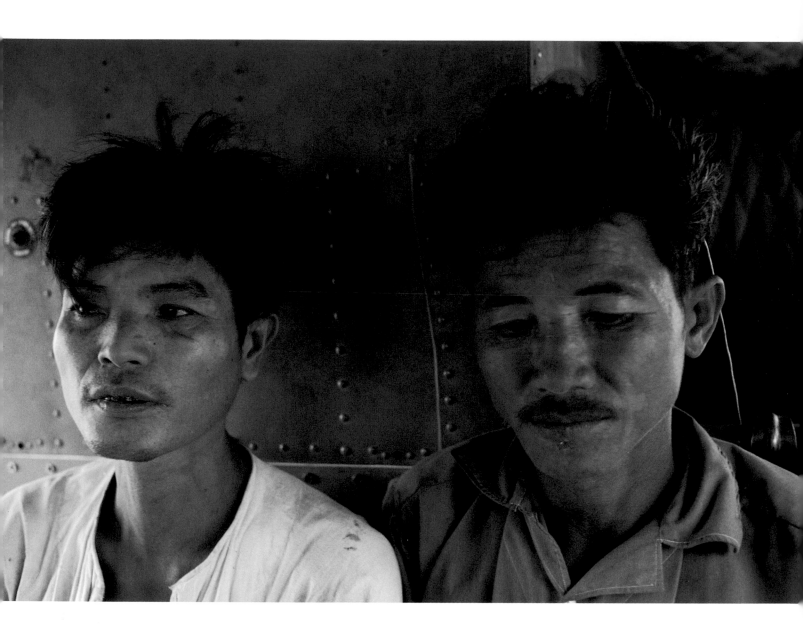

Frame from the last roll
of incountry colour: Viet Cong
suspects in the Huey, 1969

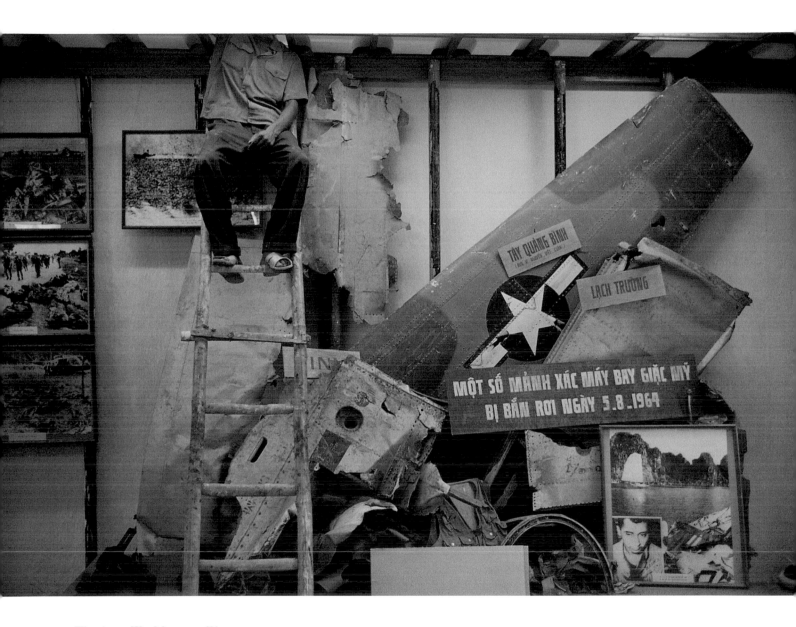

The Army War Museum, Dien
Bien Phu Street, Hanoi, 1992

Page 122: Flynn in the field with
ARVN rangers, near Tam Ky, 1967

Page 123: One-time Khmer Rouge
villager, one of the last people
to see Flynn alive, Bei Met,
Kampong Cham province, 1990

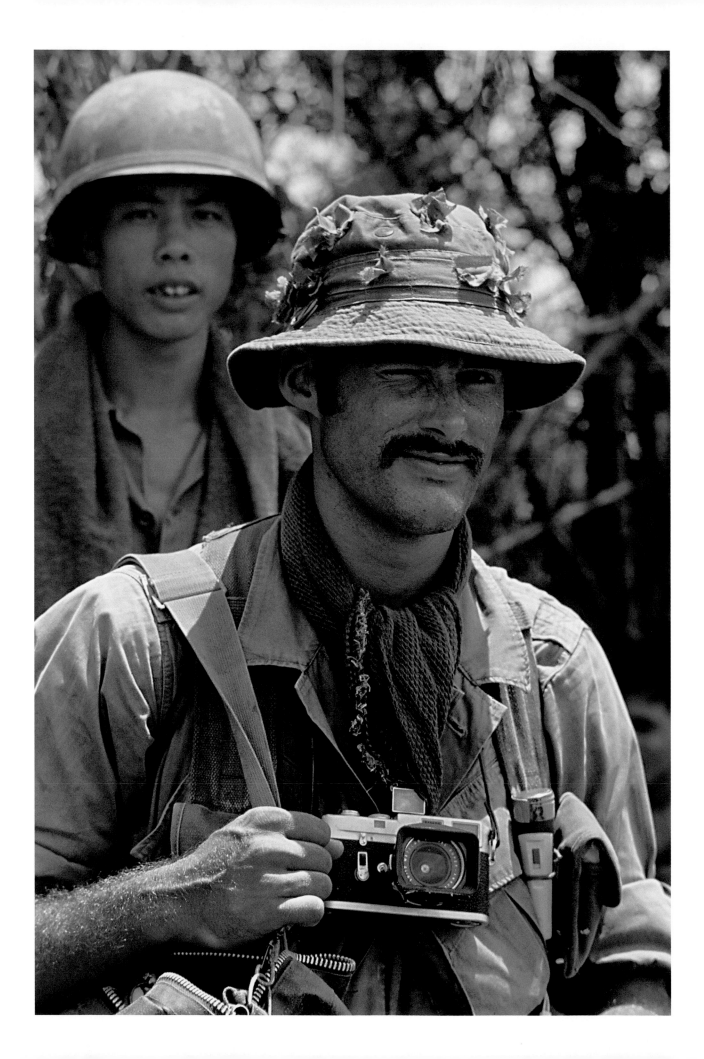

Air shaft in the Bong Sen hotel,
Ho Chi Minh, 1999

Opposite: Placing *huong* on
a comrade's grave, Xuan Loc,
north of Saigon, 1985

Dissident Buddhist monk
recently released from prison
back at the Thinh Mu
pagoda, Hue, 1995

3 Passage

'It is always sublime to break through to this other side,
to this place where tranquillity prevails.'

The curious thing about neurosurgery, I later found out, is that they prefer you to be awake so they can monitor the brain. You are quasi knocked out to protect you from pain, but the cortex, the main scream, is left to fend for itself. I'm sure the feeling is akin to the force of large doses of hallucinogenic drugs. For me, it was like being out of body. There was a float; it was a black hole; there were stars glimmering, twittering, the sky over a Death Valley night. It was also very still – a space so infinite it took on the Hindu perspective of Dhyan, a Sanskrit word meaning 'open mind'. Further east, Dhyan becomes Zen, a oneness with this mind – the perfection of the moment. The moments out there were near perfect, tantalizingly so, comfortingly so.

The details got jigsawed together slowly, not all at once. Initially, a grenade was blamed, then a booby trap, which grew to a mine and eventually, after I met the miraculously alive retired top sergeant in the '80s, an anti-tank mine, command controlled, probably manufactured from unexploded American ordnance. The shrapnel's implosion had taken away the right side of my skull, causing a massive haemorrhage. By the time I got on the operating table, my good surgeon, Doctor Major Jacob Mathis, said it was about 200cc, as big as a reasonably sized orange. On the chopper to the field hospital at Long Binh my heart had been jump-started three times. The Leica revealed a nurse pumping down on my chest and a gurney rushing to the MASH unit.

The days blur by, lapsing into spasms of sleep, the conscious bits of time dreading the approach of a gowned figure, ecstatic to find a shape materialize as a friend. I'm told that I am hemiplegic, partially paralysed, the left side of my body non-functioning from tip to toe. No one wants to be frank with me about my situation, but further surgery is hinted at. Recovery is guaranteed, they hope, though 'we don't know what state you will be in'. A little head movement reveals my gut looking like the butt end of a Christmas turkey, great loops of wire holding in the stuffing. It hurts to move, even a little bit. Friends are the only relief. Linda and my other housemates visited around the clock, upsetting the military with their outrageous non-regulation behaviour. Flynn appeared magically – I could smell his soap, feel his presence – notified by the US embassy while biking around Laos. He brought a small wooden Buddha, who sat minding me throughout. It was the last time we touched; he left soon after and disappeared for ever, physically.

There are times, when meditating, that I see all these people, all these intimates, in a space that seems formed out of clouds. All the deceased, here happily alive, appear seated on pouffes of little cumuli, a few in Serbian Orthodox pews, framed soft, all chattering away, reassuring voices telling me that the cause and the spirit are not yet dead. I am just off set, looking into this private place from outside. I can freely hear their conversation, but I cannot talk with them. Somehow, though, I feel they know I am trying to communicate. Sometimes their talk just fades and haunts

Page 134: A Dao island
grandmother remembers, 1998

Page 135: A Dao palm, 1996

the day – fleeting overheard microbits continue to dog my thoughts. It is always Flynn's voice I hear chuckling the most, closely followed by Sam Castan's. Other friends now missed come to join the pantheon of souls, some wandering, some at peace. It is never a surprise to tune in. Adjusting to the right frequency is a question of combining focus, stillness and mindfulness. Occasionally, I flash deeply into this psychic state, at one with another space at the most bizarre of moments. Smoke from incense sticks liberates the block between the tangible and intangible, the now and then. It is always sublime to break through to this other side, to this place where tranquillity prevails.

It's difficult to focus in the convulsions of the urban conundrum. It comes at moments in the green, becalmed by water, trees and open spaces. Then there can be a pure communion uncorrupted by the desires of consumption, the pressures of forced sociability. A retreat in a Buddhist monastery is the quickest way to reassert the order of being mindful, disciplined and at peace with the world around. The utopic plane achieved there annuls the stresses and tensions of modern society. Leaving the sanctuary is a massive assault on one's retuned reality and values, values that seem to be waning outside. A daily dose of medication, tuning in to the spirits and one's own sanctity of soul, contemplating our very harmony, at least lets the mind maintain a modicum of balance. The yin and yang spins gently rather than kaleidoscoping into an unfathomable infinity.

Initially, my recovery in the '70s took me on the opposite tack to the mindful. The precepts I had learned in Asia drifted away in the confusion of drugs in North America. It was a slow process, the healing of the body, avoiding the issues of the soul. Gradually, movement returned to my paralysed left side; the turkey trussing disappeared. I was declared ambulatory after a few months and allowed to live outside the New York hospital where I had finally ended up. It had been a journey through two field hospitals in Saigon and two in Japan, before reaching a privileged bed in the Walter Reed Military Institute in Washington DC. The prognosis was still unsure: definitely further surgery, uncertainty as to permanent damage, a candy jar of medications to keep things normal. Frustration and impotence filled a year between the first and second head surgeries. Number two installed a large sheet of epoxy resin to cap the hole in my right cranium. Repaired at last, I fled the States with Linda and went to Rome and a compensatory year-long Time Inc. photo contract. Rome palled. Marriage to an American translated into a move to frigid Seattle, then descent to Hollywood, where at least a smidgen of work appeared. Destitute yet wedded, though depressed and suicidal, I started to get more desolate. I stayed in the plastic Californian night only because I believed that somehow America owed me a living, or at least Time Inc. did.

Getting a grip on reality became increasingly remote. Self-pity, compounded by alcoholism and abuse of my medications, deepened the problem. There was no faith in anything or anyone,

the only tangible limb to grasp onto being the benevolence of friends and fellow veterans. Oscillating between northern and southern California as the economies and cheap cars permitted, I never broke out of the circle of self-destruction – PTSD waxed at full boogie.

Catharsis, maybe even a certain exorcism (although erasure of the madness is impossible), came from a phone call in early 1980. The *Observer* magazine asked me to go on the first tourist trip to Vietnam organized out of the UK. Compared with today's streamlined packages, this was more of a guinea-pig expedition, led by an overweight gay Scot (who was later caught *in flagrante* in Ho Chi Minh). The tour came on the back of a trip home to England. There had been a BBC documentary in the autumn of 1979, followed by the death of my father and my first exhibition, with a mini-roll of attention and sales.

Landing in Hanoi was strange, a feeling of having landed in the enemy's camp. I almost expected the air-raid sirens to wail at any moment; they actually tested the main one on top of the PTT every day at noon. During the war, we had only ever known the North from the daily press briefings, the Five O'Clock Follies, as unfamiliar place-names targeted for their bridges or structures, or for their proximity to a truck or train route or military installation. The capital had a depressed, post-World War II, European feel about it – facilities were rudimentary and you were watched everywhere in the classic paranoid communist way.

Progressing south by plane, and then by road, was like going from darkness into daylight. The depression of spirit was less evident the farther south you went, except in Da Nang, where Soviet seamen were being attacked. Everyone thought we were *Linh Xu*, Russians. The only tourists back then were E. bloc-ers, from the satellite communist states of Eastern Europe. All the Indochinese regarded these new colonialists as Yankees with no dollars, who never smiled, never washed and smelt, never tipped and understood little, except for the cut-rate shopping they could take home. Once we declared we were *Anh*, English, a constant stream of would-be English speakers besieged us with a spectrum of offers and demands. The ostracism of Vietnam from the world community at that time hinged on its 1978 invasion of Cambodia and the ouster of Pol Pot and his Khmer Rouge henchmen. The subsequent trade embargo meant that doing business with, or even going to, Vietnam was as difficult as dealing with Albania, Cuba or North Korea. The United States' bitterness still ruled UN politics, prohibiting aid from fuelling recovery. The once rich exporting country was having to import; next door there was starvation.

The Chinese, in retaliation for the demise of their Khmer Rouge allies, swept across Vietnam's northern provinces in a lightning campaign, only to be drummed out in a matter of weeks. Like in India during the early 1960s, there was general apprehension of any foreigner. Ho Chi Minh Ville still reverberated to the old sounds. The captured AFRS tapes had been

clandestinely dubbed to boom out from small illicit private bars and teahouses, which harboured a nascent surge in prostitution and drugs. Aid trucks convoyed to Phnom Penh from behind the opera house downtown. Only a few of the old hotels reopened; the choice of feeding places was limited. Hanoi was the same – it had just one semi-private restaurant. The black market ruled: the dong, made up of ten hao, was worthless; coinage was minted from recycled beer and pop cans dug up by those in re-education camps; ex-hookers were making mattresses for people's barracks.

The war was still fresh all around. Old military equipment littered the roadsides; old firebases and battlegrounds had not yet been tidied up. The Cu Chi tunnel complex remained a raw landscape of destroyed armour and bomb craters; we were the first (experimental) tour group to turn up there. Everywhere people harvested scrap for a pittance; unexploded ordnance prohibited the use of much land. The disabled, mostly limbless, crawled the streets begging. The western and northern provinces in the former South were still poisoned with Agent Orange.

It was hard to feel nostalgic. It was just so sad that it had all led to this turgid socialist conclusion, the people denied help just when they needed it most. The old haunts were boarded up; who knows who or what was living in our old abodes? It was difficult to leave the strictly guided tour. It was, however, terrific to be back, full of flashbacks, mostly sublimely suppressed. But it was all too much to digest and process all at one time; and then there was still the *Observer* assignment to do. Too many waves to crash through to be able to surf comfortably back.

The most jarring event came during an excursion down to My Tho in our beat-up, old USAF crew bus. A boat trip was put on to the now derided, virtually vacant Peace Island. There was a sense of foreboding on the approach past the downstream end of Phoung, overgrown with mangroves and unkempt vegetation, the paint on the twin towers faded and peeling. The island was now billed as the 'coconut monk's omnireligion pagoda'. It was ridiculed and the truth concealed. A few of the erstwhile residents had been allowed back, one being Dao Phuc, then our official interpreter. He caught my eye, took me aside and enquired in a whisper as to the health and whereabouts of Johnny Steinbeck and Sean Flynn. An officious local minder hustled us up before we got much further. The Dao Dua had disappeared, having had a premonition of the bad times ahead, and died in 1974. With liberation, his peacemongering disciples were bundled off to push pineapples in old 'Free Fire Zones', the former battlefields where anything had been target practice. The island was now under the aegis of the ministry for tourism, stripped of any dignity, of all recognition of its peaceful prophesies, lumped into the generalized religion dumpster.

Hanoi's policy was still negative on the spiritual level – the country's energies were to be put instead into resolving as many missing in action (MIA) cases as possible. All over the country 'Heroes Cemeteries' were built and extended in expectation of recovered remains. For the

Vietnamese, a return to the earth of their native village is necessary for the continuum of the spirit, for the endowment of the family's soul. At that point, there were still half a million missing. Relatives would send a senior family member down south armed with comrades' information to retrieve a son, a brother, a father, or an uncle for home burial. With the demise of communism, the onset of a free-market economy and the liberalizing under the policy of *doi moi* – openness – deceased Southern Regime soldiers are now being allowed to return home, too. At first, their graves were systematically trashed, traditional values being sullied in the flush of proletarian victory.

Looking back, I can see that I was unprepared for what I found on this first trip back, the depth of emotions it brought to the surface. But it enabled me to write a book – *Nam* – that drew away a curtain from the pain of wishing, wanting and sometimes believing that I should be dead or that I had nothing anymore to compare to those incredible moments on the edge. Now I could stop feeling sorry for having been there, for having touched the heart of the matter and survived the rip. I knew I would be back to explore further the thresholds the country was offering. The mind traps that had snapped to on this taster trip had released much of the pent-up confusion; fears had been allayed; a hurdle had been overcome.

Visually, spiritually, I was wooed to make continued returns, each visit stretching to months, ministries only too pleased to let departments swing permits. The *étude* shaped itself slowly into another book, the missing jigsaw pieces scripted for revisits at the right moment, season and light already reconnoitred, test frames exposed.

Somewhat stunned by the reception of my first cathartic book of war frames, I saw the tenth anniversary of liberation as the perfect opportunity to seal the genie in the cam of time once and for all. The next project, I decided, would be a portrait of Vietnam a decade after the war. I needed little encouragement to shoot the book. An old friend of mine, Neil Davis, promoted the idea to the Vietnamese. He was and still is one of the spiritual gentlemen of our business. He had covered the entire conflict impeccably, initially as a one-man film unit. An Aussie with no axe to grind, he put a lot of his not insubstantial earnings into helping refugees and folk he had befriended during the war. The Vietnamese, the Laos, the Cambodians all trusted him.

After a small remonstration by Hanoi, *Ten Years After* was eventually given a green light, a solid contract and funds. More than six hundred rolls of film and eighteen thousand kilometres in six months produced the necessary sequel to *Nam*. Here was the proof that we should 'give peace a chance'. Here was the proof for myself that I was not a cripple, that my passion for photography was still curving and that spiritually my heart's home was back where the brain had gone down the drain.

Then Vietnam still ranked way down the list of impoverished nations. Most people were lucky to scrabble $100 together in a year; the infrastructure was rudimentary; corruption and the

black market were rampant. But there was a purity, a Vietnamese ethical way that has since been corroded by the influx of megacorporates. Pepsi and Coke now dual it out to sponsor the marathons; Japanese electronics companies compete to build incountry factories producing affordable consumerables. Today the country is one of the world's top three rice exporters, and there is oil.

Photographic infractions sometimes brought confrontation with the local authorities; the tentacled arms of Hanoi still twined downstate, requiring endless bureaucracy before one could travel and function. To these ends you acquired a sponsor, a ministry, and a minder, who doubled as an interpreter/fixer. You virtually slept together, or did sleep together, schemed and plotted, not always within the parameters of his job or the state's definition of it. The word had been put about to lighten up, and everyone volunteered far more than was healthy, the neutrality of the camera persuasive enough to put a lick on their minds. Hanoi had also been wise in unshackling places of worship. Though still run by a people's committee, each faith now had fully restored senior prelates. The Buddhists had been ceded theirs; the Vatican was chiselling the Christians back onto the pitch; while the minority Muslims along the Cambodian border relaxed after Vietnamese troops started pulling back from their factioned neighbour. The Dao Island, though, had degenerated further: the last of the faithful had disappeared and new shops had been set up flogging coconut artefacts and trinkets; two cafés served non-vegetarian cuisine.

Creating books causes a retreat, a marginally monastic one, into oneself, an introversion necessitated by the isolation chamber into which the author puts himself. Every day there is the blank page, the empty wall and the white screen to fill, hopefully with mindful creativity. It is soul-destroying, cathartic and rejuvenating all at the same time. For a photographer, writing is the antithesis of his normal expressive mode. Once we have made the frame, the job has basically been done, save inputting a caption. Editing a book demands more concentration than the shooting. Removing the emotions behind the frames, searching out a purity of style and content, seguing things so meaningful in their unveiled pose that their issues are not resolved by the click of a cursor or a stroke of a pen. Moments caught. Even when there had been a magic Zen pulse to the pushing of the shutter button, these frames do not necessarily fall onto the page in an easy edit. They constitute private moments consigned to a bank of stock images. The experience of making them is what propels one's boat through the troubled waters of life. Occasionally, you reach a still part of the river and all is clear rowing, the blades pulling long and deep. Then come the turbulent stretches of confused currents, the surface troubled with eddies and dangerous protrusions. Steering a beneficial course, while still wanting an exciting ride, requires a belief in the metaphysical, an adherence to a life credo that maintains flexibility yet subscribes to the fundamentals of compassion and mindfulness. Age and experience don't necessarily mollify the

impact of documenting the desperate, the deprived or the dying. It doesn't get any easier poking your camera into someone's ecstasy or sadness. Many cultures believe you are stealing part of the person's soul at the very instance the shutter freezes the moment. Finding a faith that permits survival at these testing times is the balance itself – a humanitarian belief that still lets the selfish voyeuristic streak come out of the artist, and then opens its doors to perception and progress.

When I returned from Vietnam at the end of the '80s, glowing with the weight of the spiritual hook-up, loaded with good images, I was stunned by an envelope of declassified CIA/DIA (Defense Intelligence Agency) documents that lay unopened on my desk. A young Frenchman doing his dissertation on the media coverage of Indochina had focused on the story of Flynn. Years had gone by since I'd helped him in his research; here was the reciprocation. Frustratingly, a lot of the most sensitive material – agents' names, codes, rendezvous, the details of running a network – had been blocked out. But the core information gave a locale, in various spellings but backed by USAF map coordinates, firmly on the east bank of the Mekong in Kampong Cham province 150 kilometres northwest of Phnom Penh. It was clear that local Khmer Rouge dignitaries were key players in Flynn and Stone's fate. There was only one way to find out the truth and that was to go to Kampong Cham.

Cambodia was still in a state of turmoil. The UN had yet to arrive; the Vietnamese occupation forces had just gone home; and there were enough weapons in the country for every man, woman and child. Communications and logistics were primitive, roads were cratered, bridges were often missing, fuel and vehicles were scarce. The bureaucracy was run inefficiently and rife with corruption. It cost four dollars for the half-day bus ride from Ho Chi Minh to Phnom Penh (and a dollar to return on an ex-Yokohama municipal single-decker bus overloaded with cement, cigarettes and Hondas, the front windscreen replaced with a sheet of flat shop glass). A dodgy Toyota Corolla from circa '72 humped its way through the dozen roadblocks to Kampong Cham; a rented river boat, for which I bought a new propeller shaft and provided a squad of local militia goons, took me the four hours upstream to one of the names in the declassified docos. Kroch Chmar, a small hamlet, lies on the first major bend of the river above Kampong Cham, on the edge of the Khmer Rouge heartlands, established when they first went underground in the mid-1960s. Our friends had last been sighted a couple of hours southeast of here in the village of Bei Met, fifteen kilometres north of the only continuously functioning rubber plantation at Chup. At Kroch Chmar, I was stymied by a tousled, sleepy-looking district officer who emerged from his private quarters buttoning up his fly. We were offered lunch by his maid, who emerged from the bedroom rearranging her sarong. He would not be persuaded to crank up his ancient Chinese truck out back and venture to a far corner of his fiefdom.

That night, coming back downstream, there was one of those acid sunsets of orange and purple where the colour and intensity suck you up onto a higher plane, a sunset more familiar in a desert than on a tropical river. It was then that the inspiration came to me, the idea of building a memorial to my fallen comrades – in fact, why not something for all the journalists, of all nationalities, who perished in the three decades of war that had seen the Indochinese countries liberate themselves? As I took the bus back to Ho Chi Minh, I was delirious with the idea.

I got advice from an old father-figure friend, Don Wise, an ex-POW of the Japanese, a one-time rubber planter, a Para/SAS officer during the Malaysian business in the '50s, and then a reporter for the *Mirror* when it was a paper of repute with a staff of brilliant correspondents. He suggested that the memorial be a garden, and said that it should be somewhere in the old DMZ. His backing signalled the way ahead, and a nucleus of media veterans subscribed to the new cause. Soon the authorities, both in Hanoi and locally, gave us permission to inaugurate the site by planting a sacred bodhi tree on the south bank of the Ben Hai River, which defines the 17th parallel. But after we had planted the tree, held a small ceremony and then watched the protected tree grow, Hanoi rescinded the arrangements, and the tree died a political death. We had even left some money with two locals to erect a fence and nurture the tree until we could return to make the memorial more permanent.

A good friend, a TV director-producer and correspondent of old, John Sheppard, had been out during the war making documentaries and had met the tight-knit group of stoned *bao chi*. He had also been privy to Flynn's charisma and had remained fascinated since his and Dana's disappearance. The opportunity to make a meaningful film to resolve the mystery of an old buddy lent the necessary tone to persuade the powers that be in the TV game to push contracts and budgets through at an abnormal pace. Just six months after we had the idea, we were on the ground, split into teams, initially two of us in Hanoi, the other crew in Phnom Penh. The technical lads would arrive once the research had been done.

Hanoi was not very forthcoming. The ongoing conflict in Cambodia still galled, was still being supplied, though not acknowledged. Anything known about what happened back in 1970 was spoken of only in a circuitous fashion. We suspected that Sean and Dana had been captured by a squad of roadblocking recon troops, in the middle of a massive battle, but nothing was verified. The crew in Cambodia, however, struck gold: witnesses to different parts of our buddies' fate were inexorably drawn together, witnesses to their ambush, to their time in Cambodian hands, and to their being led away to supposed execution. All that was left unaccounted for were their six months of captivity, probably entirely in Vietnamese hands. It started to unravel when they were handed over to the Khmer Rouge. Today, ten years later, the arrangements of how and why this happened are freely available in the Hanoi archives. They are there in the taciturn agreement recognizing the

Khmer Rouge as the legitimate front among three opposing the US-backed Lon Nol regime after Sihanouk's dethroning as head of state in 1970. One clause gave jurisdiction over any western POWs caught in Cambodia to Pol Pot's men. Nobody got out of that one alive. Not a single foreigner survived captivity then or later when they came to power in April '75.

Under heavy guard, John got into the heart of the Khmer Rouge turf, right to the coordinates mentioned in the declassified DIA documents as Sean and Dana's place of execution. The villagers probably thought these white-faced round-eyes were from outer space – they hadn't seen the like for twenty years. The older ones had incredibly sharp memories of those times, readily picking out our friends from the ID photo sheets. Anecdotes came forth; other old folk emerged, their local cadre, their landlady, the local shopkeeper. There was no way that all of these people had pre-received a script from the central government; they had no TV, no power, they were dirt poor. Although they were peasants, they were highly attuned to their predicament. The ebb and flow of conflict had savaged their livelihoods, poisoned their land, filled it with craters and left them in a worse state than before it had all started. They were at the epicentre of Nixon and Kissinger's secret bombing campaign of their country. They had hosted the rear echelon of the North Vietnamese forces hitting into South Vietnam. They had been enslaved by the Khmer Rouge, and only now was the crusher being lifted from their lives. Subsistence crops were breaking even at last.

At the point of capture, too, the local villagers were consistent in their accounts of the moment our lads had ridden up to the roadblock and were led away. The tale was continued by an amputee who had secreted himself to watch their first lengthy interrogation in a deserted *wat*. Too many people with too many idiosyncratic details for the story not to ring true. It was much more than we could ever have expected to find. Sherlock Holmes would have awarded us a sleuth degree.

The bareness of it, the frighteningly realistic details, the knowledge of their suffering seemed to hover about us. Uncannily, there was a vibration, a resonance like the one I had experienced many years before in the Marble Mountain cave when I felt the presence of Sean's spirit. Like a water diviner sensing a strike, my tuning fork hummed portentously. They had been here, on this very spot. Their energies still seeped down time. In the *wats* where they had stayed, some now in disrepair from the war and the Khmer Rouge holocaust, the vibrations were even more profound. The prevailing peace, even in the desecrated places, was overawing, the struggle between the violence perpetrated therein and the sense of forgiveness enveloped the search, impelled it with a certain sanctity. It gave the whole a stability. It seemed that at every turn we were being given another fortuitous detail or clue. Much remained unanswered; later on other information would supersede. Still, it unravelled like a perfectly peeled orange, each segment pithlessly separate.

The harmony followed us back to Phnom Penh. The folk assigned to us from the foreign

press department had caught the fire, understanding so completely the nature of restoring missing spirits. On our last morning in the city, at sunrise, the senior abbot of Wat Lanka on the banks of Tonle Sap presented us with a decorated sapling. Having heard of our aim to build a stupa to peace and truth, to the memory of those who had died enshrining those thoughts, the Cambodians saw it as fitting to provide 'this cutting from the sacred bo tree, which grows upon the hill of Phnom Penh. It is more than five hundred years old. It is the heritage of Cambodia and its Buddhist religion. I offer you this tree. I hope it will flourish and bring success to your plans', thus spoke the Thero.

At last I felt I had a clear path laid out in front of me. This feeling sealed with thoughts I had back in England when I went on a retreat at the Cittaviveka Buddhist monastery in West Sussex following another disastrous end to the latest relationship. There I enjoyed the calming counsel of abbot Anando, an ex-Vietnam veteran, an ex-marine radio operator who, like me, had had part of his head blown away. I now had another mentor to guide the scrambled sane bits back into a mindful shape. For three days it was an undisturbed period of reflection, total calm, total peace. A regime that began just before dawn with an hour's meditation, then chanting, then quiet. There was but one meal, vegetarian, served before noon; the rest of the day we drank milky tea.

It always seemed, still seems, a shock, after immersion in a totally minded space like this, to emerge into the day-to-day reality of western existence, where quantity rather than quality, the economic, takes precedence over the way we are and the way we interact. But now, with the right guidance, the path in my mind was finally unrolling, as defined as a red carpet across the tarmac to a VIP plane. It wasn't necessarily a question of faith or credence – it was just a belief in the path itself and the precepts of walking it that became clarified. It didn't suddenly unravel the ultimate mysteries and meanings of life – that didn't seem necessary. The issue was one of flexibility, of staying in equilibrium, though always able to sway like the bamboo in the poem Uncle Ho wrote on his prison walls. Bamboo is the perfect allegory, mirroring our lives, for like it we are vulnerable.

Emerging from this chrysalis of realization after too many years of cycling round the perimeter provided the juice to fuel the process of establishing our memorial. It was about reaching a point where one is attuned to one's own karma, where the equilibrium is achieved, or at least recognized and employed. I debate the semantics between 'mission' and 'obsession'. The desire or need to resolve friends' fates. The need to perpetrate and continue quests at the other end of the shrinking globe. The drug-like addiction to returning *ad infinitum* to these worlds touched in more naïve, youthful times. To cut an undisturbed wake through the water, leaving banks unwashed by eroding ripples. A balance that is never easy.

Later a wider purity became evident, the birth of a son provoking the deepest of once rejected emotions. No line to question, just the simple reality of a child and the pure love he feels

for you and you feel for him. The ultimate Zen frame must be the midwife's hands reaching through breached waters to grasp for the searching tiny mitts that were his first diving desires. But it was also confusing to arrive at this megabridge so late in life, having rejected the concept, the very ism, of fatherhood after being soaked in dioxin. The possibility of siring something like I had seen in the clinics and orphanages was more than I was prepared to live with. In the end, the powers were with us and Kit has no untoward effects, blessedly.

Strangely, the new-found purity that came from his birth drove me away from him and security and back to Cambodia. The mysteries still needed solving, even if only to provide a break from the routine. I felt the need to take the result to the coalface of experience again, the need to prove the intangible, not to mention the economic need to support a family.

I returned to cover the UN-sponsored elections of 1993, probably the first Cambodia had experienced without massive tampering or violence. Most of its postcolonial life had been as a one-party state, opposition a luxury barely tolerated. But now factions that had fanned the fire of civil war for a decade were facing up to each other over the ballot box. The whole country was in turmoil, littered with an estimated nine million land mines and UXOs. No one knew what the population count was; none of the roads or railroads were secure; food was being imported as the weather pattern proved disastrous. There were enough NGOs (non-government organizations), do-gooders, to fill a small phone directory. Confused Cambodians were registered, censused, polled and processed; white vehicles brought tidings of peace and a rip-off prosperity. Folk flooded to the towns to cream off a bit of the international aid packets. Out in the boonies nothing changed. Disease and explosives corroded the people; hunger and danger hardly retreated with the arrival of troops from twenty-six countries. The only constant was the gradual rebuilding of the *wats*. Two years earlier villagers had begged for donations by the roadside, drummers and dancers blocking traffic and passing a bucket round for riels. The small communities refurbished their temples as the centre of their lives, trying to reinstil the traditional moral and ethical precepts back into a society turned upside down. Often the *wats* had been desecrated, used as ammunition dumps, army barracks, even killing fields. Many had been simply razed, as was Phnom Penh's beautiful cathedral, dismantled brick by brick by slave labour. Now, through community energy, the classic steepled roofs were starting to grace even the smaller towns. Traditionally, schools were attached to the *wats* to provide basic education; young men were once again encouraged to join the order, normally at the age of eight, for a year. Every community had been based around the *wat*. The system provided food for the *bikkhus* and elders as they performed *bindabat*, the morning alms round. Reintroduced, the Sangha of Cambodia, the central Buddhist synod, gave special dispensation for the saffron-robed monks to accept money in their bowls: in Therevada cultures

it is forbidden for monks to handle cash. Few of the clergy had lived through the holocaust; those who had survived had been tortured and often put out to watch the animals in an attempt to humiliate them. Their calm had been their survival. The primitive, sometimes teenage, Khmer Rouge guards and soldiers often fell under the aura of these monks, even after they had been defrocked, and eased off and conversed with their prisoners. As with the Jews living in pre-World War II Europe, one is taken aback that so many of the monks actually survived.

Prior to the elections, the Sangha promoted and ran peace marches that criss-crossed the country. Foreign devotees joined their throng, which swelled as it journeyed through the broken land. Hundreds of media personnel flocked to cover the story. Photo pickings were rich. Wherever you went you were guaranteed a story. Once the sideshow, Cambodia was now centre stage, sponsored by the corporates that had made the UN powers what they were. Heineken duelled it out with San Miguel, Coke with Orangina, Toyota with Mercedes; the real god of the country was fast becoming Honda, followed by Sony. It was the fastest injection of consumer proselytization we will ever witness. The starring Cambodes took to it like ducks to water – they yearned to consume.

Vietnam became my sideshow. It was next door, the perceived perpetrator of continued Cambodian ailments. Admittedly, Saigon had been a Cambodian fishing port only a 120 years earlier. Their neighbours had traditionally been their enemy. Visiting Cambodia again reinstilled in me a sense of cause. The anti-mines movement, the feasibility of an international body effecting peace, the restoration of a once flourishing nation. The Viets continued to be obstructive as far as the memorial was concerned. Banging on doors in Hanoi and Dong Ha was frustrating – as I told them, it was like shovelling sand. Assignments had gotten me to the middle of the country three times, excuses to visit our site to check out the healthy growth of the tree that other people had reported. On one trip, we transported a Hanoi-made *cuong*, a free-standing small hotel, a shrine house, so that the spirits could live alongside the bo, now fenced in against the goats. A crowd gathered when we lit the first *huong*, incense stick, and placed fruit and flowers on its platform. The guardians of the tree were tipped some more and encouraged in their duty, to which they seemed committed. From Marble Mountain we brought back an effigy of the Buddha made from the same white marble found in the cave. The tree now had the feeling of being blessed for ever.

A few months later, on a rainy day, dragging along a Belgian TV crew, I found the tree gone, the fence strewn about, the *cuong* smashed and the Buddha missing. Our triangular plot had been destroyed to make way for the new Ben Hai bridge on the improved Rte 1. It felt like the loss of a friend, a child, a deathblow. Though these were only symbols, the project seemed to be unravelling as fast as my life had in the '70s. Now Hanoi claimed that the shrine had been ill-considered and unapproved. We had to prove the point through other methods.

The change came in Bangkok, under the guidance of another old Nam-hand, Denis Grey. He had witnessed Hanoi's rebuffs – the crowing Judas cock of denial. We decided that the memorial should be a series of journalism courses for media personnel from the three Indochinese nations. Later it would include students from the host country, Thailand, and Burma. Our end goal was to establish an incountry faculty of media studies, an ongoing tribute to those who had set the standards, who had changed a minor course of history. Putting skills back into the land where we had flourished felt the right thing to do. It was the classic way forward, reflecting the Mandarin Confucian system of the wiser being promoted after examination to the next level of scholarship.

Appeal letters brought stamp and stationery funds. Putting on a gig in Bangkok to exhibit and then auction donated prints happened far smoother than we could have expected. At one point the Viets intimated that they thought I was building a bizarre shrine to the wackier elements of the war's coverage. But enough money materialized to jump-start the courses locally, proving that there was indeed a non-personal endgame. In the end, Hanoi donated ten prints to the event. A second auction a year later and more funds and more courses sealed our future. Students began to pass through the various studies, forming a new cadre in a media whose own shape and future was unpredictable, as the speed of communications, the nature of the business, evolved in ways that would have staggered our mentors. We were almost being overtaken by progress, the instant live-from-the-front reportage. We were approaching a dinosaur fate. The ethics, the veracity, the integrity of the business were in danger. Our mission shaped itself into preserving the purity of the news, the strength of its creative form, the power of photography. One succinct, iconic frame is said to be worth more than a million words or a billion pixels. Icons are indelible.

Constantly returning to Southeast Asia was reassuring in the face of the business' demise. At least there progress was meaningful. One felt that even if the story didn't grace the front page, it would contribute to a greater understanding of the state of play, on both a local and global level. There was gratification to be among friends of a like mind, trying their best to illuminate the world to a small plight. Cambodia, especially, contained this element. Vietnam, becoming ever more sophisticated, sped ahead in its development, complicating dealings with the hierarchy, which was trying to assimilate these imported changes.

A freedom of expression was returning to the country. A plethora of publications filled the racks and stalls, from trade-union papers and policeman's poop sheets to fashion and football magazines. The lotus was opening – people wanted a say, even in parody and sarcasm. The youth papers were the most critical, cynically trying to editorialize the corruption and intractability of the regime. They prayed for change. The country swam with travellers and tourists; residency for foreigners became easy. Religion was once again tolerated. Catholic churches and the cathedral

in Hanoi reopened; mosques down in the Delta were refurbished; the Cao Dai temples became part of the tourist itineraries. This tolerance was reflected in the plethora of roadside shrines, the re-emergence of the hole-in-the-wall temples staffed by boy-scout-hatted monks. In the major temples, nuns and monks once again studied, with the authorities still suspicious of being subverted as had happened in the past. The Buddhist conscience was most prevalent in Hue. At the Thinh Mu pagoda on the Perfume River, the car that had carried Thich Quang Duc to the first protest self-immolation, in Saigon in 1963, is displayed on blocks in its own carport; Malcolm Browne's Pulitzer Prize-winning picture of the burning monk is displayed on the windscreen.

The grey-robed monks here continue to yo-yo in and out of incarceration for spreading their liberal views – ironically, views expressed by most folk should you question them. The opening-up of the old spiritual ways, tied to the ancestral, to the soil, to regeneration in the ancient Mandarin Confucian concepts, pleases both peasant and sophisticated urbanite. It had been and still is the thread of their balance. Veneration of the abstract had been discouraged during the people's struggle. Now festivals and rites were back to normal, and not just to enhance the tourist brochures.

The scars of the war are being healed, the forgiveness enshrined in the Buddhist eight-fold path to enlightenment enabling all parties to coexist. They are confronted with the issues that faced occupied countries after World War II, and are now facing the Balkan states and central Africa. The same blue-helmeted, white-vehicled body, the United Nations, has been involved in all these cases. We shall be discussing the merits of its success at securing peace until we finally destroy all, or are destroyed. But one questions whether it is right for developed nations to dictate the 'correct' course of action to the undeveloped. Having foisted our dogma upon them in darker colonial days we would do well to absorb, as the Dao Dua proclaimed in '69, a little of their energy before we start imposing our fiscally loaded ideas.

Familiarity is a funny thing. It endears you to a place, though it becomes transparent. It drives you to despair. The inefficiencies seem more compatible with the intangible ones back home – the homogeneity of the new age of easy travel. Both Cambodia and Vietnam engender those feelings every time I go back. It has become like a commute to work, the network rail link taken over by whichever airline facilitates an upgrade the easiest. Working the systems has become routine, rather than the previous sand-shovelling, the images that fill the assignments richer for the freedom of access and attitude. Making a film documentary or shooting an essay or personal frames has become less tangled in red tape than ever before. Virtually nowhere is off limits now, with most folk speaking openly, even critically. The hatred for former enemies has dissolved. A new breed of young people, privileged to have known only peace and the burgeoning prosperity, now constitutes over fifty per cent of the electorate. War is an anathema their parents sometimes speak of, like mine had.

Inspiration is something that rarely touches us. We are given to few pure crystalline thoughts. We are lucky to accumulate a mere handful of enlightened moments. Photography provides such instances of purity, a sensation of absolute as you squeeze the shutter button. Somehow you know all the elements have sashayed and segued into the ultimate form. The image you have created is apparent, rushes at the instant of taking. It is as Zen as you can get. Sometimes there are days when you are so honed, so on top of it, that you can touch off a whole roll of excellent frames. A musician on a high, pouring notes from his instrument. The Zen archer, who, having sighted the target once, draws, fletches, aims and shoots perfectly. The freedom to perform flawlessly, happily into one's soul. The affinity with the subject becomes absolute, and in a certain sense you become invisible – even the camera's prying iris is merely a participant. It is rare when all these elements melt together. It is not often you are given the opportunity, the privilege, to share in a family's grief and joy, to be front row at a traditional Buddhist funeral.

The woman who had just died peacefully at the age of eighty-six was the head of a family that encompassed all the dichotomies faced by any clan in a country that had been so recently divided. Madame Huynh Thi Thi's extended family had served both sides of the conflict, but had remained devout Buddhists and had continued to live within the square kilometre of Hue's walled imperial city throughout, including during the Tet Offensive. Like many Vietnamese Mandarin families, its members had remained nationalist, though politically split. Some had ended up emigrating. They returned for her funeral from a dozen different countries, both east and west. The local people's committee was obliged to be represented, as the family had abetted the revolution, even when other relatives had defected to the erstwhile enemy. In the wake of publishing *Requiem*, a book celebrating the work of the 135 photographers from all sides who perished in Indochinese conflicts between 1945 and 1975, I was there as the correspondent for a French TV crew making a film about their photographers, their spirituality, their soul. The local authorities enthused about our documentary inquisition, proud to avail themselves to unfurling correct Vietnamese traditions.

Obviously, we would have to observe the religious protocols, firstly by visiting the deceased's family home and paying homage while being introduced to the relatives, including her sprightly eighty-seven-year-old husband. She had been lying in her lead-lined coffin for a few days, enabling the relatives to pitch up from afar. Accompanied by sundry officialdom, we came in on the last afternoon before the interment, along with the California-based favourite granddaughter. This girl represented the latest in overseas Vietnamese (*Viet Khieu*) chic: tight Moschino T-shirt, moulded jeans and Raybans – the antithesis of party thinking, the sort they both despised and yet needed and courted. For matters spiritual the regime had loosened up, letting relatives of even undesirable elements return for deaths and anniversaries where ancestors were being worshipped. We had had

the fortune to fall upon an event of great importance in the community. It represented the very essence of continuance, the font of appeasement – time honoured without malice.

Female family members were wailing and keening around the raised coffin in the living room. A multitude thronged about – it was as packed as the underground at rush hour. There was a buzz above the keening; the air was full of the waxy smoke of candles and countless incense sticks smouldering. We passed before the coffin, upon which sat a portrait of the deceased in younger times. This part of the ceremony is Confucian-based, the point at which the soul leaves the family home and peace is made so that the spirit may return *ad infinitum*. We retired outside to explain this to camera and ourselves in the correct way. We would return the next day for the procession to the cemetery and the burial. Our acceptance into the family circle was so heartfelt, so complete, at such a moment that we took on their mood, their flow, and their calm of a kin's passage.

The cortège the next day was full-on pomp and ceremony. Nearly five hundred folk were milling around the house. Outside, a line of Japanese mini-vans and beat-up East German IFAs bedecked in funeral attire awaited the mourners for the ten-klick ride to the southwest of the city. Everyone was dressed in the white muslin costumes designated for the occasion. The pallbearers all wore red pantaloons and white headscarves. The funeral master had a red-and-yellow tunic; his musicians, cornets and drums, wore blue robes. The band leader and chief caller also wore blue, their pantaloons hitched up like plus-fours with bits of string, revealing blue socks and natty canvas slippers. They could have tramped out of the back lot of Twentieth Century Fox.

At the end of the road, everyone piled out of the motorcade, and the pallbearers hefted the half-ton, lead-lined casket onto their shoulders with four-metre-long red staves. The Buddhist clergy in yellow and grey fell in behind the family members carrying the framed image of the deceased; the relatives and friends stretched back a couple of hundred metres as we snaked over hills, through a shallow river and over old graves. There was a *déjà vu* to the terrain. Back in the war there had been an operation in this area with US marines and a Vietnamese combined action platoon. It had been, thankfully, a non-shooting day, just a hot, fraught plod and hump through a barren landscape and inhospitable villages. Now this jerky thread of colour was trudging through the same landscape, sadly but with a glow to the pace. It had more of a festive than a funereal atmosphere. At the difficult bits, in and out of gullies, round old tombs, everyone pitched in. The wavering haunts of the cornets and drum rolls kept it all in an eerie hypnotic rhythm.

By now it was almost midday and seriously hot. How could we have humped this land before? And then I remembered the droves of grunts flopping down with heat exhaustion, the endless pulls on water bottles, the salt pills popped. The discomfort and foolishness. Now there was an incredible energy pulling the procession along, the elders all shielded from the killer sun

with a panoply of red parasols and black umbrellas. Upon reaching the gravesite, the pallbearers laid the coffin on the poles across the brick-walled hole. The monks and nuns in yellow and grey gathered closer at the head of the coffin; the women broke through the encircled crowd to keen over the casket before it disappeared. They scooped dirt onto the top as massive bundles of incense were lit. The poles were withdrawn as the casket was lowered, with everyone shovelling dirt between wall and wood. Into this gap slid the entire cast of pallbearers, holding their poles upright like gondoliers. The funeral master climbed atop the coffin and started to intone his rap eulogy. In triplet verse he composed and recited in a chanted hypnotic voice praises to the deceased, eloquent traditional rhymes extolling her virtues, her attributes, which bequeathed a slot in the other world of peace. The pallbearers picked up the riff and charted along and repeated each *haiku* three times. The cadence picked up, the drums and cornets punctuating.

The heat had you swaying in time; the keening and wailing echoed the eulogy; the joy and sadness mingled hypnotically. It had a slight North African jujuka emotion, a blues lament with a discordant plaintiff sound that oriental music involves. Emotionally, it waved over you, entrancing, lifting one's spirits, projecting into the unknown, yet known. It sounded the very passage of the body as it left the now. Now was not something to fear – it was a mere slide to the more comforting, the more entire, the more replete. The entire gathering understood this, even the demented teenage girl who lived in the cemetery like a ghoul, tolerated by funeral parties as some benign wandering soul.

As the earth filled in around the coffin, the pallbearers rose out of the ground continuously circling, chanting, the master on the lid now pouring sweat like James Brown at a concert. The orchestration was held together by the rhythm, the mourners coming forward to add their handfuls of dirt. The Buddhist contingent stood under their umbrellas, smiling down on the proceedings. The widower moved about beaming and chatting with the throng. After mourning over the casket, everyone focused on getting into the shade and lunch.

We were left exhausted. Twenty-five rolls of film had wound through the cameras, nary a bum frame; the TV lads had virtually run out of DVD and DAT tape. We were in a state of transcendence, profoundly affected, mesmerized at one with the gathering. We were loath to leave, having witnessed such a liberalizing event, this Buddhist passage away from the humdrum and heavy to the realized, the osmosis of the passage, our frailty, our fragility, our temporary nature all so evident – the need to pass in a seamless way from the living to a plateau unfurled in the mystery of the verse and cadence. Here there was no fear, no dogma, no terror. What was on the other side was only placid. We left feeling at peace, profoundly quiet and excited that death has no dominion, that it is merely a transitory passage to a better rejuvenated energy.

Never after a shoot had there been this profound feeling of completeness, a sensation transcending normal assignments. There was a realization that all the elements had come together. It was liberating. It must have shown, for the process of getting the 'Requiem' exhibition staged incountry was put on fast track; other projects saw green lights, too. The umbilical cord to Indochina, rather than being severed, was being reinforced. Our memorial concepts were no longer being regarded as quirky, personal or frivolous. We had let the spirit of the project speak from its own heart, risen above the politics and recriminating policies

'Requiem' came home to Hanoi and Ho Chi Minh in 2000. Fittingly, it was also the twenty-fifth anniversary of liberation and unification. Ironically, Vietnam is the only place where the show, the tribute, can hang in permanence. To do so in the west would only result in endless hassles over copyright and royalties. Anyway, where could we display it permanently? No single country could rightfully claim it – not France, the United States, Japan, the UK or any of the other countries that lost one or two *bao chi*. They died in Indochina; some are still missing, either captured in Cambodia in the '70s or killed without trace. Our percentages of MIA probably reflect those of the once warring factions. The show itself was remarkable. The somewhat retarded one-party system had opted on an ideological level to accept the view of history told by those who had given their lives. Their heroes, our stars, our brothers. To stand there in the people's exhibition hall in the Hoa Lu, ten minutes from downtown Hanoi, and to hear the party faithful declare that the war was now over with this show was simply overawing. It was the definitive final statement.

It was echoed when the same set of prints went up in refurbished rooms at the war remnants museum in Ho Chi Minh. Before, the museum had been 'the war crimes museum', with nothing but a negative, anti-American, anti-west and colonial slant. Now the appeasement was evident, the tone modified. The circle was being completed. During the Hanoi showing, the grapevine brought the news that Louise Stone Smiser, as we knew her, had finally passed away. For years, this once beautiful woman had been disabled, riddled with multiple sclerosis. When Dana disappeared he had a braid of her hair woven around his neck. Theirs was the only true love story of the war. His demise had brought on her rot. We had been to see her in Cynthiana, Kentucky, after the show went to Frankfort, the state capital. She could move only two fingers and her mouth. I fed her chocolates and tried to talk of the future. Now the show had come to where it belonged, Dana and Sean and all the others were up there. Their energy poured from the images, reminding us that theirs was the ultimate sacrifice in the pointlessness of war. Louise was with us, too. We had all come full circle and the conflict was over in my head. A eulogy recited, a prayer intoned, the passage completed, a peace achieved.

This will be continued.

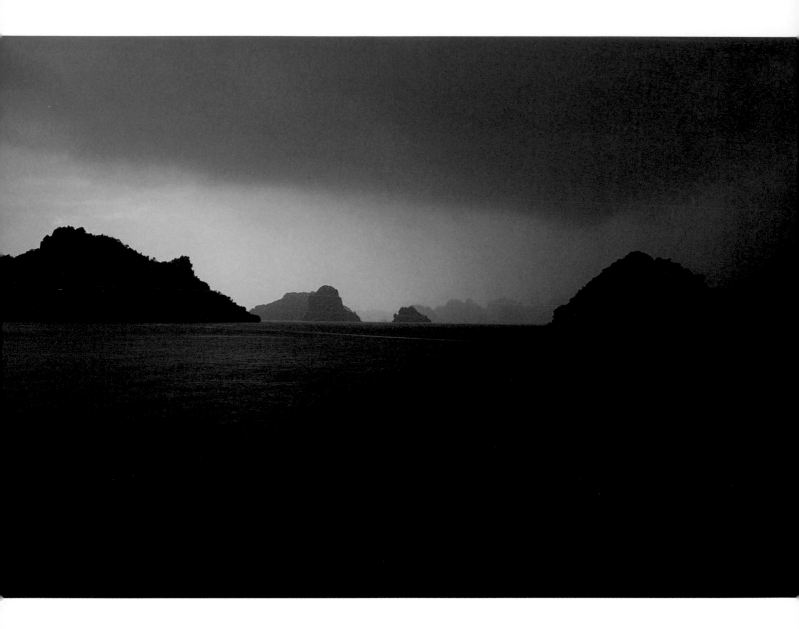

Ha Long bay, Gulf of Tonkin, 1992

Opposite: Double rainbow from UN
helicopter over the Tonle Sap,
Cambodia, 1993

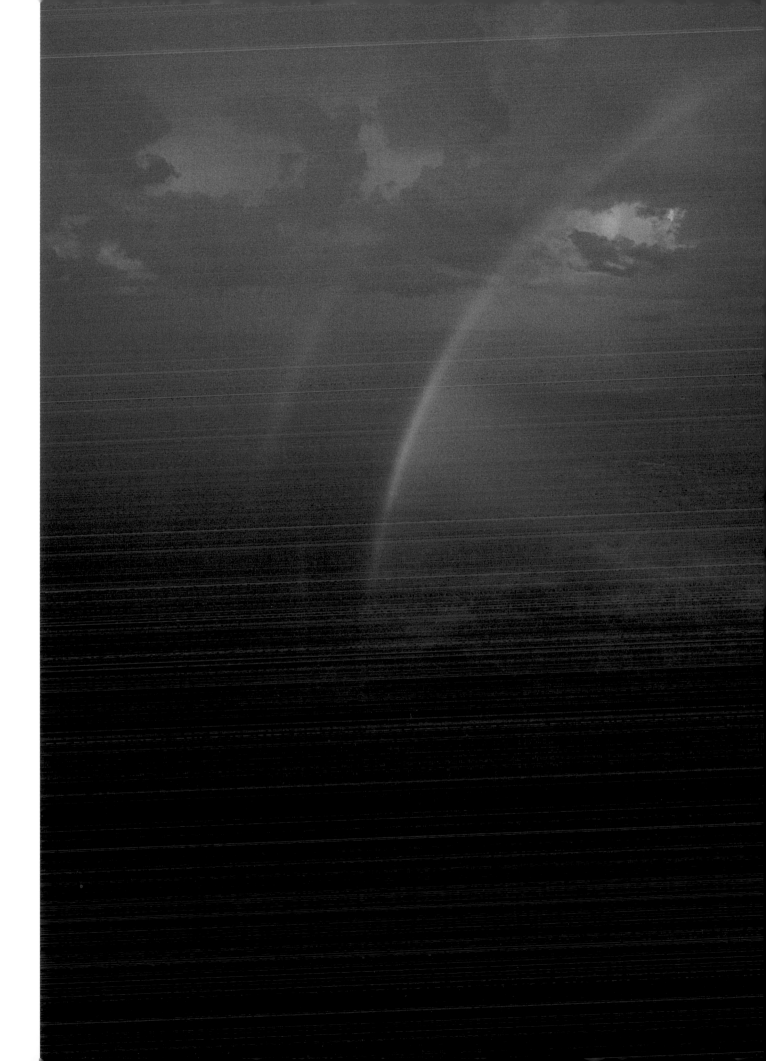

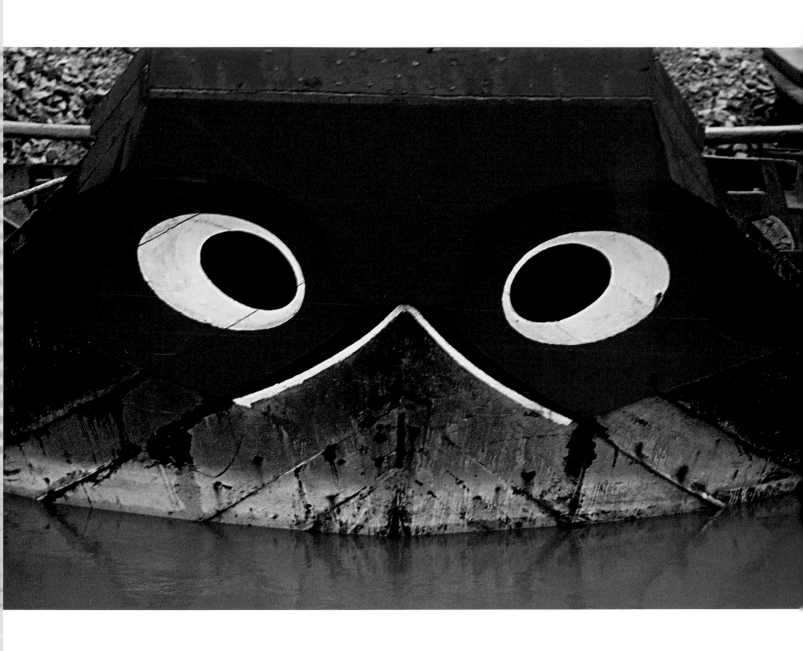

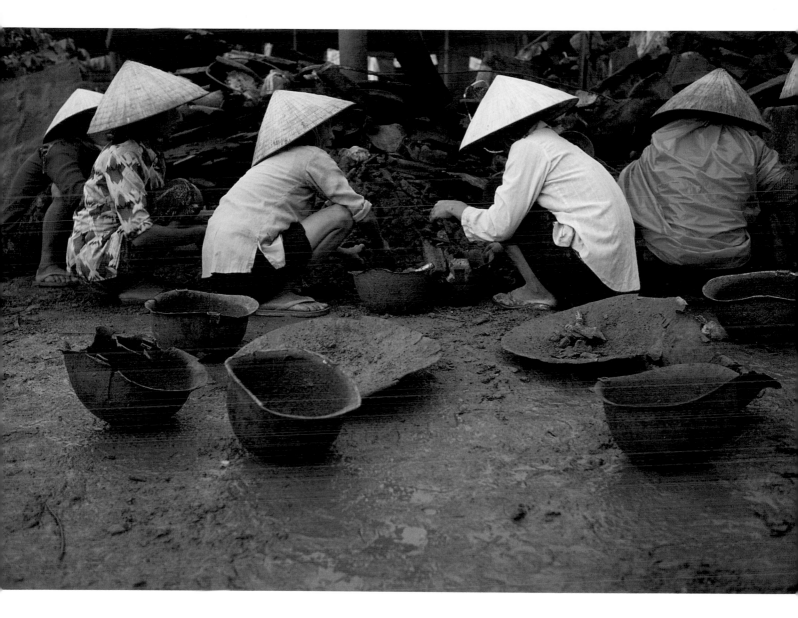

Women sifting battlefield scrap
at the former ARVN Ai Tu combat base
near Quang Tri, Vietnam, 1994

Opposite: Spiritual protection on the bow
of a Mekong river boat, My Tho, 1993

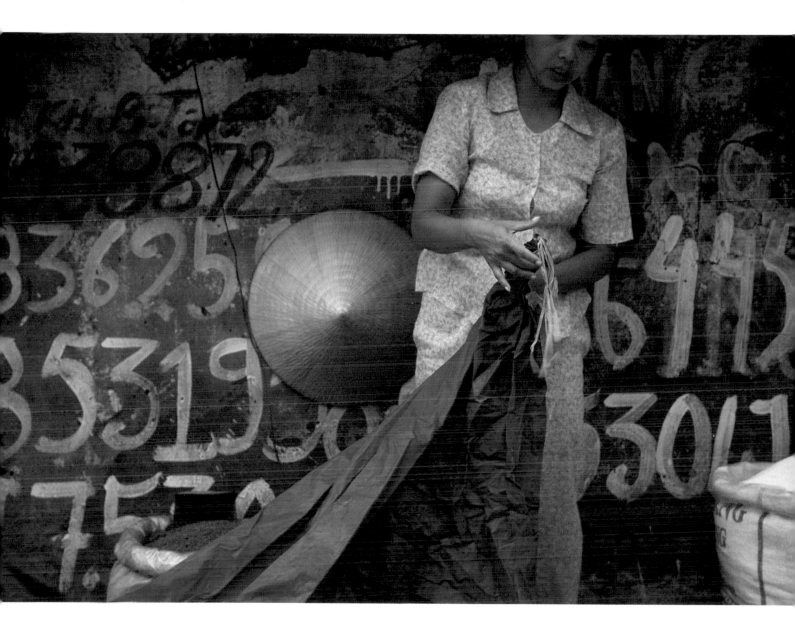

Rice market beneath the railway arches,
Hanoi, 1998

Opposite: Sunrise t'ai chi beside Le Petit
Lac (Hoan Kiem), Hanoi, 1992

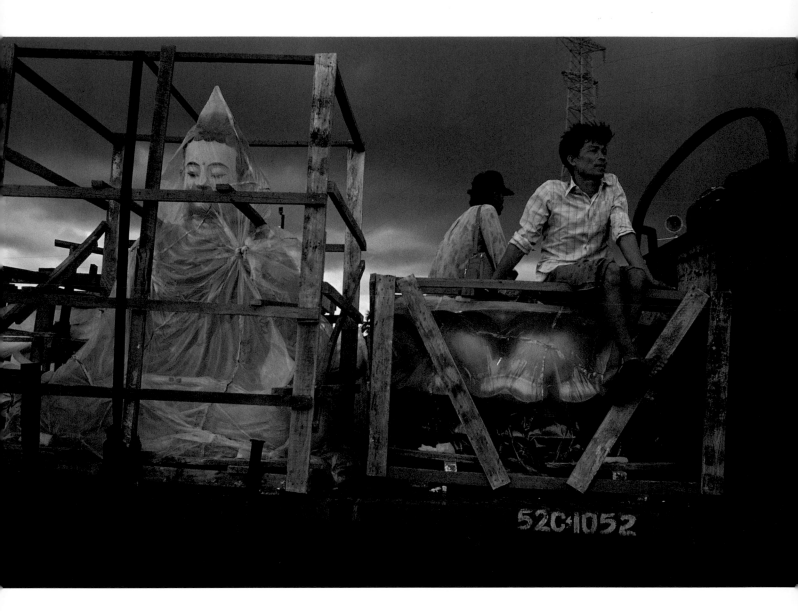

New Buddha awaiting ferry ride across
the lower Mekong, Vinh Long, 1993

Opposite: Lotus blossoms near Tam Ky,
Vietnam, 1992

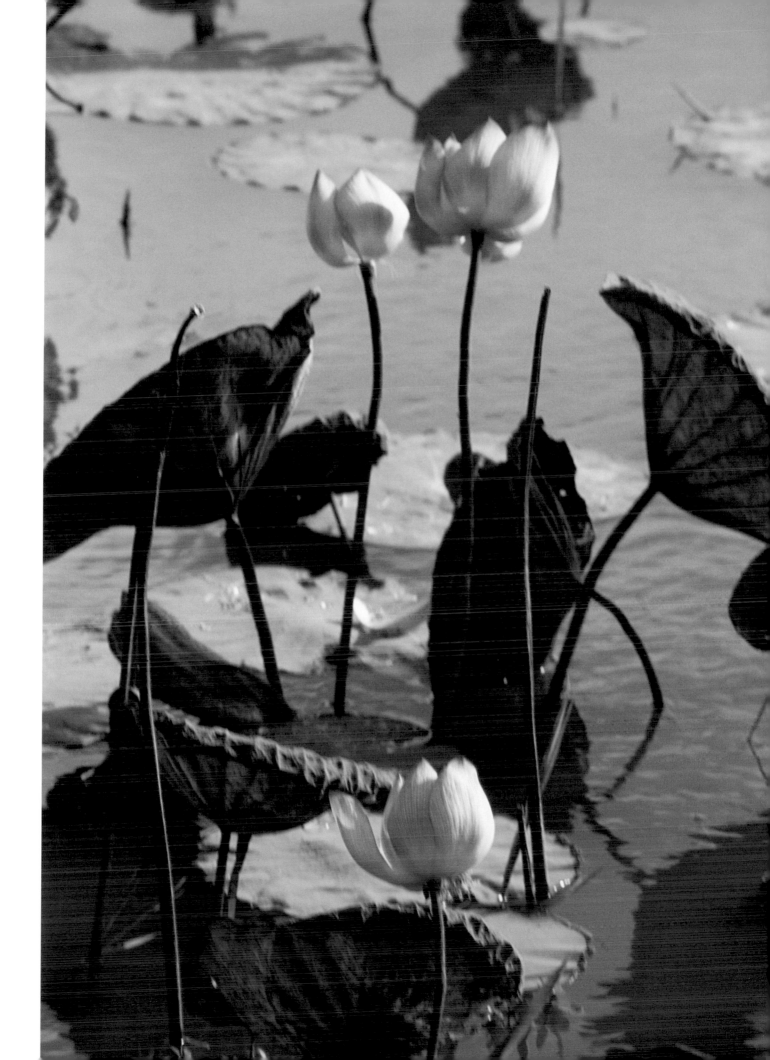

The site of a B52
downed on Christmas Day
1972, western suburbs
of Hanoi, 1994

Page 166: Protection offered
at a Chinese-owned teashop,
Ho Chi Minh, 1992

Page 167: My Tho,
Vietnam, 1999

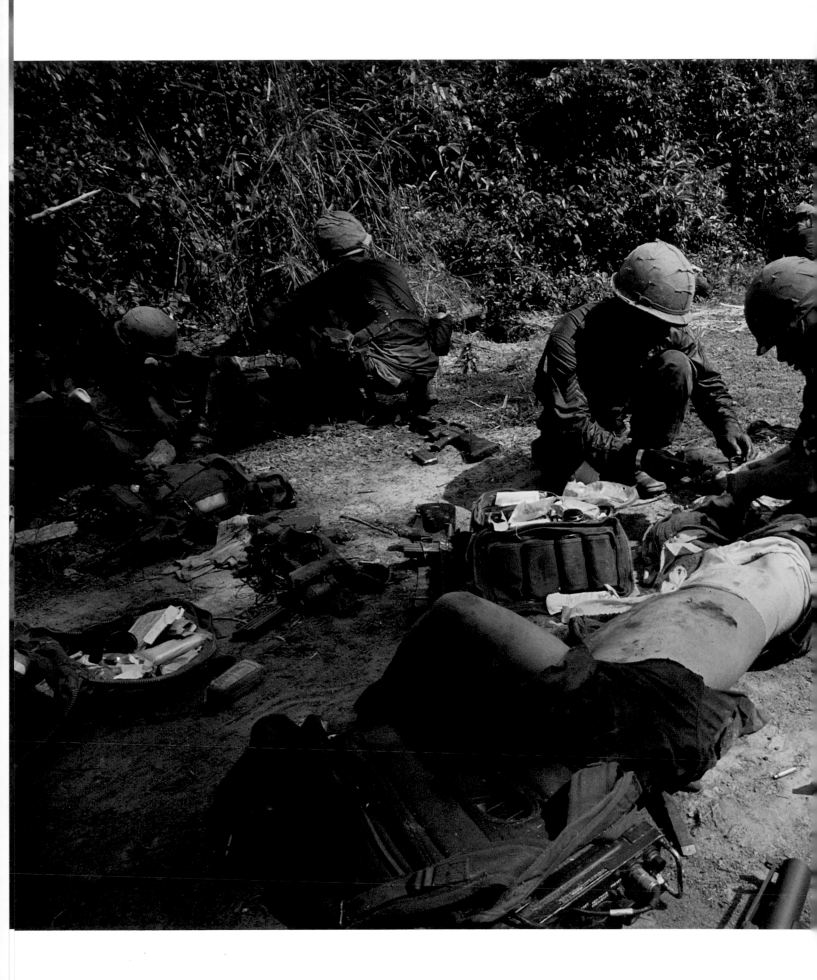

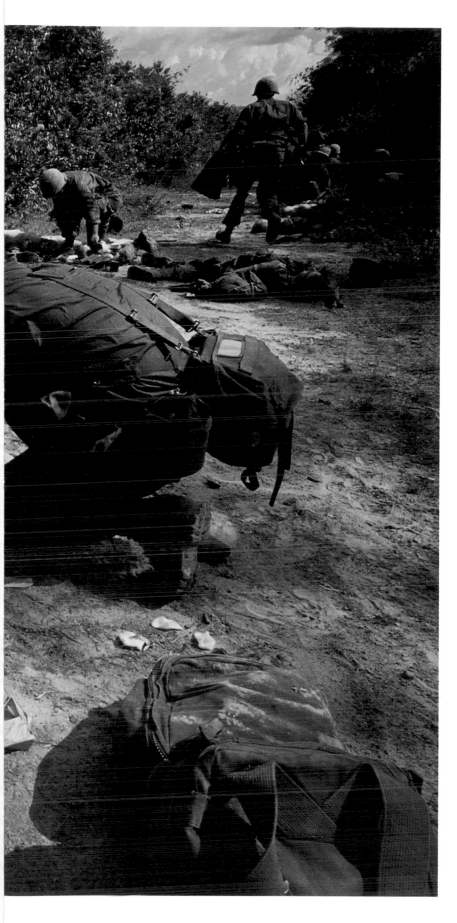

Ambush of the 173rd Airborne
in the Iron Triangle, northwest
of Saigon, 1965

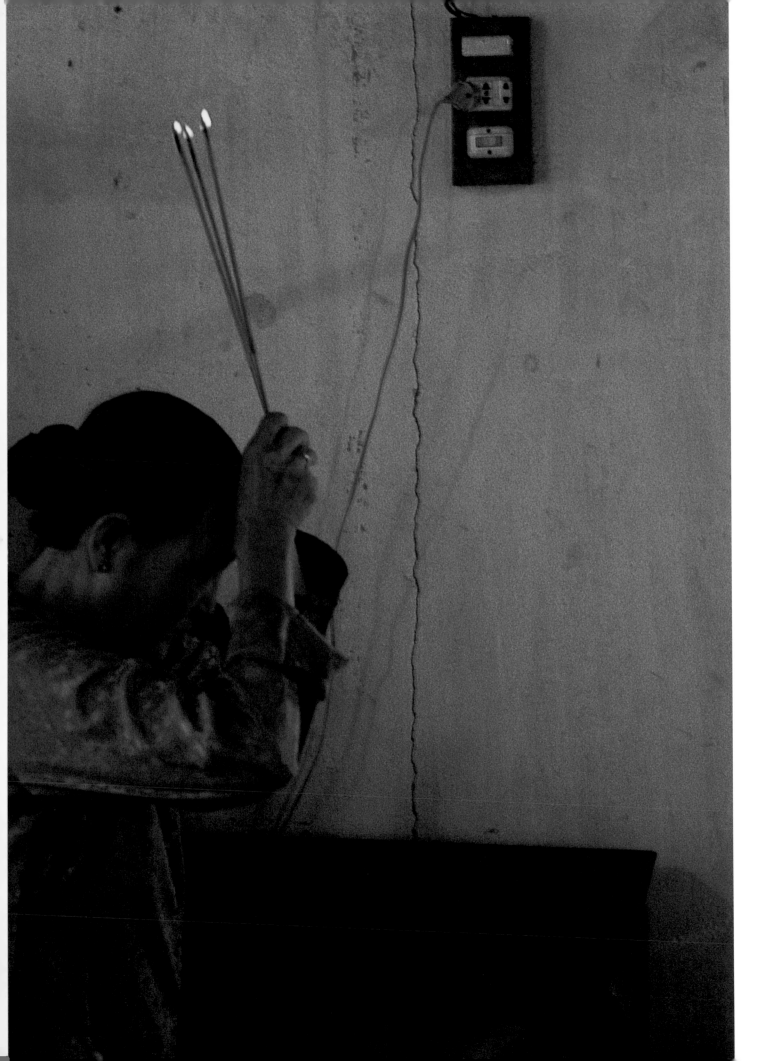

Opposite: Lighting *huong* at the family
cuong, Hanoi, 1992

T3 Prison, Phnom Penh, 1994

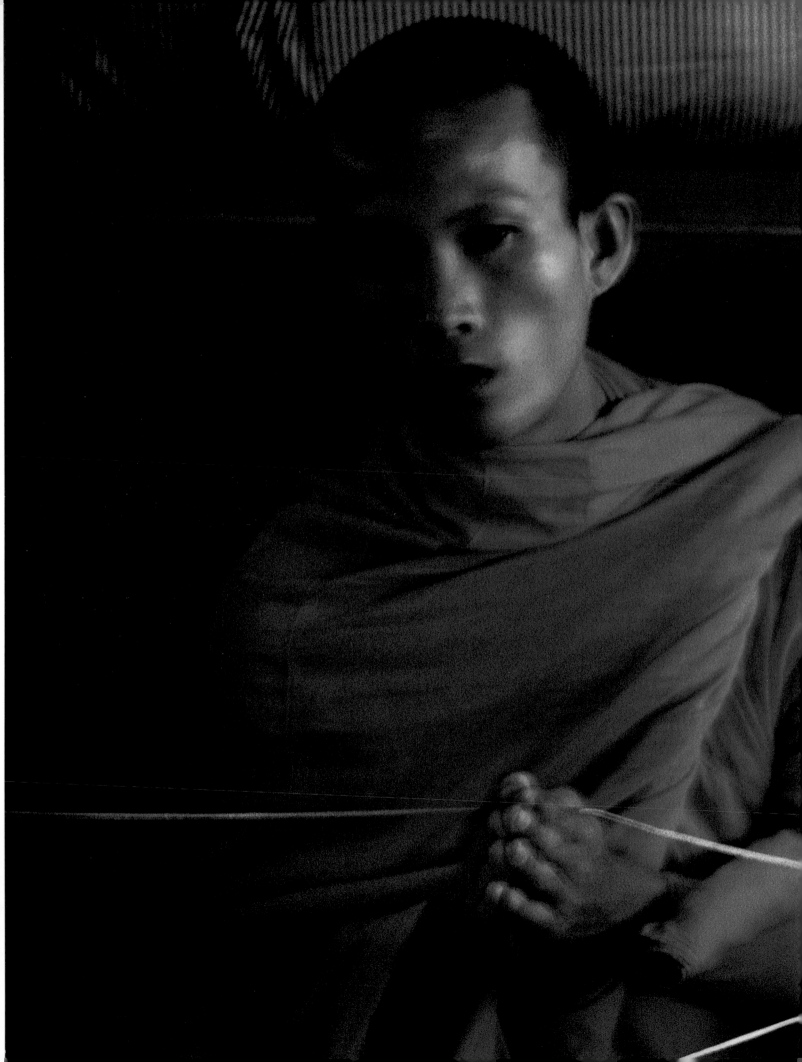

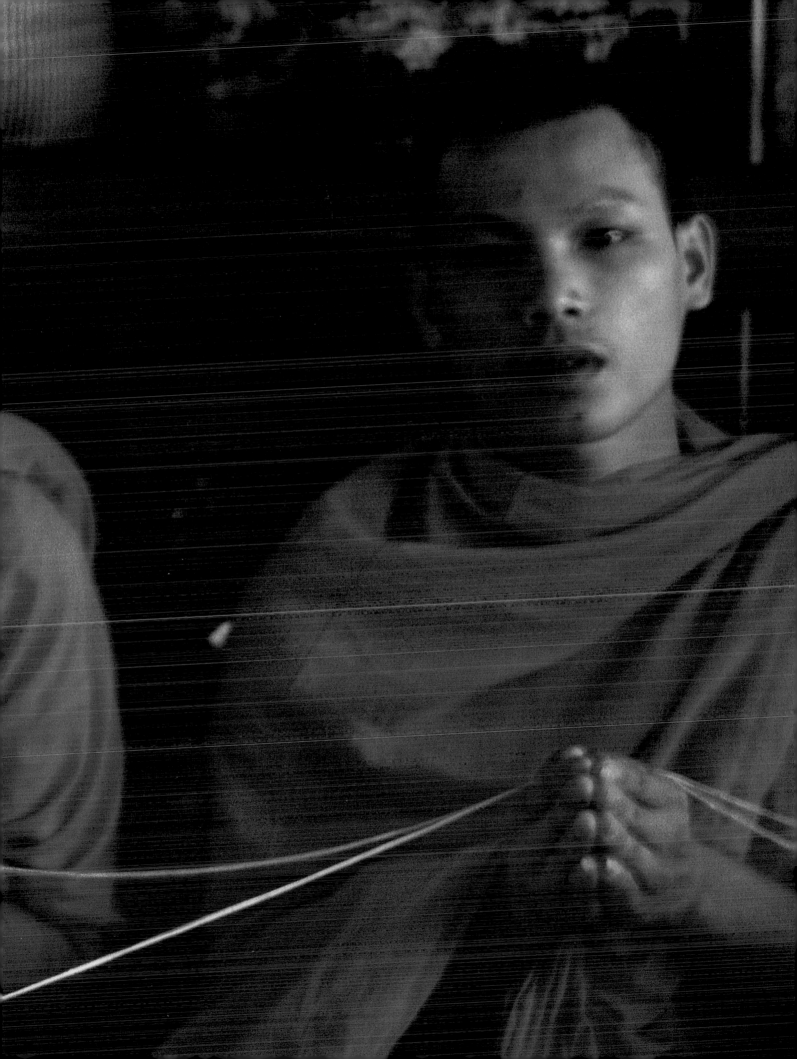

Co Lé pagoda, 1990

Opposite: Street market,
Hanoi, 1985

Page 188: Le Petit Lac, Hanoi, 1990

Page 189: Buddhist monk's funeral,
south of Hue, 1985

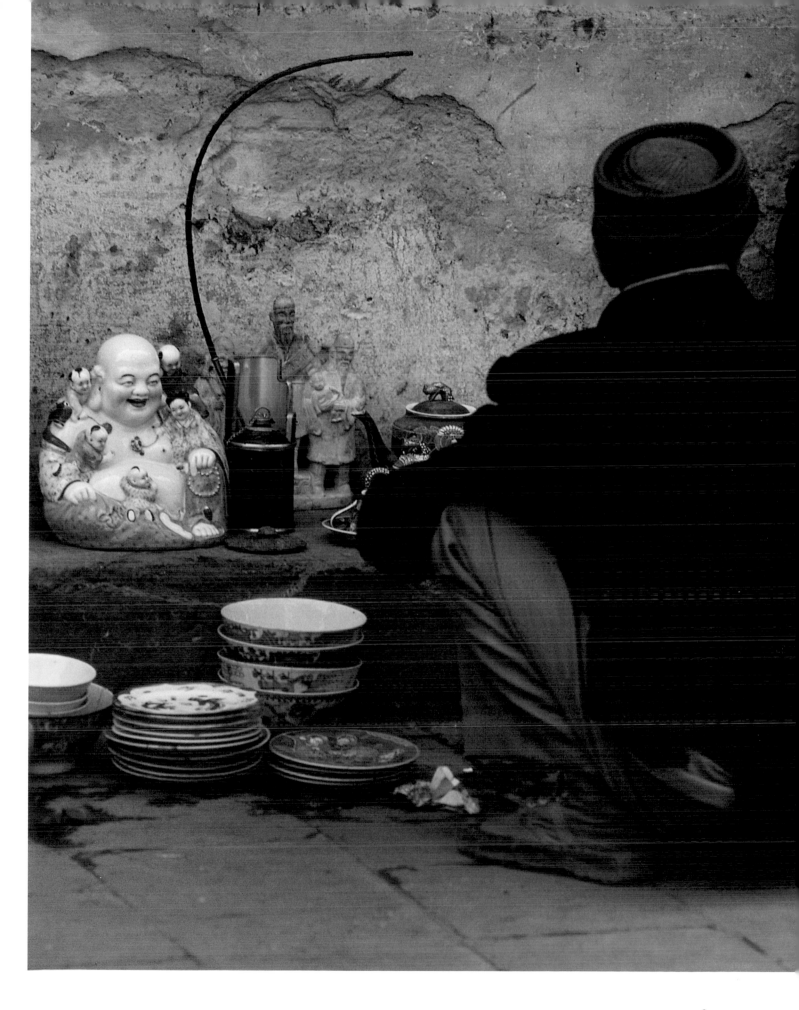

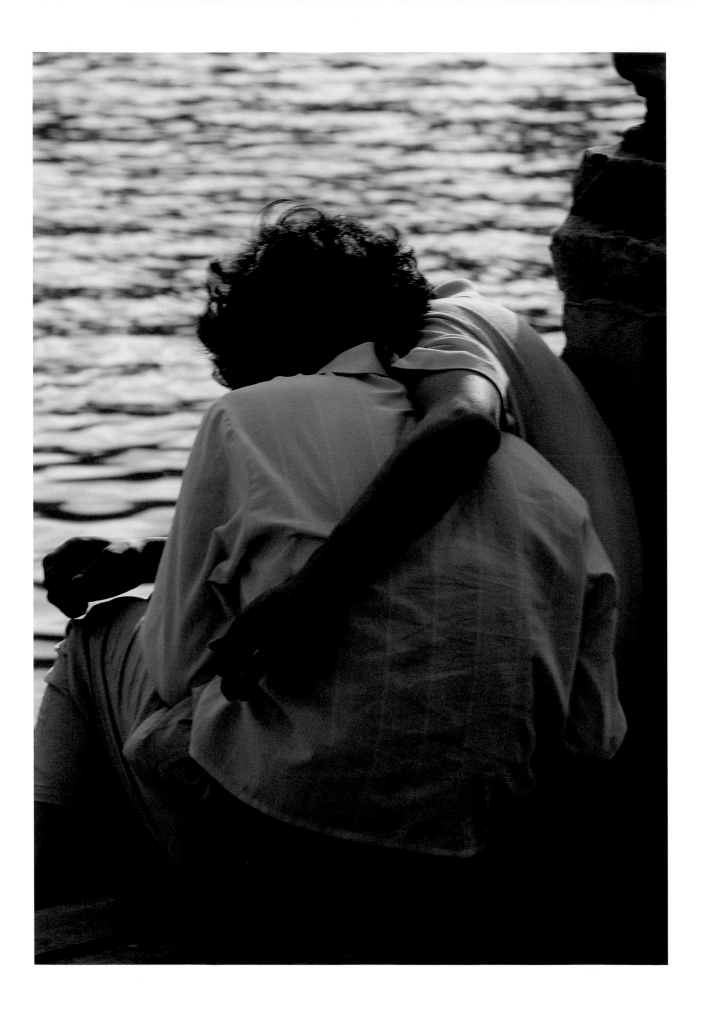

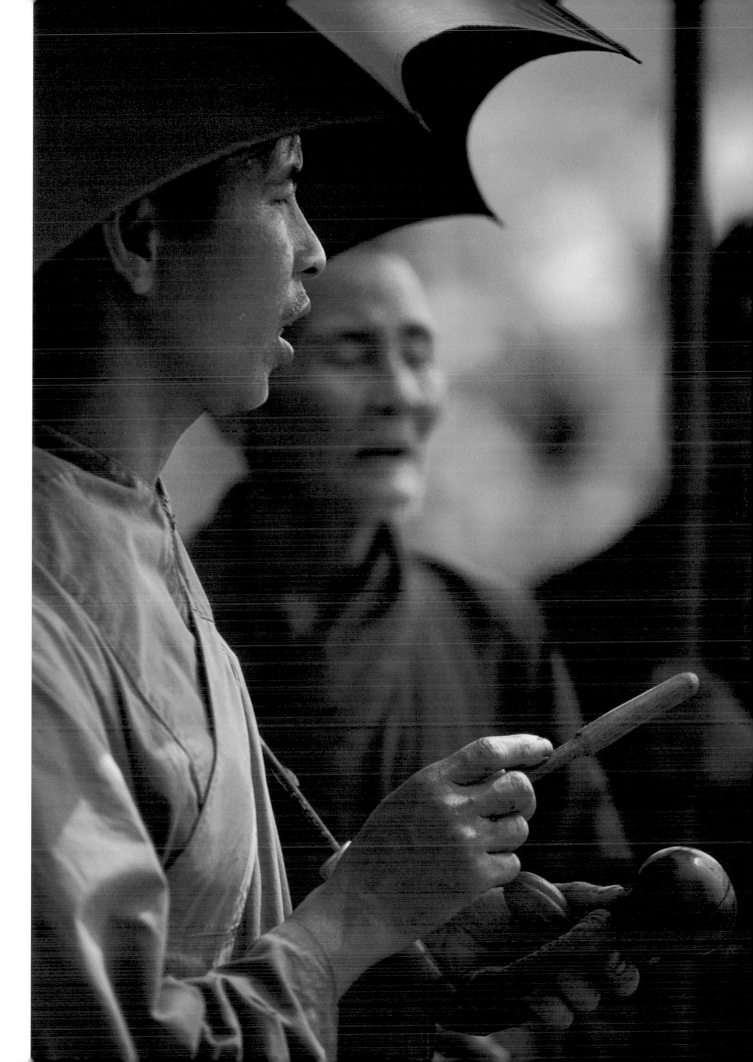

On the pilgrimage trail to
Huong Son Mountain,
southwest of Hanoi, 1985

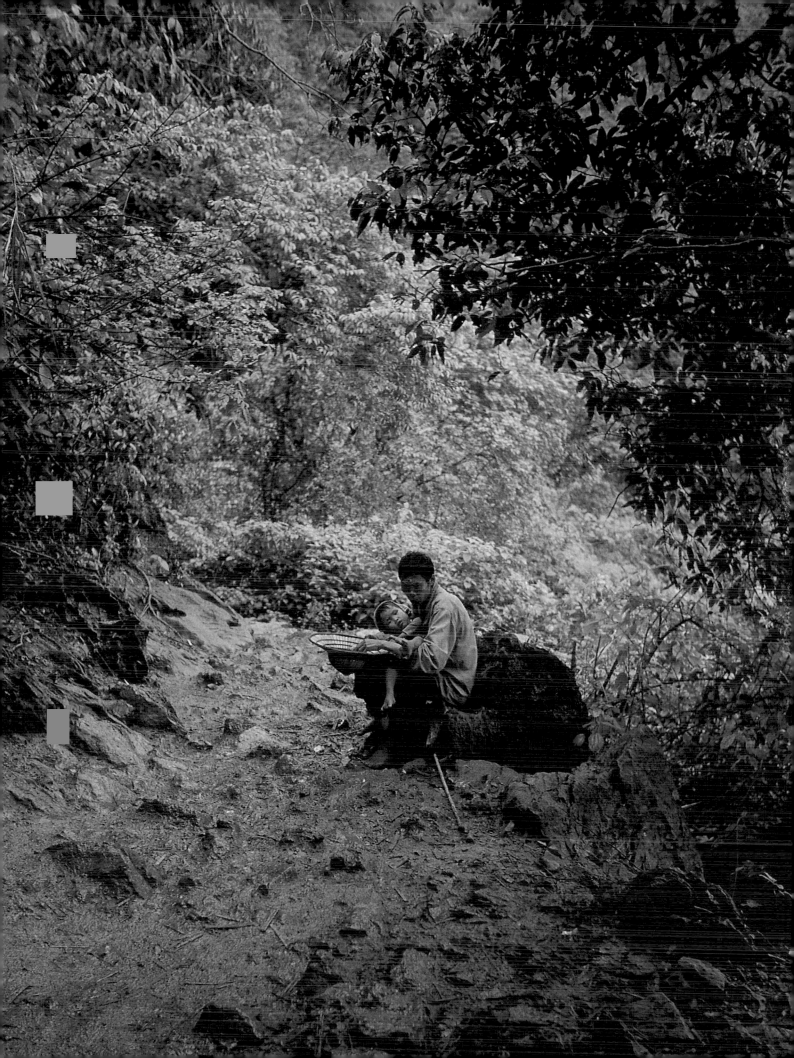

Ethnic *montagnard* girl
near Muong Lay, in the extreme
northwest of Tonkin, 1990

Page 194: Aboard the Cuu Long ferry as it
runs aground on the Mekong, 1984

Page 195: The younger brother of a girl
mini-gunned in the abattoir beside the
Y Bridge during Mini-Tet, 1968

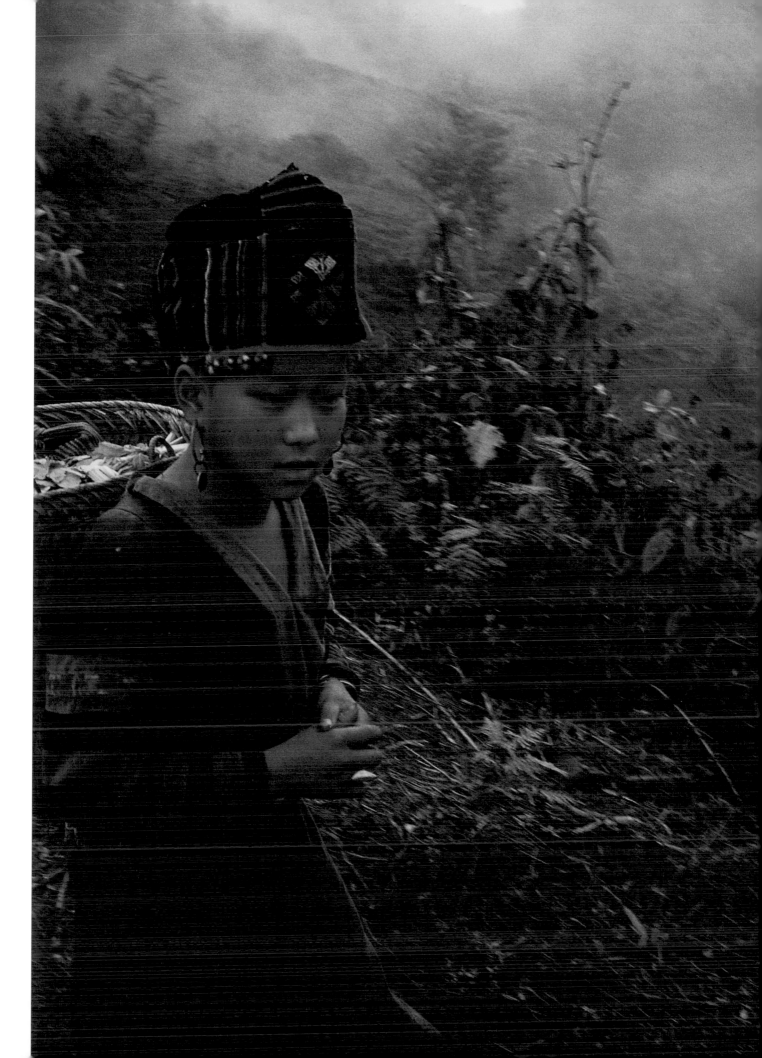

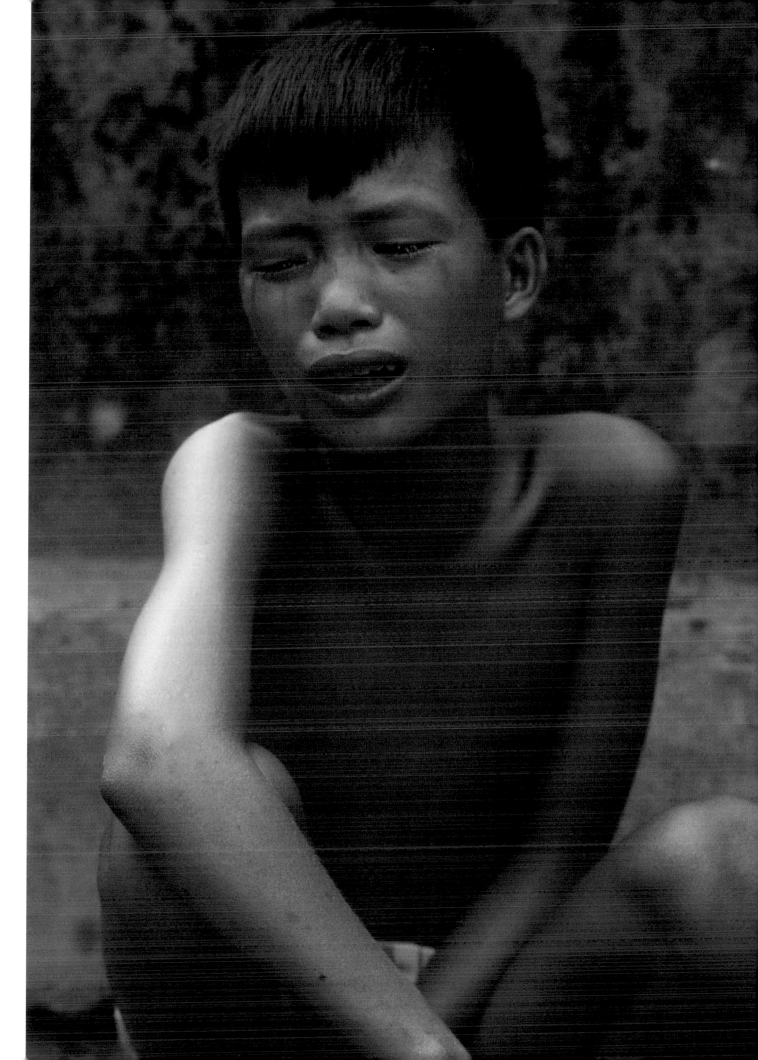

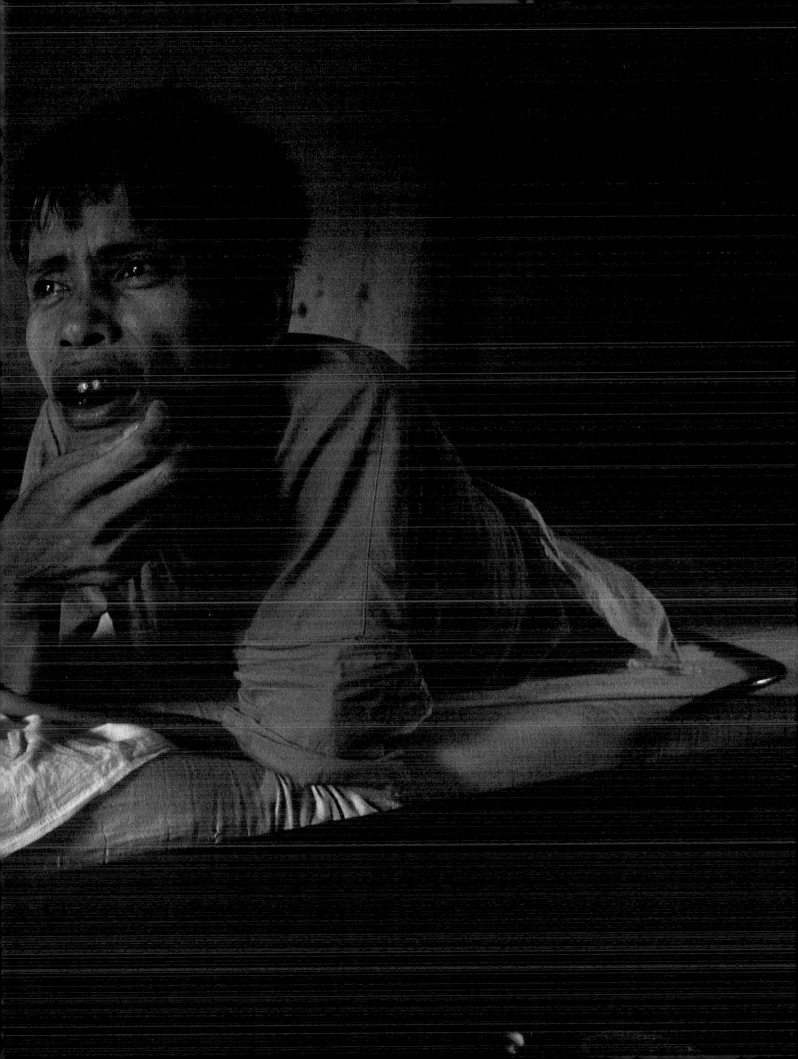

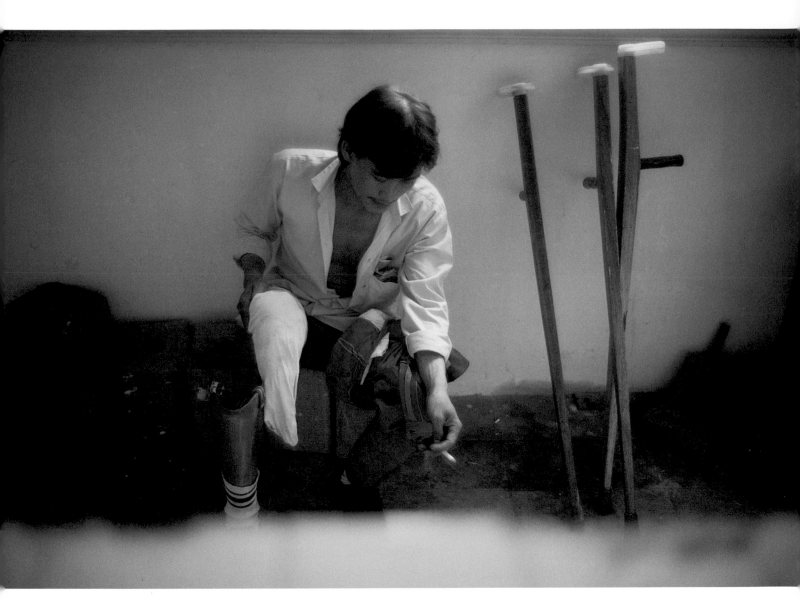

An amputee soldier-victim of
Vietnam's war in Cambodia receives
a prosthetic at the ICRC centre,
Ho Chi Minh, 1989

Pages 198–9: Paraplegic NVA
veteran awaits his morphine in the clinic
for the disabled at Ha Bac, 1994

Buddhas desecrated in the flush of
the Liberation of Laos, in Wat Sisaket,
Vientiane, 1996

Fisherman who has just survived
ramming by Chinese gunboat,
Da Nang, 1999

Opposite: Autistic Agent Orange child,
Hanoi, 1985

Page 204: 9th Division grunt on patrol
near Tan An, South Vietnam, 1968

Page 205: NVA soldier killed knocking
out an M-48 American tank in
the Michelin Plantation, 1969

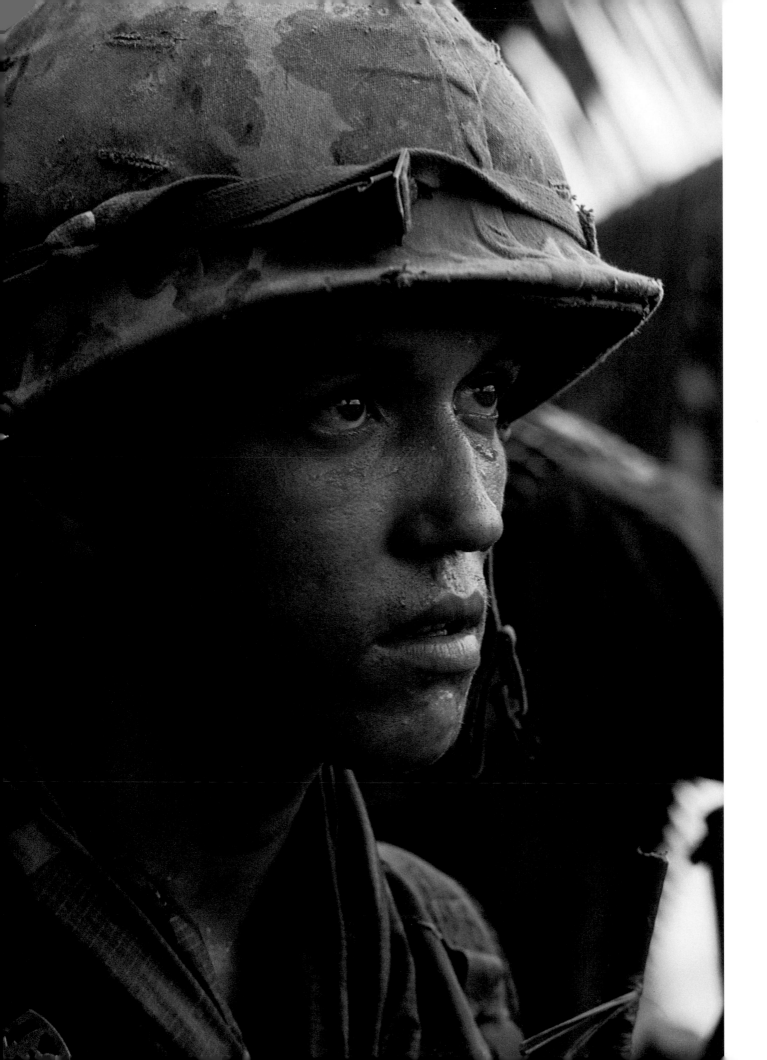

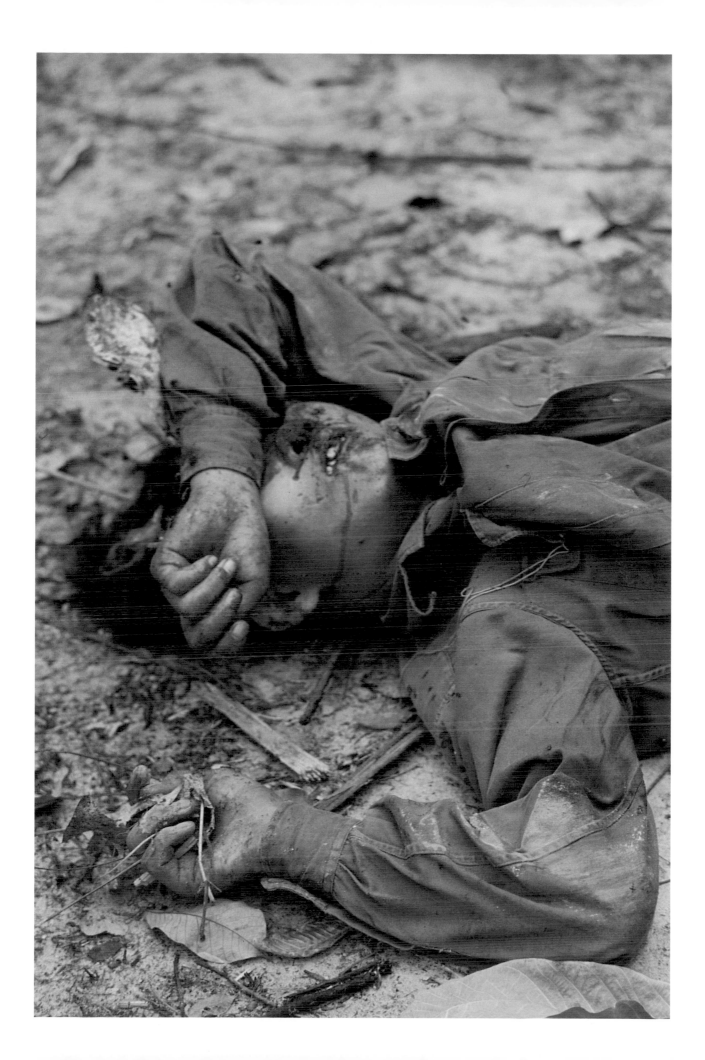

Army recruit, Hue, 1990

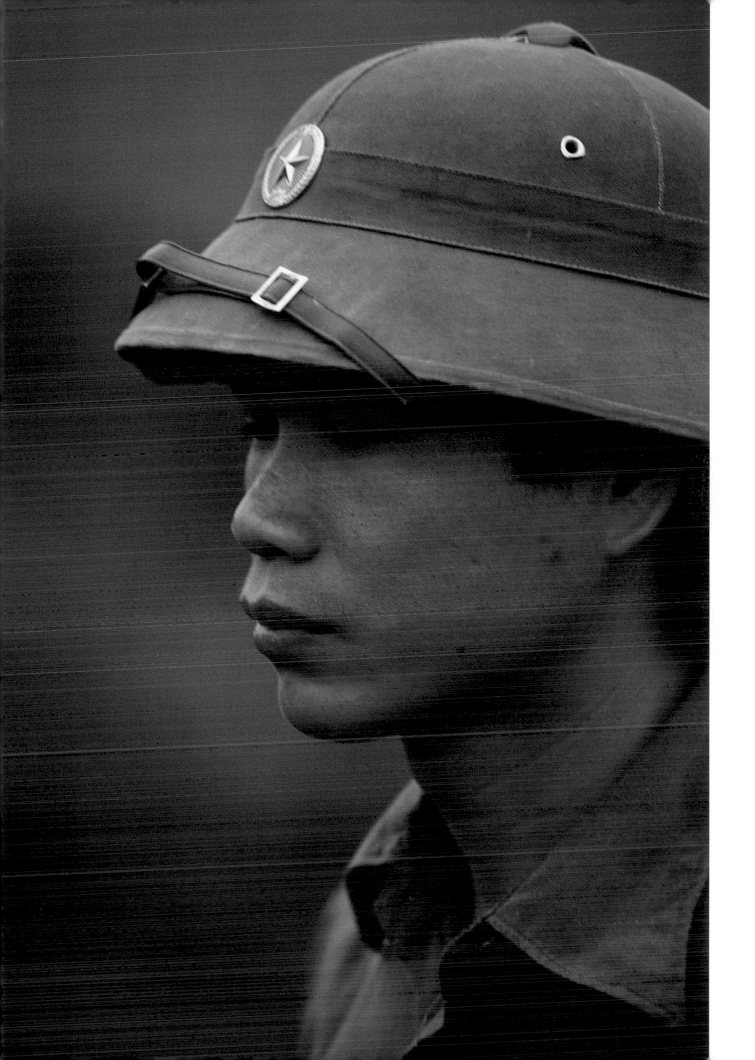

Blind mine victim rolling a smoke at
the Klaeng Klang rehabilitation
centre, Phnom Penh, 1991

Page 210: A Rhade villager from a
model hamlet south of Buon Me
Thuot in the central highlands
of Vietnam, 1985

Page 211: A shrine to the Dao
Dua on the Peace Island, 1985

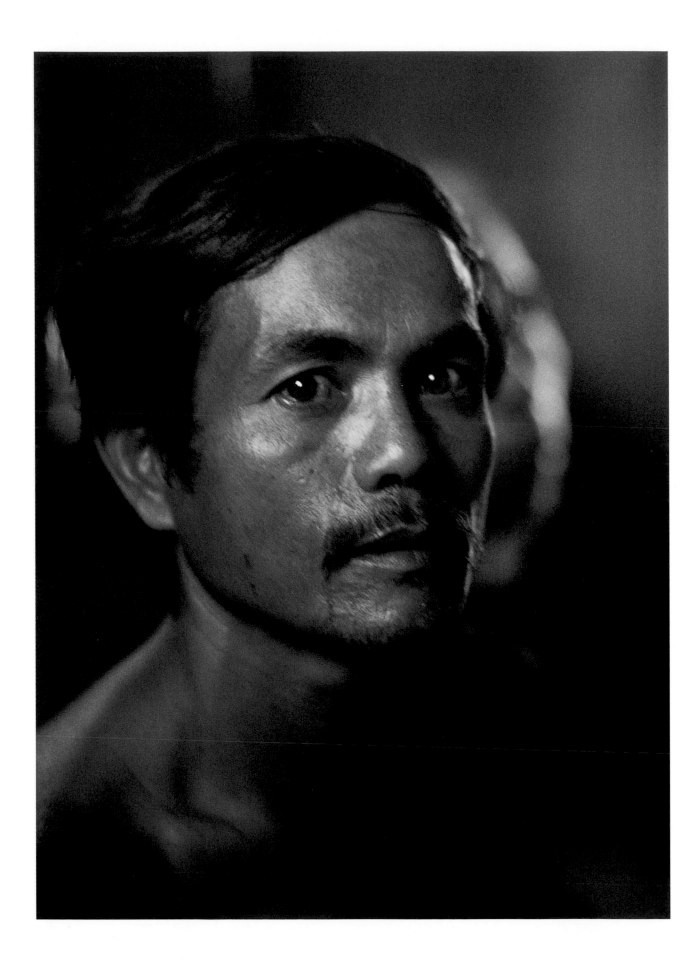

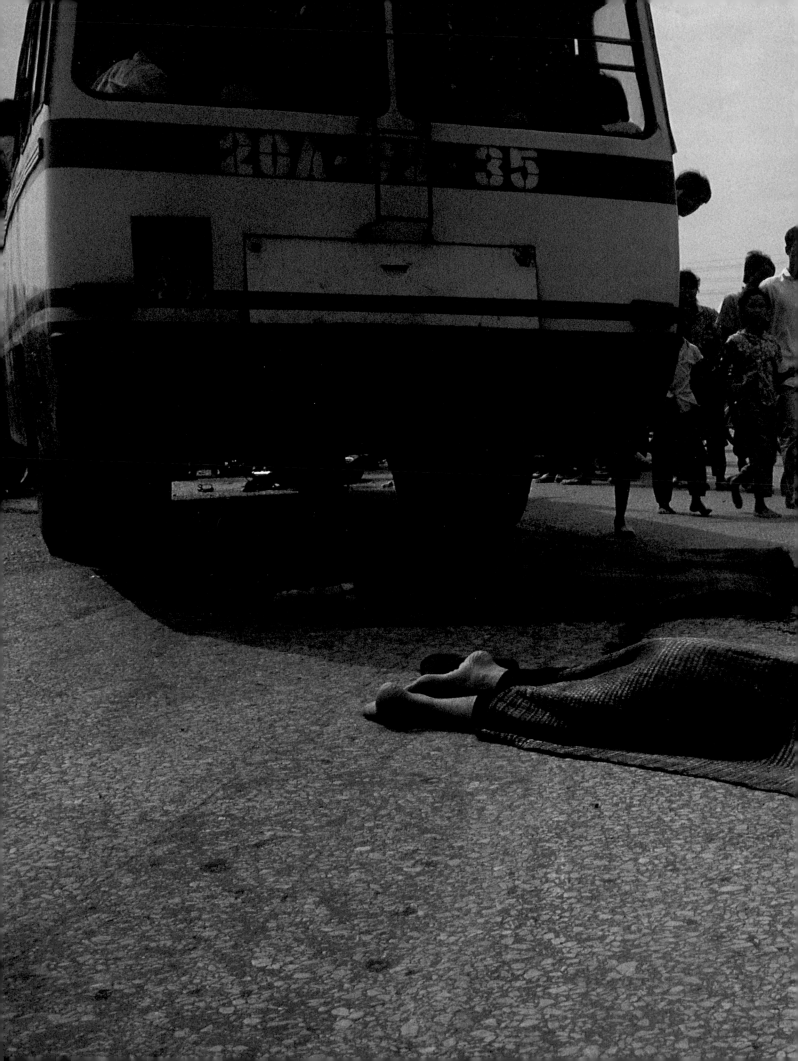

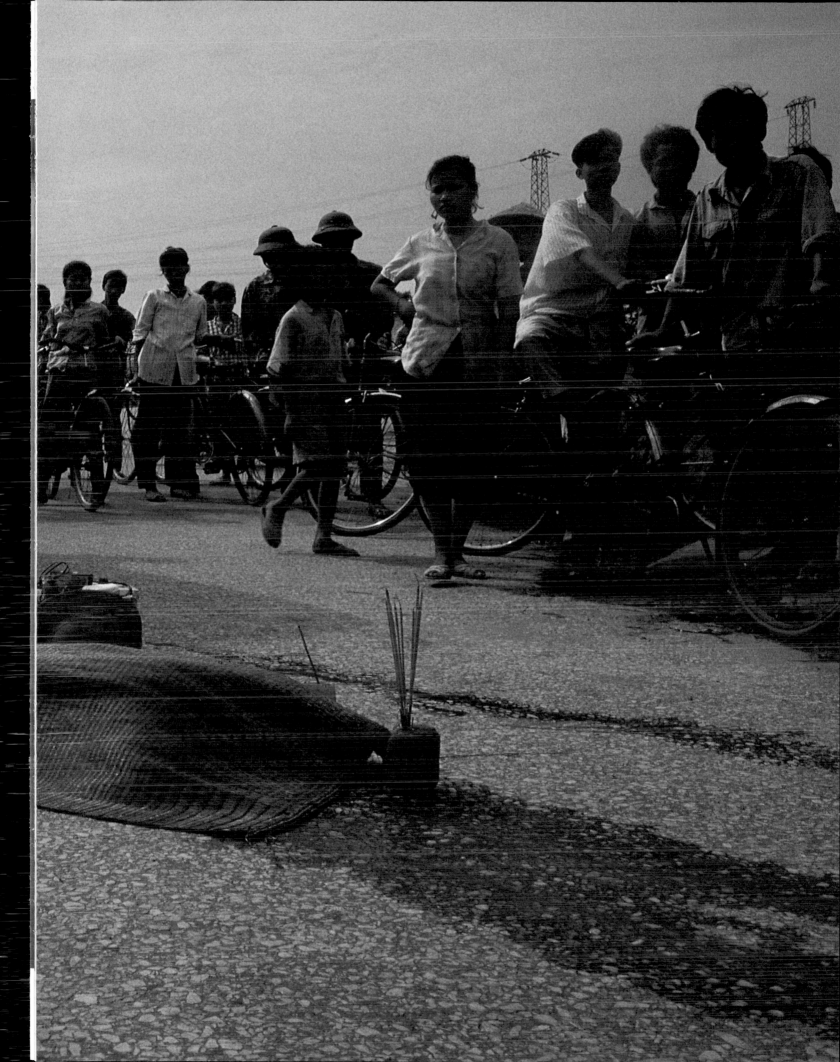

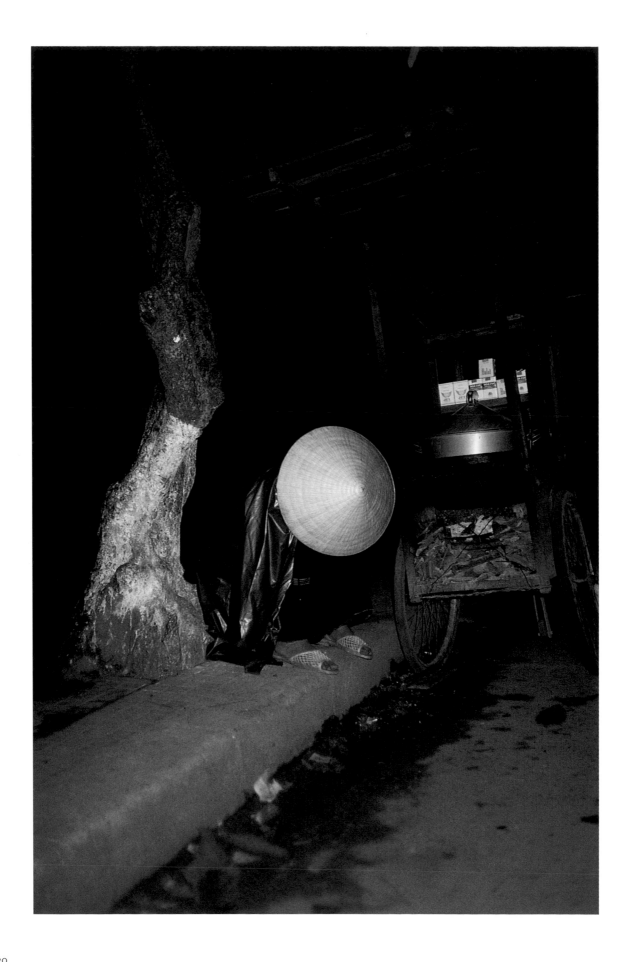

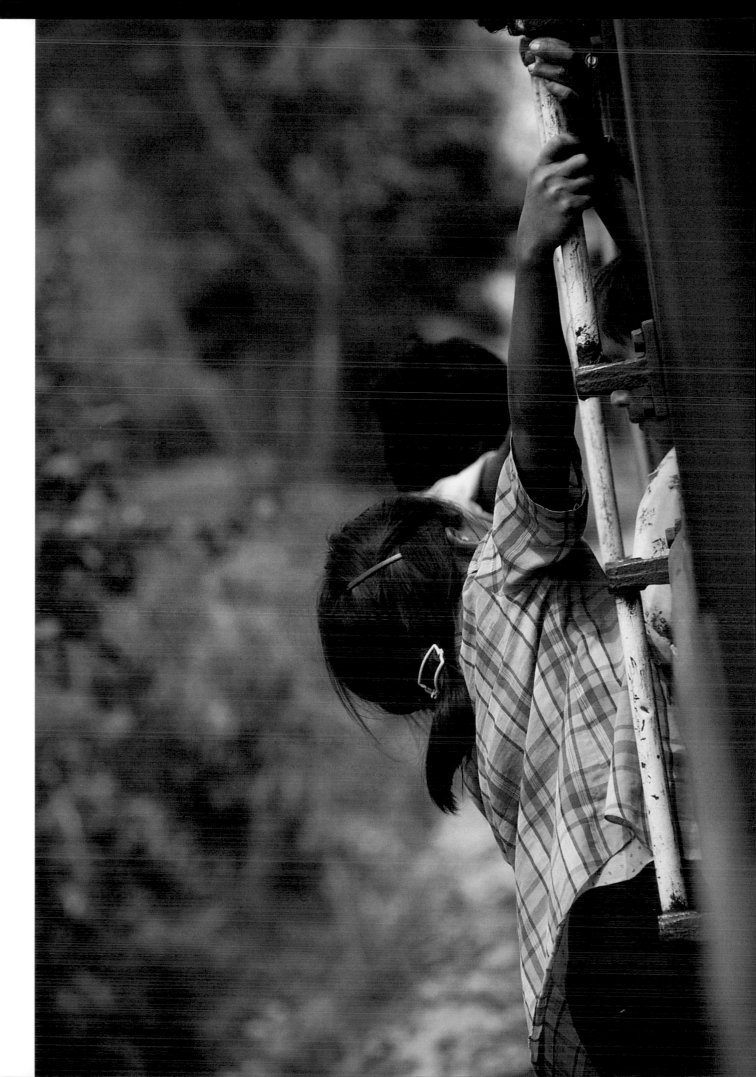

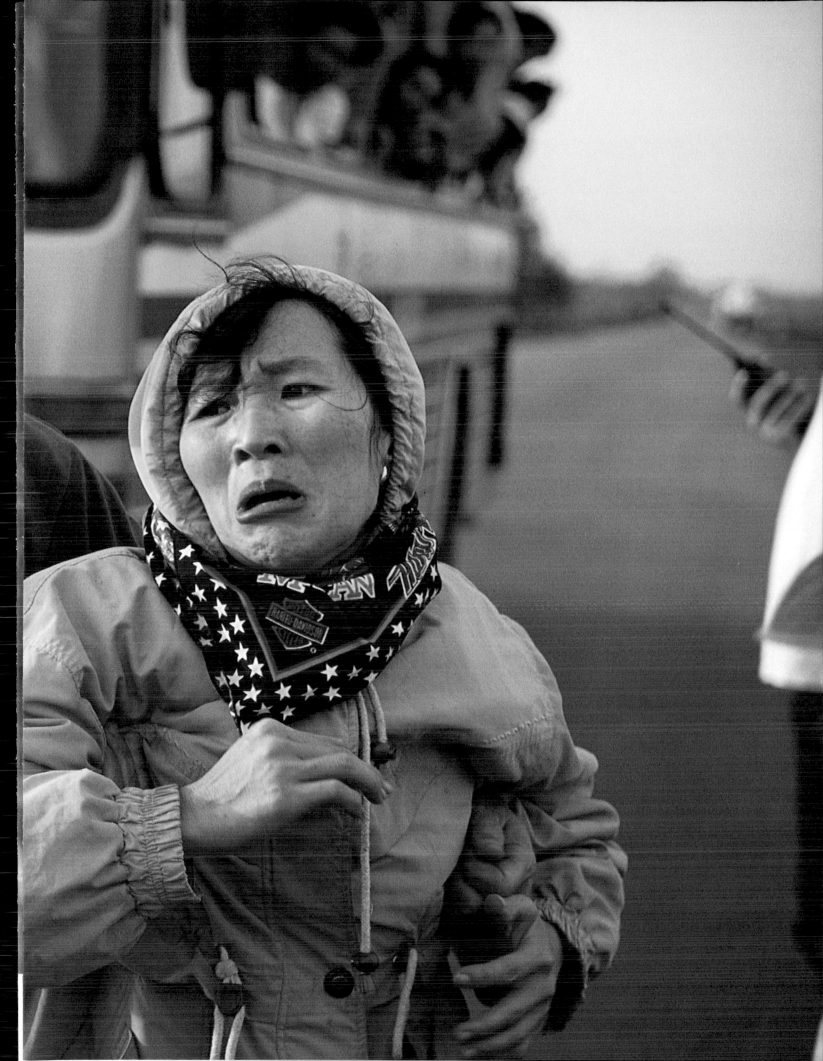

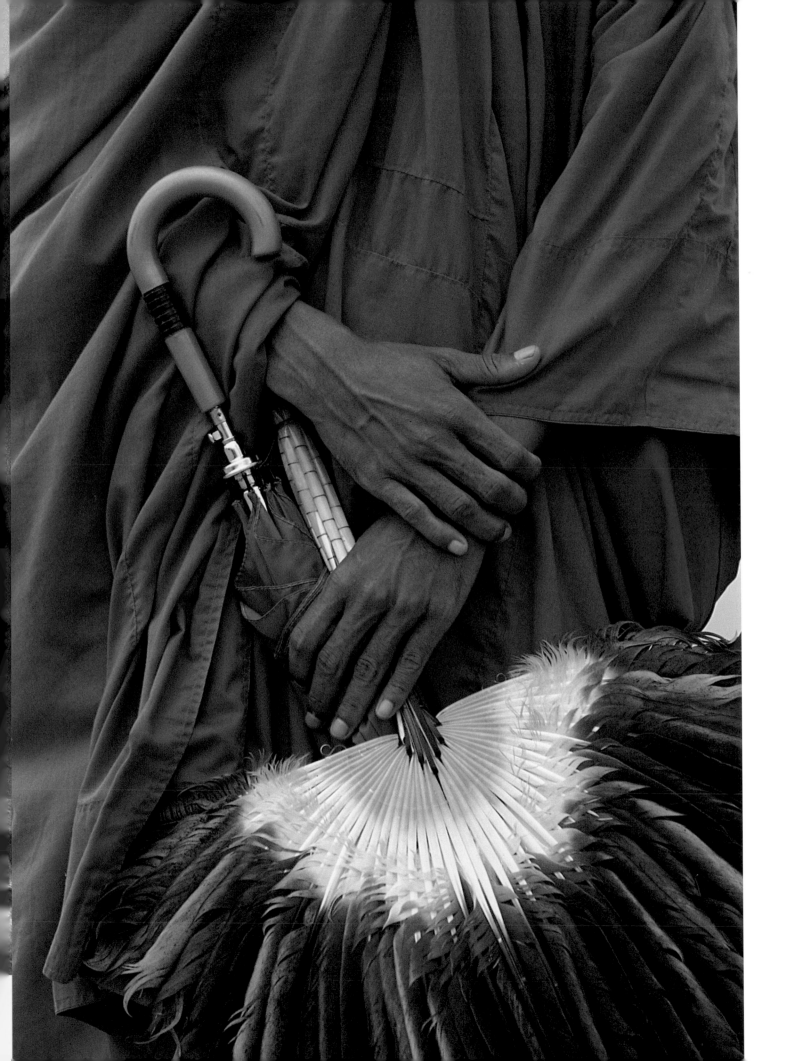

Lighting *huong* for the spirits of dead
veteran-relatives, Xuan Loc, 1985

Opposite: Greeting Buddhist dignitaries,
Pochentong Airport, Phnom Penh, 1992

Page 228: Classic Confucian
ceremony in the home of the deceased
matriarch of a traditional Annamese
family, Hue, 1999

Page 229: The vigil at the family home

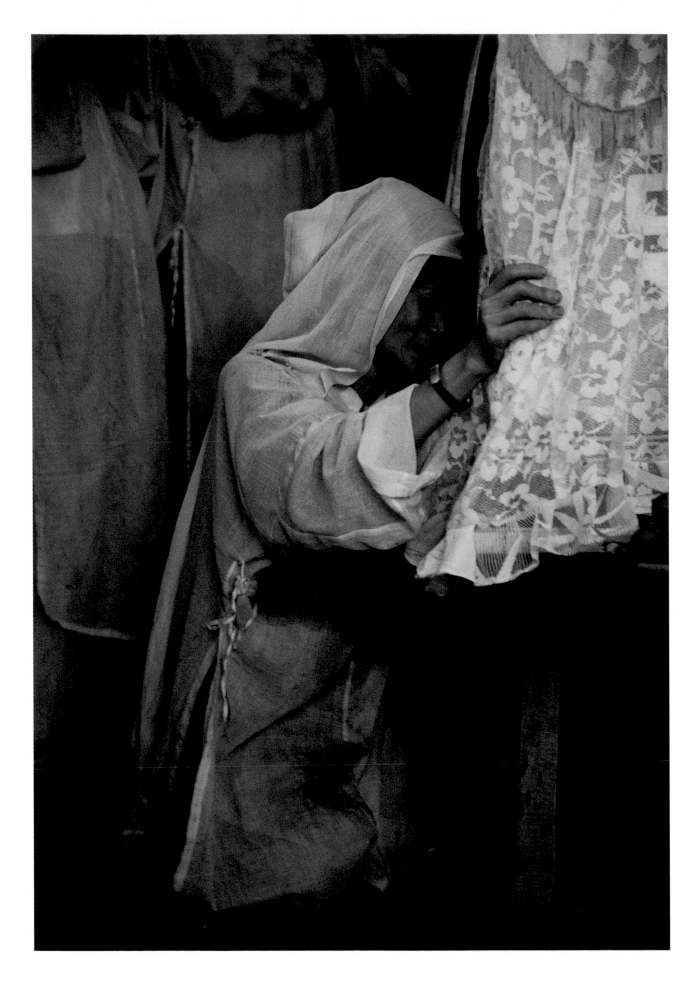

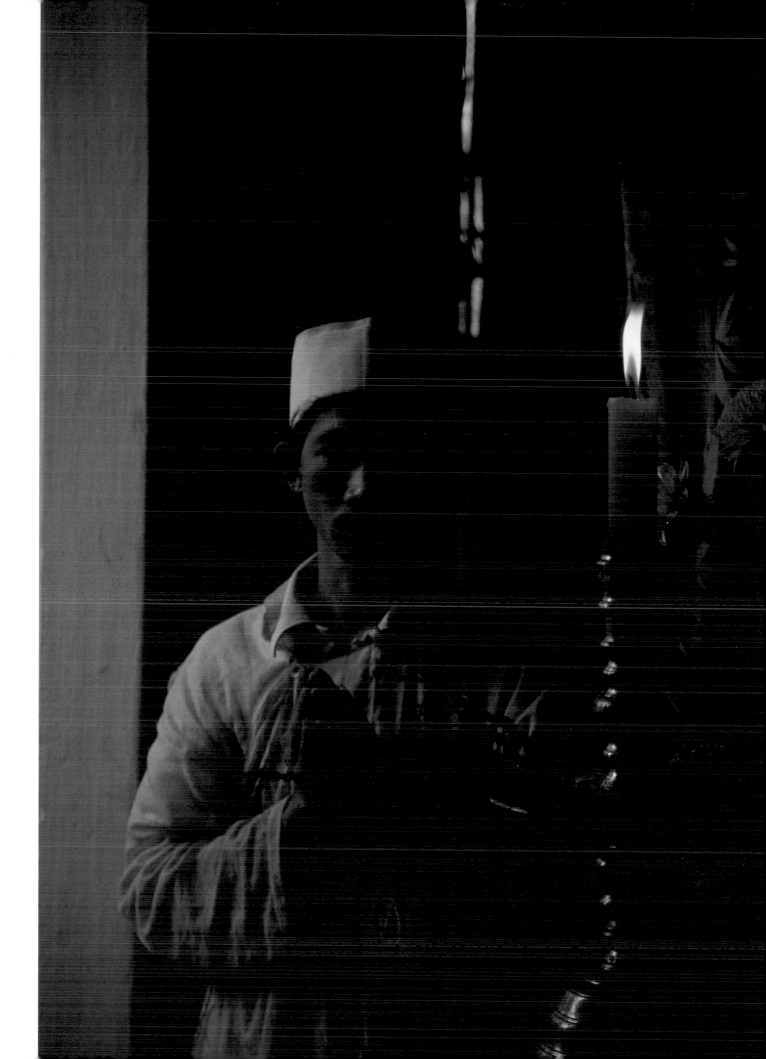

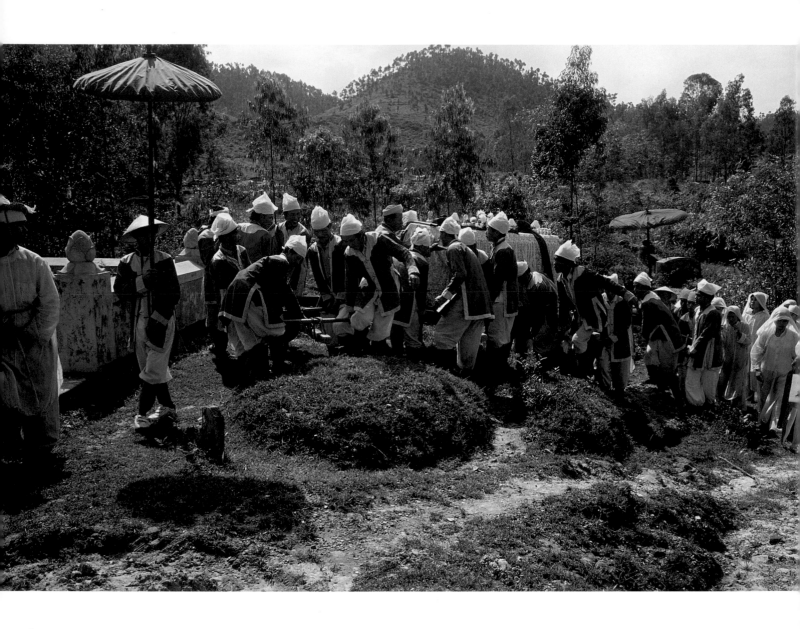

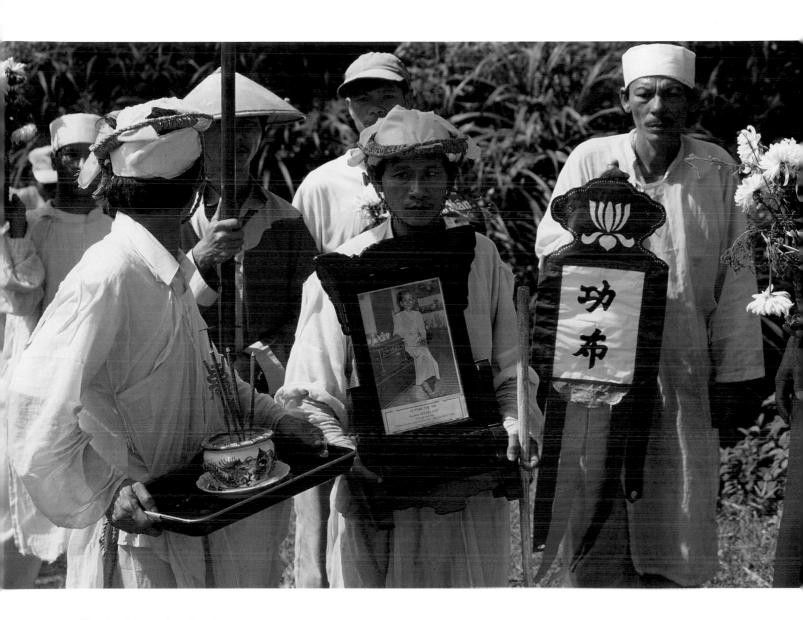

The family members head
the procession to the cemetery

Opposite: The funeral procession
arrives at the Buddhist burial
ground south of Hue

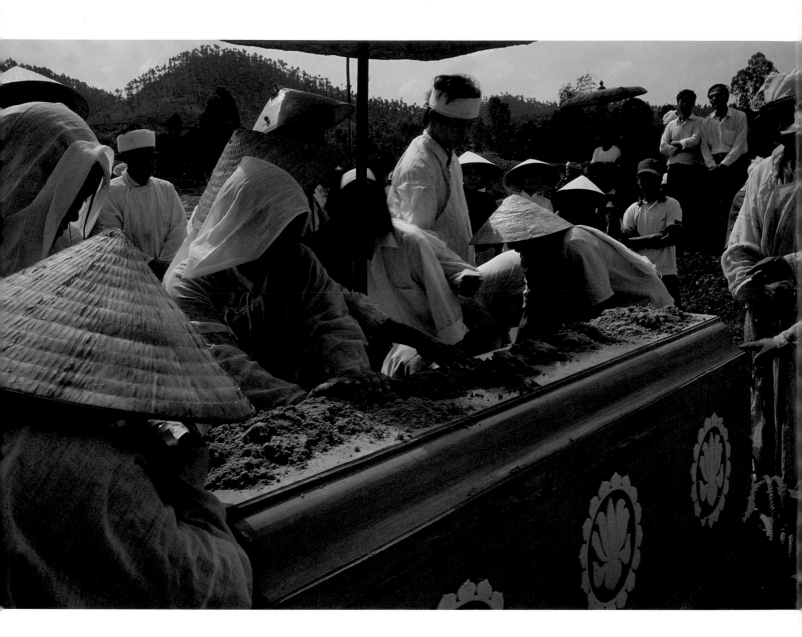

The interment

Opposite: A mourner at the graveside

Tat Bat ceremony during the
fifth anniversary of the
Liberation of Laos, Tat Luang,
Vientiane, 1980

Pages 236–7: A UN Mi-26 Soviet
helicopter lifting off from a rice
relief mission during the
Cambodian elections of 1993 at
Bantay Mean

A new Buddha at the entrance to
Tat Luang, Vientiane, 1996

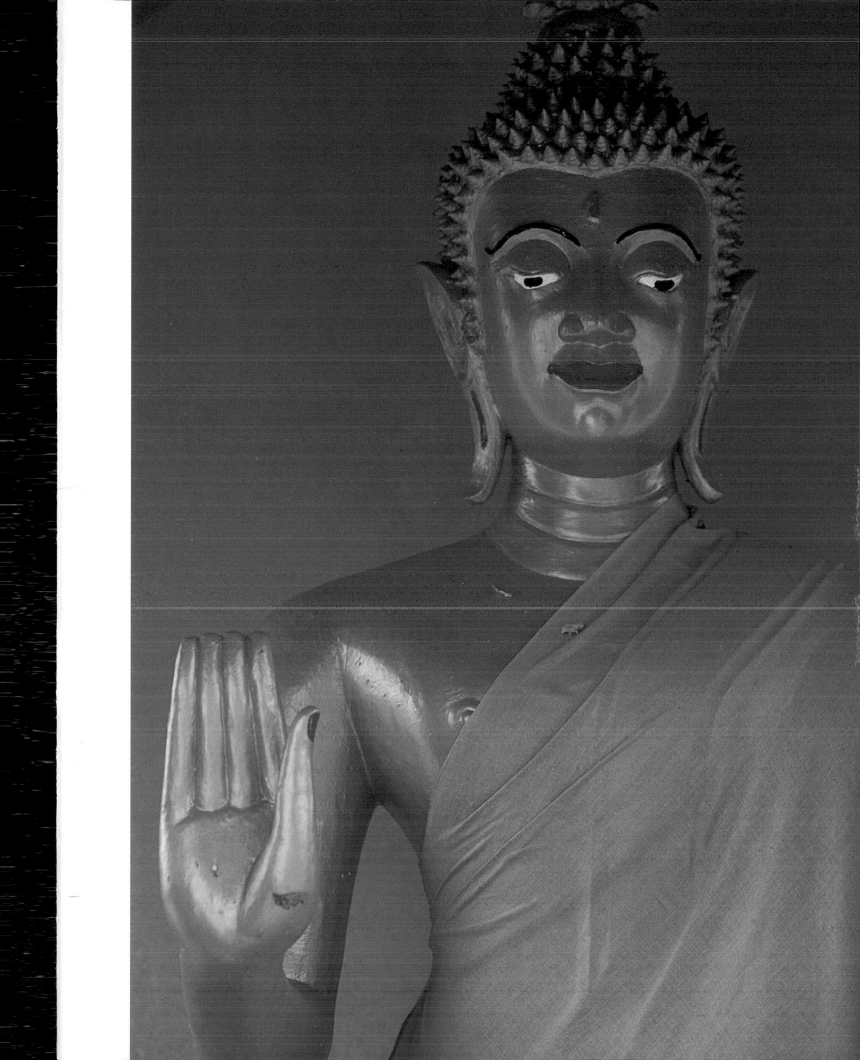